The Sustainable Legacy of Agnès Varda

The Sustainable Legacy of Agnès Varda

Feminist Practice and Pedagogy

Edited By
Colleen Kennedy-Karpat and Feride Çiçekoğlu

BLOOMSBURY ACADEMIC
LONDON • NEW YORK • OXFORD • NEW DELHI • SYDNEY

BLOOMSBURY ACADEMIC
Bloomsbury Publishing Plc
50 Bedford Square, London, WC1B 3DP, UK
1385 Broadway, New York, NY 10018, USA
29 Earlsfort Terrace, Dublin 2, Ireland

BLOOMSBURY, BLOOMSBURY ACADEMIC and the Diana logo
are trademarks of Bloomsbury Publishing Plc

First published in Great Britain 2022
This paperback edition published 2024

Copyright © Colleen Kennedy-Karpat and Feride Çiçekoğlu, 2022, 2024

Colleen Kennedy-Karpat and Feride Çiçekoğlu have asserted their right under the Copyright,
Designs and Patents Act, 1988, to be identified as Editors of this work.

For legal purposes the Acknowledgments on p. xiv constitute
an extension of this copyright page.

Cover design: Ben Anslow
Cover image: *Bord de Mer* (2009), an installation by Agnès Varda © estate varda

All rights reserved. No part of this publication may be reproduced or transmitted
in any form or by any means, electronic or mechanical, including photocopying,
recording, or any information storage or retrieval system, without prior
permission in writing from the publishers.

Bloomsbury Publishing Plc does not have any control over, or responsibility for,
any third-party websites referred to or in this book. All internet addresses given
in this book were correct at the time of going to press. The author and publisher
regret any inconvenience caused if addresses have changed or sites have
ceased to exist, but can accept no responsibility for any such changes.

A catalogue record for this book is available from the British Library.

Library of Congress Cataloging-in-Publication Data
Names: Kennedy-Karpat, Colleen, editor. | Çiçekoğlu, Feride, editor.
Title: The sustainable legacy of Agnès Varda : feminist practice and pedagogy /
edited by Colleen Kennedy-Karpat and Feride Çiçekoğlu.
Description: London ; New York : Bloomsbury Academic, 2022. |
Includes bibliographical references, filmography, and index. |
Identifiers: LCCN 2021042175 (print) | LCCN 2021042176 (ebook) |
ISBN 9781350240902 (hardback) | ISBN 9781350240940 (paperback) |
ISBN 9781350240919 (epub) | ISBN 9781350240926 (pdf)
Subjects: LCSH: Varda, Agnès, 1928–2019–Criticism and interpretation. |
Varda, Agnès, 1928–2019–Influence. | Feminism and motion pictures. |
Motion pictures–Study and teaching. | Women motion picture producers and
directors–France–Biography. | Motion pictures–France–History–20th century.
Classification: LCC PN1998.3.V368 S87 2022 (print) | LCC PN1998.3.V368 (ebook) |
DDC 791.4302/33092–dc23/eng/20211027
LC record available at https://lccn.loc.gov/2021042175
LC ebook record available at https://lccn.loc.gov/2021042176

ISBN: HB: 978-1-3502-4090-2
PB: 978-1-3502-4094-0
ePDF: 978-1-3502-4092-6
eBook: 978-1-3502-4091-9

Typeset by Integra Software Services Pvt. Ltd.

To find out more about our authors and books visit www.bloomsbury.com
and sign up for our newsletters.

Contents

List of Illustrations vii
List of Contributors ix
Acknowledgments xiv

1 Sustaining Joy in Varda's Legacy *Colleen Kennedy-Karpat* 1

Part 1 Creation

2 Agnès Varda's Formalist Feminism *Jennifer Stob* 15
3 Gleaning Metaphors from Reality in the Documentary Films of Agnès Varda *Joseph Horsey* 29
4 The Nude Auteur, Denuding Filmmaking *Ayça Çiftçi* 41

Part 2 Connections

5 Women Directors on the Edge of Hollywood: Agnès Varda/Shirley Clarke in and beyond *Lions Love* (1969) *Zizi Li* 55
6 Agnès Varda and Ursula Le Guin in Dialogue: The Narrator's Carrier Bag *Ruken Doğu Erdede* 69

Part 3 Environments

7 Passion, Commitment, Compassion: *Les Justes au Panthéon* by Agnès Varda *Sandy Flitterman-Lewis* 83
8 Urban Environments and Agnès Varda's *Genius loci* *Zeynep Demirhan and Colleen Kennedy-Karpat* 99
9 Iran Under Varda's Eyes: Interview with Dr. Ali Rafie *Negar Taymoorzadeh* 113

Part 4 Teaching Varda

Section Introduction: Teaching Varda *Colleen Kennedy-Karpat* 127

10 Agnès Varda: The Queen of the Margins *Beth Tsai* 130
11 Teaching Varda Teaching *Sandy Flitterman-Lewis* 137

12	Varda's *Sans toit ni loi/Vagabond* (1985): The Center of My Feminist Film Teaching, 1998–2020 *Kate Ince*	143
13	Teaching *Vagabond* (1985) *Homay King*	149
14	*Cléo* from Abu Dhabi to Seoul *Seung-hoon Jeong*	155
15	Digital Time, Teaching Temporalities, and Feminist Pedagogies: Teaching Varda's *Gleaners* (2000) Twenty Years on *Jenny Chamarette*	161
16	Gleaning with Visible Machines: Teaching Digital Cinema and Embodiment with Agnès Varda *Michael Cramer*	169
17	Teaching *Le Bonheur* (1964) *Jeremi Szaniawski*	175
18	Vardian Lessons: From Sea to Screen and Beyond *Nadine Boljkovac*	181
19	Farewell to Idols with Varda *Feride Çiçekoğlu*	189

Filmography: Agnès Varda	195
Additional Filmography	197
Bibliography	198
Index	206

Illustrations

2.1 Jane Birkin as reclining nude, part of a series of pastiched tableaux vivants featured in *Jane B. par Agnès V.* (1988). Frame capture, Criterion DVD — 21

2.2 Woman as weight-bearing architectural ornament in *Les dites cariatides* (The So-called Caryatids, 1984). Frame capture, Criterion DVD — 23

5.1 Director Shirley Clarke, playing herself in *Lions Love ... and Lies* (1969), attempts to act out a suicide scene with a drug overdose upon Varda's request — 62

5.2 Agnès Varda, wearing Clarke's outfit, carries out the same scene, lying on the bed after swallowing an excessive number of pills in *Lions Love ... and Lies* (1969) — 62

7.1 Television channel France 2 shows the interior of the Panthéon as Varda's installation of film and artifacts honor *les Justes* (the Righteous) with an arrangement that makes full use of the ceremonial and patriotically inflected space. Footage included in *Agnès Varda: L'intégrale* box set (Ciné-Tamaris, 2019) — 84

7.2 Detail of selected historical artifacts and photographs on display at Varda's commemorative installation *Les Justes au Panthéon* (The Righteous in the Pantheon, 2007). Included in *Agnès Varda: L'intégrale* box set (Ciné-Tamaris, 2019) — 87

7.3 A close-up on a yellow Star of David being affixed to a piece of clothing, part of the film loop projected in *Les Justes au Panthéon*. Included in *Agnès Varda: L'intégrale* box set (Ciné-Tamaris, 2019) — 88

7.4 For *Les Justes au Panthéon*, Varda filmed actors reenacting specific, documented acts of heroism, framing these shots especially from the children's perspective. These scenes were projected in four loops on screens suspended around the nave of the Pantheon as part of the installation. Included in *Agnès Varda: L'intégrale* box set (Ciné-Tamaris, 2019) — 90

7.5 Sandy Flitterman-Lewis with Agnès Varda in Rennes, November 2007. Photo courtesy of Sandy Flitterman-Lewis — 95

8.1 A recurring theme in *Daguerréotypes* (1975), Varda's study of her residential street in Paris, is the workday routine and what allows people to escape from it. Shopkeepers open for the day's business with practiced gestures and terse but friendly greetings to delivery workers and other passersby — 103

8.2 A mural by Manuel Cruz juxtaposes the image of active, violent death with a young life in repose in *Mur Murs* (1980), Varda's study of Los Angeles street art — 108

8.3 In *Mur Murs* (1980), Los Angeles resident Betty Brandelli stands in front of her cocktail bar whose exterior wall features a mural painted there in 1973 that features Betty with her late husband, a former boxer. Varda's framing in this shot recreates the framing of the mural itself as it also centers Betty telling her story — 109

10.1 Frame capture from *Les Plages d'Agnès* (The Beaches of Agnès, 2008) that shows Agnès Varda (frame right and mirror image) adding live, spoken credits to thank the assistants, Céline Miquelis (center) and Jérôme (left, last name unknown), who carried the mirrors on set — 135

11.1 Agnès Varda in the courtyard of her rue Daguerre home/studio, Paris, c. 1996. Photo courtesy Sandy Flitterman-Lewis — 137

13.1 Agnès Varda's *Shattered Portraits*, as they appear in *Agnès de ci de là Varda* (Agnès Varda From Here to There, 2011) — 150

13.2 "She's got to be crazy": Mona seen by others in *Vagabond* (1989) — 152

13.3 Mona with her back to the camera in *Vagabond* (1989) — 153

15.1 Sample screengrabs from the *Cléo de 5 à 7* teaching resource developed in 2011 — 165

17.1 Thérèse and François (Claire and Jean-Claude Drouot, married in real life as well as in the film) reclining in nature, an idyllic image before the tragic event in *Le Bonheur* (1965; Ciné-Tamaris) — 178

18.1 Le Champo flyer advertising the June 29, 2014 screening of *Sans toit ni loi* (Vagabond, 1985). Photograph courtesy of Nadine Boljkovac — 187

Contributors

Nadine Boljkovac (PhD, Cambridge) is Assistant Professor, Institute for Media and Cultural Studies, Heinrich Heine Universität Düsseldorf, and was Senior Lecturer in Film (Falmouth UK, 2016–19) following postdoctoral fellowships (Edinburgh; Brown; New South Wales Australia). Her first book, *Untimely Affects: Gilles Deleuze and an Ethics of Cinema*, explores Chris Marker and Alain Resnais's works. One of her books in progress is *Beyond Herself: Feminist Portraiture and the Moving Image*. Most recent works appear in *Camera Obscura*; *Revisiting Style in Literary and Cultural Studies*; *Studies in European Cinema*; "Materialising Absence in Film and Media" (co-edited for *Screening the Past*); *The Anthem Handbook of Screen Theory*.

Jenny Chamarette is Senior Research Fellow in the School of Art, the University of Reading. She is the co-editor of *Guilt and Shame: Essays in French Literature, Thought and Visual Culture* (with Jennifer Higgins, 2010) and author of *Phenomenology and the Future of Film* (2012); she has published widely on embodiment, gender, affect, disability, intermediality, and the cultural politics of the moving image in installation, multi-channel, and theatrical formats, in France, Europe, and the Middle East. She is currently Co-Investigator on the AHRC-funded Dwoskin Project, working on the digital archive, disability activism, and cultural legacy of artist-filmmaker Stephen Dwoskin.

Feride Çiçekoğlu holds a PhD in architecture from the University of Pennsylvania. The military junta of 1980 in Turkey interrupted her academic career. She spent four years as a political prisoner, after which she adapted her first novella *Don't let them shoot the kite* for the screen. She co-scripted *Journey to Hope* (1991 Academy Award for best foreign language film) and resumed teaching with scriptwriting and film. She has edited and written in collections on digital culture, gender, the cinematic city, and film. Currently she is the director of the master programs in film and television at İstanbul Bilgi University.

Ayça Çiftçi is a postdoctoral researcher at Kadir Has University. She obtained her PhD from Royal Holloway, the University of London in 2015. She published

a book chapter, "Kurdish Films in Turkey: Claims of Truth-Telling and Convergences between Fiction and Non-Fiction," in *Kurdish Documentary Cinema in Turkey* (2016). She has been a film critic and a member of the editorial board of *Altyazı Cinema Magazine* since 2006. She is currently working on a book chapter and a video essay on the representation of female desire in Yeşilçam cinema.

Michael Cramer is a Professor of Film History at Sarah Lawrence College. He is the author of the book *Utopian Television: Roberto Rossellini, Peter Watkins, and Jean-Luc Godard Beyond Cinema* (2017), and the co-editor (with Keith B. Wagner and Jeremi Szaniawksi) of *Fredric Jameson and Film Theory: Marxism, Allegory and Geopolitics in World Cinema*.

Zeynep Demirhan was born in Aydın, Turkey, and graduated in 2018 from the TOBB Economics and Technology University department of architecture. Since then, she has focused on photography and video, participating in solo and group exhibitions as well as in international events. Her documentary *Neighbor* (2019) focuses on the gentrification in Dolapdere, and her grandmother's Alzheimer's disease is the focus of another documentary short, *Lost in The Fifth Residence* (2021). Currently, she is finishing her master's thesis in the Film and Television department of Istanbul Bilgi University, an autoethnographic journey in search of how Varda's filmmaking has inspired the ways in which she films and documents her memories of the city.

Ruken Doğu Erdede completed her BA (double major) in the Department of Film and Television and the Department of Political Science at İstanbul Bilgi University. She received her master's degree in Film and Television at the same university. Her research interests are film theory, essay film, philosophy of ethics, visual ethics, feminist theory, politics of images, and digital visual cultures. She published an article (with Ebru Thwaites Diken), "Touch Me Not: The Ethics of Intimacy" in the *Journal for Cultural Research*.

Sandy Flitterman-Lewis is a groundbreaking feminist film scholar who wrote the first intensive analysis of Agnès Varda's filmography to appear in English: *To Desire Differently: Feminism and the French Cinema* (1990). Her work has foregrounded other major filmmakers as well, including Germaine Dulac and Chantal Akerman, who is the subject of her recent essay in the 100th issue of *Camera Obscura*, a journal she co-founded. Her writing has appeared in numerous anthologies and journals and has been translated into nearly a dozen languages. She is Associate

Professor at Rutgers University, where she teaches in the Department of English, the Comparative Literature Program, and the Cinema Studies Program.

Joseph Horsey is a PhD candidate in the University of York's department of Theatre, Film, Television and Interactive Media. His research interests involve film and television studies, particularly focused on experimental documentary film. His thesis explores the role that metaphor plays in how documentaries communicate meaning, with chapters on the documentary work of Agnès Varda, Werner Herzog, and Patricio Guzmán. He has presented papers at conferences including Virtual Varda (2020) and RaAM13 (2020). He runs seminars and gives lectures as part of a nonfiction module for Film and Television Production students at the University of York.

Kate Ince is Professor of French and Visual Studies in the School of Languages, Cultures, Art History and Music at the University of Birmingham. She has published books on the performance artist Orlan (*Orlan, millennial female* [2000]), the French documentarist and filmmaker Georges Franju (*Georges Franju* [2005]), the field of films directed by women (*The Body and the Screen: female subjectivities in contemporary women's cinema* [2017]), and the contemporary director Mia Hansen-Løve (*The Cinema of Mia Hansen-Løve: Candour and Vulnerability* [2021]). From 2018 to 2021 she has been PI of an AHRC network co-run with Prof. Marc Siegel (Mainz) and Dr. Pierre Eugène (Amiens) from which an essay collection titled *Serge Daney and Queer Cinephilia* will be published in 2022.

Seung-hoon Jeong is Assistant Professor of Film and Electronic Arts at California State University Long Beach. He wrote *Cinematic Interfaces: Film Theory after New Media* (2013); co-translated Jacques Derrida's *Acts of Literature* into Korean (2013); co-edited *The Global Auteur: The Politics of Authorship in 21st Century Cinema* (2016); guest-edited an issue of *Studies in the Humanities* "Global East Asian Cinema: Abjection and Agency" (2019); co-edited Thomas Elsaesser's *The Mind-Game Film: Distributed Agency, Time Travel, and Productive Pathology* (2021); and is writing *Global Cinema: A Biopolitical and Ethical Reframing* (forthcoming in 2022).

Colleen Kennedy-Karpat is a member of the faculty in the Department of Communication and Design at Bilkent University in Ankara, Turkey, where she teaches film and media studies. She is the award-winning author of *Rogues,*

Romance, and Exoticism in French Cinema of the 1930s (2013) and essays that have appeared in *Adaptation*, *Camera Obscura*, the *Journal of Popular Film & Television*, and a number of published volumes, including *The Films of Wes Anderson* (2014), *A Companion to the Biopic* (2020), and her own co-edited collection *Adaptation, Awards Culture, and the Value of Prestige* (with Eric Sandberg, 2017).

Homay King is Professor and Eugenia Chase Guild Chair in the Humanities in the Department of History of Art at Bryn Mawr College, where she co-founded the Program in Film Studies. She is the author of *Virtual Memory: Time-based Art and the Dream of Digitality* (2015), and *Lost in Translation: Orientalism, Cinema, and the Enigmatic Signifier* (2010). Her work has appeared in *Afterall*, *Discourse*, *Film Quarterly*, *October*, and collections including the exhibition catalog for the Metropolitan Museum of Art's *China: Through the Looking Glass*. She is a member of the *Camera Obscura* editorial collective.

Zizi Li is a PhD candidate in Film, Television, and Digital Media at the University of California, Los Angeles. Her primary research revolves around the relationships between digital media economy and extraction of natural/human resources and racialized/gendered labor. She holds strong pedagogical and research interests in transnational media, feminist theory and praxis, and decolonial methods.

Jennifer Stob is Associate Professor of Art History at Texas State University. She researches at the intersections of aesthetic theory, experimental film, and transnational cinema. Her essays appear in publications such as *Texte zur Kunst*, *Film Criticism*, and *Studies in French Cinema*. She has contributed chapters to several anthologies, including *On Women's Films: Across Worlds and Generations* (2019), *Architectures of Revolt: The Cinematic City circa 1968* (2018), and *European Cinema after the Wall: Screening East-West Mobility* (2013). Her book on social space, cinema, and the Situationist International is forthcoming.

Jeremi Szaniawski is Assistant Professor of Comparative Literature and Film Studies, and Amesbury professor of Polish language and culture at the University of Massachusetts at Amherst. He has authored and edited several volumes, including *The Global Auteur: The Politics of Authorship in 21st Century Cinema* (with Seung-hoon Jeong, 2016) and *On Women's Films Across Worlds*

and Generations (with Ivone Margulies, 2019). His research interests include Marxist film theory, women filmmakers, and queer and feminist revisiting of film auteurs.

Negar Taymoorzadeh is a PhD candidate in the Department of Cinema Studies at New York University, where she works on transnational melodrama. She has taught at New York University, the American University in Cairo, and at Boğaziçi University in Istanbul. Her work has appeared in *CINEJ Cinema Journal* and the *Historical Dictionary of Middle Eastern Cinema* (2012).

Beth Tsai is Visiting Assistant Professor in East Asian Languages and Cultural Studies at the University of California, Santa Barbara. Her research focuses primarily on the cinema of Taiwan, film festivals, and transnational film theory. She has published in the *International Journal of Asia Pacific Studies*, *Quarterly Review of Film and Video*, *Journal of Asian Cinema*, and *Oxford Bibliographies*. Her first book, *Taiwan New Cinema at Film Festivals*, is forthcoming from Edinburgh University Press.

Acknowledgments

The editors wish to thank all presenters and participants at the "Gender Equality and Sustainability: Agnès Varda's Sustaining Legacy" conference held on March 28, 2020, hosted by İstanbul Bilgi University, an event unofficially renamed "Virtual Varda" after the proceedings were moved online. Many of those presentations went on to become the chapters contained in the first three sections of this volume.

A special thanks to Nilüfer Neslihan Arslan and Serhat Burak Şungar, the research assistants of the Film and Television Department, and to Furkan Sucuoğlu and Ekin Ersin from IT support for guiding this shift at a stage of the Covid-19 pandemic when video conferencing was not yet a fixture in our daily lives. Thanks also to Anıl Karasaç for his invaluable feedback on a draft of the manuscript and Eda Güven for help with the index. We also wish to thank İstanbul Bilgi University for highlighting gender equality and sustainability among its basic values, particularly the university rectorate and Vice Rector Professor Aslı Tunç for their continuing support of these scholarly initiatives.

The editors wish to thank *Camera Obscura* for permission to reprint a version of Sandy Flitterman-Lewis's keynote, initially delivered at the "Virtual Varda" conference. An extended, Turkish-language version of Ayça Çiftçi's chapter appears in *Ten ve Hafıza: Agnès Varda*, edited by Tolga Yalur, and we are proud to include an abridged translation of her work in our own collection.

Colleen Kennedy-Karpat thanks her co-editor Feride Çiçekoğlu for her joy and commitment to this project from its inception, and shares heartfelt gratitude for her continued mentorship and friendship.

Likewise, Feride thanks her co-editor Colleen for an unprecedented adventure in her not-so-short history of collaborations, since no reconciliations were required; joyful at each turn, the lived experience yearns for continuation.

1

Sustaining Joy in Varda's Legacy

Colleen Kennedy-Karpat

In the year following Agnès Varda's passing on March 29, 2019, her fans and film scholars turned to the task of defining and honoring what her daughter Rosalie Varda has called her "joyous legacy," the sum of over six decades of art created through intimacy, tenacity, and compassion. Rosalie observed that her mother "was younger than me in her head, you know? She was so curious about everything," and this curiosity defines her films.[1]

What marks this curiosity as distinctly Vardian is how overwhelmingly it is directed outward, toward others, even when Varda uses this extroverted engagement to reveal her own subjective experience. Reflecting on the time he spent with Varda making *Visages villages* (*Faces Places*, 2017), artist JR remembers Varda's insistence that "the most important thing is to take the time to look at others."[2] This individual act of looking is important: it requires dedicated time and concentrated effort that looks effortless in Varda's hands, but actually involves considerable investment of self in the pursuit of others' stories. Thus, the idea of community, and the practices involved in building communities, anchors the outlook that Varda expressed through her art. Connection and creation are intimately linked, and she recognized her own rare privilege in being able to connect firsthand with people all over the world. In her later films, she would narrate these experiences through her own authorial perspective, culminating in the filmed masterclasses compiled in her final documentary *Varda par Agnès* (*Varda by Agnès*, 2019).

The environments that situate and facilitate these connections also shape Varda's art. Her work invests heavily in specificity of place: from the rue Mouffetard in her early short essay film *L'Opéra-Mouffe* (*Diary of a Pregnant Woman*, 1958), to the stop-motion postcard aesthetic of *Salut les Cubains!* (*Hello, Cubans!* 1964), to her portrait of a Parisian neighborhood in *Daguerréotypes* (1974), to her Los Angeles diptych *Mur Murs* (1980) and *Documenteur* (1981),

to her recurring visits to the island of Noirmoutier that culminated in the exposition *L'Île et elle* (The Island and She, 2006). These studies of *genius loci*—the spirit of an individual place, as Zeynep Demirhan and Colleen Kennedy-Karpat discuss in this volume—then give way to Varda's late documentaries that showcase travel in disparate locations: *Les Glaneurs et la glaneuse* (The Gleaners and I, 2000), *Visages villages*, and *Varda par Agnès* all take Varda to remote corners of France and adjacent countries, while her miniseries *Agnès de ci de la Varda* (Agnès Varda: From Here to There, 2011) adopts an even more global scale to produce an audiovisual mosaic of distinct places and discrete experiences that still projects a unified, panoramic view. *De ci de là* also breaks from the introspection of *Les Plages d'Agnès* (The Beaches of Agnès, 2008) to consider artistic creation from other artists' perspectives. The entire documentary series is structured around the notion of the encounter: both the personal encounter with art and the interpersonal encounters that feed, form, and facilitate its creation and reception.

This global interconnectedness hits differently in a pandemic, which is the context in which the authors and editors have prepared this book. Serendipitously, in the midst of this crisis defined by separation, when self-isolation is a kind of resistance, our work has turned in earnest to Agnès Varda, an artist devoted to the spirit of human connection. And few artists could claim to match Varda's foresight in understanding how digital film and media arts can address and even overcome the disconnectedness of our world. From the visual experimentation in *The Gleaners and I* to the global panorama in *De ci de là*, Varda's late career lays bare the conventional restrictions that have always threatened to limit our outlook, especially our perspective on others. Mundane acts—Varda pouring a glass of wine with friends, Varda watching crowds in a museum, Varda meeting eager film students—reveal her generosity and genius in inviting viewers to listen alongside her and learn from the subjects she brings before her camera. Later, in *Varda par Agnès*, she explicitly framed this spirit of *partage*, sharing, as a driving force of her art.

This collected volume underscores how the interrelated notions of creation, connection, and environment form the core of Varda's artistry and authorship, and this introduction presents these same qualities as key to a sustainable (and sustaining) legacy. In contrast to the vision of the auteur as an isolated artist, for Varda it is relationships—with her family, with other artists, with her audiences, even with passersby—that have left an indelible mark on her memory. In the spirit of creating new relationships to both sustain and expand Varda's legacy, this book's fourth section is dedicated to dispatches from the classroom, where

pedagogy intersects with feminist practice in essays from prominent scholars who describe how teaching Varda's work has influenced them. But before approaching the praxis of transmitting an artistic legacy to new generations, we must first explore the question of legacy itself.

Toward a Sustainable Legacy

A personal legacy can take shape after any momentous departure—graduation, retirement, death—as long as there is common understanding that this person's past experience and accomplishments have something to offer the future. While legacies can be circumscribed within specific institutions, as with alumni and employment, they can also resonate outside these structures, as is generally the case with posthumous legacies.

Given their emotional charge and their tendency toward formal institutionalization, legacies are often treated as objects to be preserved. Preservation suggests fixity and stasis—in other words, resistance to change. Yet the means and method of activating this resistance are not uniform. Fossils preserved in amber are perfectly suspended in death, maintaining their exact living form so long as their encasement remains intact; meanwhile, food might be preserved in any number of ways to hold onto some essence of its fresher form, yet the preservation process also subjects it to transformative change. When it comes to legacies, if someone is convinced that preservation must work as with amber, it becomes easy to overlook the transformative power of preservation as a process, even to the point of denying that successful preservation can require transformation or that this process is definitive: there can be no reversion to old forms.

Varda and her oeuvre demand a different conceptualization of legacy and a different attitude in how it might be carried forward. In lieu of preservation, what we advocate in this book is a sustainable legacy for Agnès Varda, one that eschews formal institutionalization through its reflection of her artistic, dynamic response to social change. The intent in creating a sustainable legacy is not to worship the immutable form of the creator as she lived, nor to define her work solely by the context and circumstances of its creation. A sustainable legacy seeks, instead, to embrace the inevitability of change and to acknowledge *a priori* that future publics may not continue to value this work (or its creator) for the same reasons or in the same way. This change, in itself, should not constitute an existential threat for a legacy; rather, a legacy's persistence over time should

depend on its ability to evolve with the times and find fresh resonance with new audiences. Unlike a preservation-centered approach, a sustainable legacy adopts a future-focused, more expansive perspective on how one person's life and work can maintain their relevance through active dialogue between the past that shaped them and the present moment that confronts them.

The need for new concepts of artistic legacy extends beyond Varda. The rise of #MeToo and the concomitant question of what to do with, as Claire Dederer memorably phrased it, "the art of monstrous men," have articulated with new force why legacies must shift with new information and changing social mores.³ Legacies are, therefore, a feminist issue. Actions and behaviors once dismissed as irrelevant to the finished art—and, by extension, the artist's legacy—have been confronted with increasing frequency and unprecedented visibility, revealing entire careers indelibly marked by harm inflicted onto others. The call to consider their harm alongside their art challenges the presumed separation between art and artist. As Dederer asserts,

> Authority says the work shall remain untouched by the life. Authority says biography is fallacy. Authority believes the work exists in an ideal state (ahistorical, alpine, snowy, pure). Authority ignores the natural feeling that arises from biographical knowledge of a subject. Authority gets snippy about stuff like that. Authority claims it is able to appreciate the work free of biography, of history. Authority sides with the (male) maker, against the audience.⁴

This hegemonic authority echoes the preservation-minded approach to legacy: it requires both the careful excision of details that might threaten its durability and the support of an undergirding ideology that would justify this selective ignorance. Authority would argue, in other words, that the fossil has a right to not only survive the fracture of its amber encasement, but also keep its status as a prized specimen despite visible cracks in its veneer. But integrity affects the value of both fossil and art; looking particularly at film, the recurring cycle of bowdlerization and reintegration offers a narrative whose appeal has nourished many a cult following, from Erich von Stroheim's as-yet unrestored classic *Greed* (1924) to the so-called Snyder Cut of *Justice League* (2021).

As auteur-driven as such cults are, it is not unreasonable to extend this demand for integrity to the artists themselves. To grasp the entirety of Varda's work, *à l'intégrale*, Varda's legacy necessarily complicates any attempt to separate art from artist. Her life became so entangled with her art, especially in her late work, that it would be impossible to disentangle them without shortchanging or misrepresenting her entire *oeuvre*. Authority may have it that intermingling life

with art only cheapens the art, but Varda has long rejected this assumption. And what Dederer's observation further suggests is that Varda's insistence on making art out of her own life amounts to an act of anti-authoritarianism. Using her unimpeachable claim to auteur status as leverage, Varda's third wave, starting with *Glaneurs* in 2000, exposes any mandate to treat the art apart from the artist as ideologically suspect.

In his call for a "new cinephilia," Girish Shambu notes that "the worth of a film may rise and fall over time, depending not just on formal criteria, but also on ideological ones," insisting that "we must forever be open to the possibility of reevaluating or even renouncing our objects of previous adoration in light of new knowledge, new consciousness, new imperatives."[5] A sustainable legacy is one that can take such fluctuations in stride, finding ways for an artist's work to speak to a present they themselves could never have foreseen. While Varda's work reflected her own ideological evolution over her long career, it still feels taboo to grapple with ideas in her work that, unlike Varda herself, aged poorly. Yet several pieces in this collection blaze a trail through this thorny terrain: in "Varda's Formalist Feminism," Jennifer Stob takes Varda to task for a rigidly binary concept of gender, whose roots Stob finds in the art history training that Varda received as a young woman in postwar France. But Stob does not articulate this critique to undermine Varda's legacy; rather, she argues that this persistently binaristic thinking poses a surmountable challenge to viewers whose perspective has been shaped by queer and intersectional feminism. Similarly, Negar Taymoorzadeh's interview with Ali Rafie, longtime leader of the Iranian national theater and part of the cast in Varda's feature *L'Une chante, l'autre pas* (One Sings, the Other Doesn't, 1976) as well as its sister short *Plaisir d'amour en Iran* (Pleasure of Love in Iran, 1976), underscores how these films missed an opportunity to confront and question Western Orientalism. This collection adopts a critical stance on Varda's work neither to discredit her as an artist nor to speculate an expiration date for her relevance, but rather to model how a sustainable legacy must reject reactionary hagiography and idolatry.

A sustainable legacy requires sufficient integrity and flexibility to hold its value in constantly changing social contexts; lacking either or both of these things, the legacy falls apart along with whatever crumbling ideological or institutional framework had been propping it up. As a cornerstone of any progressive agenda, sustainability also connotes a concern for the common good—most famously in the sense of how human activity affects the natural environment—and a crucial factor is how human beings connect to one another in pursuit of this common

good. Varda's creativity was born of such interactions, making sustainability in all its breadth a prominent aspect of her work. *Les Glaneurs et la glaneuse* brings forth the environmental sense of connection with particular strength. As Kelley Conway has noted, this film "generated an enormous amount of positive press for Varda, restoring her visibility and critical reputation after several years of relative inactivity," and it redirected her filmmaking toward new avenues of personal and sociological inquiry.[6] *Glaneurs* is also among the most frequently discussed of her films in this volume, both in scholarship (Horsey, Erdede) and in the pedagogical essays (Chamarette, Cramer).

Glaneurs also brings Varda herself before the camera to an extent not seen in her prior filmography. While she had narrated and personally appeared in her own films—for example, in *Lions, Love (... and Lies)*, as Zizi Li unpacks in this volume, as well as in *L'Opéra-Mouffe*—these earlier works do not rely to the same extent on Varda's presence on camera to steer each film through its discursive course. Yet this infrequent self-representation in her earlier films gives way to more prominent self-reflexivity in Varda's late work. Elsewhere, I have aligned this shift with an assertive demonstration of her agency as an auteur, but Varda's self-representation also mobilizes the broader issue of women's visibility on screen.[7] Varda is hardly alone in using her own body as an artist to comment on cultural perceptions of age, and Michelle Meagher observes that such self-representation works against the "cultural invisibility" of their aging bodies while also "subtly disrupt[ing] the fetishistic structure of the gaze" that prizes women's "hypervisibility"—a condition which, Meagher notes, is neither universal nor permanent.[8] As a woman in the art world, Varda was always confined to the margins, and by the 1990s she found herself further marginalized by her advancing age. Yet, by making her physical presence integral to her late-career work, Varda defies the assumption that youth and desirability are what make women worth looking at. More importantly, she demonstrates how much we have to learn from listening to older women, and pairing visibility with voice allows these films to redress the deficit in the representational economy that has left them out of far too many conversations.

At the turn of the twenty-first century, when *Glaneurs* was filmed, the seventy-something Varda embraced the paradox of a veteran artist who was just getting started: with digital filmmaking, with multimedia installations, with a fresh spotlight on past achievements that garnered enthusiasm for the new work she would go on to make. And after *Glaneurs*, Varda's career saw a dramatic uptick in institutional recognition: she was commissioned to create an installation in the French Panthéon; she was the first woman and only the fourth person ever

to receive an honorary Palme d'Or at Cannes for lifetime achievement; she was the oldest person ever to be nominated in a competitive category at the Oscars for *Visages villages*; and she was the first woman to receive an honorary Oscar for her directing career. In contrast to her male peers, several of whom also were still making films, Varda's millennial pivot added further innovation to her already accomplished and eclectic body of work. Rather than cast new art from the same twentieth-century mold—a strategy that, in the past, had brought Varda only haphazard success in financial and reputational terms—Varda instead produced a new framework, one through which she could invite audiences to better understand that past even as she herself also reckoned publicly with it.

Situating Connection and Community

With Varda's late-career rise to icon status comes the risk that new, uninformed audiences might not look far enough past her accolades to recognize the barriers she faced in funding, creating, and distributing her art. As she told French film magazine *Positif* in 1982, "All this energy devoted to producing my work has veiled the fact that no one has expressed confidence in my work in the normal way this is expressed"—that is, according to the economic structures of the film industry.[9] Although now these films' value is taken for granted, making them meant a constant battle, generating tension that sometimes bursts forth with startling frankness in the films themselves. In this volume, Zizi Li considers *Lions Love ... and Lies* (1969) as a document of Varda's struggle that runs parallel to career frictions felt by American women directors like Shirley Clarke, who also appears as a character in that film. Varda's connection to these women, who like her were fighting steep odds to make their mark as artists and filmmakers, turned these setbacks into fodder for their creative pursuits.

In her later interviews, Varda became more open about these difficulties and expressed regret at their cost to her career. "I did so few [feature] films if you think about it, so few," she told Julie Rigg in 2005, adding, "Some people do a film a year you know, I could have done fifty films."[10] Yet the size of her filmography matters far less than the scope of her influence, as Ayça Çiftçi underscores here in a chapter that explores how Varda's turn toward self-reflection demystifies the process of creation and thus creates an alternative approach to authorship. By embracing vulnerability, teamwork, and the deeply personal stakes of creative enterprise, Çiftçi shows how Varda models a conscientious refusal of an authorship that would prioritize isolation and authoritarian control.

Varda's influence also expands beyond the boundaries of cinema, especially as her formal and spatial explorations brought new opportunities and new audiences in the later years of her career. In Part I of this volume, Joseph Horsey draws on *Les Glaneurs et la glaneuse* and other films to show how metaphor theory can create and amplify meaning in nonfiction cinema, centering gleaning itself as the core metaphor for Varda's style of documentary filmmaking. In her contribution to Part III, Sandy Flitterman-Lewis looks specifically at *Les Justes au Panthéon*, Varda's installation honoring the French civilians who risked their lives to help Jewish children evade capture and deportation during the Second World War. Flitterman-Lewis connects this historically resonant project to the human compassion that motivates Varda's entire *oeuvre*. As an installation, its reflection of environment is distinctive, with the highly symbolic installation space adding a poignant dimension to the juxtaposition of historical artifacts with cinematic reenactments. Taking this discussion of environment even further, in this volume Zeynep Demirhan argues that Varda's depiction and exploration of different urban geographies in her films—from Paris to Los Angeles and beyond—reflect architectural theorist Christian Norberg-Schulz's concept of *genius loci*, or that which allows space to be understood and treated as place.

Yet there are signs in Varda's final decade of work that situatedness itself is unsustainable in a globalized world. Conway asserts that *Agnès de ci de là Varda* "suggests that cross-cultural exchange and the periodic return to our hometowns, authentic or adopted, can mitigate the negative effects of globalization"—in other words, that well-tended roots make for stronger, more resilient branches.[11] But one's own situation is always subjective, as curator Hou Hanru patiently explains to an uncharacteristically dismissive Varda: "If you're in Tokyo, America is the Orient. If you're in Paris, in that case, the Orient is probably Japan, China, etc. [...] It is indeed all a bit mixed up, but it accurately reflects the concept of the world today. A mixed-up world."[12] The *genius loci* that Varda explores in her earlier work gives way in the new century to the question of how place can function both as a distinct community and as a crossroads open to interaction and exchange with outsiders.

Traveling across France in *Visages villages*, Varda and JR find ways to integrate the local character of places and people with spaces and objects that remind us of the world beyond the frame. While visiting the northern port city of Le Havre, JR affixed monumental photographs of three dockworkers' wives to a towering stack of shipping containers in which the women themselves sit and wave at Varda's camera. This moment signifies the interaction between

the local and the global while also showing, as Conway asserts, how the film "foreground[s] women's stories and workers' stories."[13] Individuals, especially women, lend *Visages villages* their personal histories and geographic specificity, while their work, performed in places like the internationally crucial port of Le Havre, connects these necessarily local efforts to an economy that exceeds these boundaries by playing host to itinerant objects like the shipping containers, which are always bound for their next destination. While Varda started out filming streets and people in her own neighborhoods—the seaside village of Sète in *La Pointe Courte*, Paris's rue Mouffetard in *L'Opéra-Mouffe*, and later, rue Daguerre in *Daguerréotypes*—her late films resist such familiar environments, aiming through travel to expand the audience's horizons along with her own.

Varda and Feminist Pedagogies

Travel is not the only way to broaden experience: education offers a way to grow into a more expansive definition of community. Education certainly shapes the artist; just as Stob's chapter in this volume traces the impact of Varda's education in art history, elsewhere Leon Sachs has recognized hallmarks of French pedagogy that Varda has repurposed to her own rhetorical ends.[14] The institutional limitations of education also inform the way Varda uses film to revisit her past. Her own self-citations—what Sandy Flitterman-Lewis has described in this volume as "her taste for proliferating forms"—hold substantial pedagogical value: as Varda used her autobiographical films to curate and narrate her own work, especially ephemeral pieces like installations, she made them more accessible to scholars and students unable to engage with them firsthand. In "Teaching Varda Teaching," her essay in Part IV, Flitterman-Lewis attests to Varda's respect for education, and *Agnès de ci de là Varda* and *Varda par Agnès* both show her warm, personal engagement with students around the world. But beyond the importance of education to the cultivation of present and future artistic minds, Varda seemed to intuit that a sustainable legacy can become even more durable when an artist's work can be incorporated into a variety of curricula.

While subject to the same ideological pressures as other forms of institutionalized prestige, pedagogy is decentralized across different kinds of organizations: schools, museums, clubs, and more. This plurality of structures can open pedagogical practice to feminism and other ideologies that might challenge current orthodoxies, and it's important to note that feminist pedagogy involves classroom praxis as well as content.[15] In many contexts, particularly in

film studies curricula, Varda has already more or less secured her place, but this can usually be attributed to her contextual connections: the French New Wave; the Left Bank filmmakers; her husband and fellow director Jacques Demy. In contrast to this emphasis on historical situatedness and representative aesthetics, the sustainability of Varda's legacy involves an evaluation of her work at a remove from these points of origin and affiliation to look instead at their expressions of feminism, their embrace of new technology, their innovative approaches to genres like documentary and autobiography, and other aspects. In multiplying the contexts through which Varda and her work might be introduced to new generations of students, audiences, patrons, and friends, the breadth and depth of these connections show, paradoxically, how well her work can stand on its own. With this volume's fourth section, we want to underscore how her work holds considerable value beyond how well (or how often) it can be and has been used to represent aspects of film history.

Our goal for this discussion of how Varda's work is being used in the classroom is to show the myriad threads it weaves together, and one way to demonstrate this impact is by refracting her art through our own lived experiences. Seasoned teachers can attest that one of the most affecting and effective approaches in the classroom is to make the subject personal—and we may not even realize the extent to which we already do this. While I have observed elsewhere the unusual depth of personal feelings manifested in the media response to Varda's death, in the days following this news I was unprepared to receive a smattering of messages from former students and longtime friends, offering me condolences for her passing.[16] Such spontaneous, heartfelt gestures speak not only to their thoughtfulness, but also to the strength of the impression left by my admittedly sporadic, semi-public engagement with her work, especially in the classroom. It felt quite strange to receive these sentiments: of course, I have taught Varda's films; I have pasted her words onto the walls of my office; but having never known Varda personally, I would never have assumed such a privileged position of bereavement. Yet those around me saw fit to grant one. The reason for this, I have concluded, stems from Varda's ability to instill a sense of community through the screen, and once someone has accepted the invitation to join this community, it's hard to forget the people who made sure you received it.

This is why we have called upon scholars and teachers to reflect on their experiences in bringing Varda's work to new audiences. In this book's final section, Homay King and Kate Ince each discuss the different ways they have brought *Sans toit ni loi* (Vagabond, 1985) into their respective classrooms. Seunghoon Jeong presents a pedagogical travel diary in his account of teaching *Cléo*

de 5 à 7 to students around the world, while Beth Tsai describes how she and her students, especially those from marginalized communities, bring their personal experience to bear on Varda's films. Jenny Chamarette and Michael Cramer have each incorporated *Glaneurs* in their pedagogy to talk about the intersection of digital technology with cinema, but have done so in remarkably different ways. Jeremi Szaniawski discusses how one of Varda's most vexing films, *Le Bonheur* (Happiness, 1964), has fared in his classroom. Sandy Flitterman-Lewis reflects on how she has integrated her groundbreaking research on Varda with her pedagogical practice, discussing a number of films that she has taught since her book *To Desire Differently* first brought scholarship on Varda to Anglophone readers in the early 1990s. Opening with her own personal encounter with Varda, Nadine Boljkovac considers the different ways Varda's work has affected her own thinking both inside and outside the classroom. Finally, Feride Çiçekoğlu concludes the book by discussing how Varda's films can facilitate the introduction of personal anecdotes to connect both students and teachers with lessons they can take from their own lives.

Making Varda's legacy truly sustainable means, paradoxically, that future generations may find the scope of her achievements harder and harder to grasp. The heights of recognition that she reached toward the end of her life have already seemed to minimize the obstacles she had to surmount, repeatedly, over decades of production—as if struggle itself is somehow incompatible with an honorary Palme or a career Oscar. Of course, feminists should advocate for Varda's successors to face a less hostile environment in pursuing their creative, collaborative endeavors. And, to echo Feride Çiçekoğlu's concluding essay, we must remain hopeful for a future in which these rising artists will not have to relearn Varda's hard-won lessons as they take up the mantle of creating art from the margins.

Notes

1. Rodney F. Hill, "The Family Business: An Interview with Rosalie Varda about *Varda by Agnès*," *Cinéaste* 45, no. 2 (2019). https://www.cineaste.com/spring2020/family-business-rosalie-varda-about-varda-by-agnes.
2. This quote from JR appears in the Film at Lincoln Center program for their Varda retrospective, December 20, 2019–January 6, 2020.
3. Claire Dederer, "What Do We Do with the Art of Monstrous Men?" *The Paris Review*, November 20, 2017. https://www.theparisreview.org/blog/2017/11/20/art-monstrous-men/.

4 Ibid.
5 Girish Shambu, "For a New Cinephilia," *Film Quarterly* 72, no. 3 (Spring 2019): 32–4. DOI:10.1525/fq.2019.72.3.32
6 Kelley Conway, "Responding to Globalization: The Evolution of Agnès Varda," *SubStance* 43, no. 1 (2014): 109–22. https://www.jstor.org/stable/24540742.
7 Colleen Kennedy-Karpat, "Agnès Varda and the Singular Feminine," in *Female Agencies and Subjectivities in Film and Television*, ed. Diğdem Sezen, Feride Çiçekoğlu, Aslı Tunç, and Ebru Thwaites Diken (Cham: Palgrave Macmillan, 2020), 11–25.
8 Michelle Meagher, "Against the Invisibility of Old Age: Cindy Sherman, Suzy Lake, and Martha Wilson," *Feminist Studies* 40, no. 1 (2014): 101–43. Citation compiled from pp. 109, 112, and 129.
9 T. Jefferson. Kline, *Agnès Varda: Interviews* (Jackson: University of Mississippi Press, 2014), 109.
10 Ibid., 189.
11 Conway, "Responding to Globalization," 120.
12 Cited in Ibid.
13 Kelley Conway, "*Visages villages*: Documenting Creative Collaboration," *Studies in French Cinema* 19, no. 1 (2019): 22–39. DOI:10.1080/14715880.2018.1545199.
14 Leon Sachs, *The Pedagogical Imagination: The Republican Legacy in Twenty-First Century French Literature and Film* (Lincoln: University of Nebraska Press, 2014).
15 The online feminist journal *MAI* devoted an entire issue to feminist pedagogies (issue 5, winter 2020), in which Charlotte Morris offers an overview of how feminist pedagogy can be practiced in the classroom. https://maifeminism.com/teaching-to-transform-reimagining-feminist-pedagogies-in-contemporary-higher-education/.
16 Kennedy-Karpat, "Agnes Varda and the Singular Feminine," 11–12.

Part One

Creation

2

Agnès Varda's Formalist Feminism

Jennifer Stob

"I am a woman. Woman must be reinvented." These words are part of the declarative exchange that ends Agnès Varda's seven-minute film, *Réponse de femmes: Notre corps, notre sexe* (Women Reply: Our Bodies, Our Sex, 1975). The woman who speaks them does so with composure and calm defiance, addressing the camera directly and anonymously, as do all of the other women in the film. Arranged in rows and clusters, the camera panning over them presents them as a series of visual contrasts: naked or not, pregnant or not, married or not, old or young. With this shot composition, Varda emphasizes womanhood as subjective and universal at the same time. Over the course of the film, this paradox is reclaimed and celebrated: "I am unique, but I am all women," one insists, and those surrounding her cheer.

Varda made *Réponse de femmes* at the invitation of the French television channel, Antenne 2. She dubbed it a *"ciné-tract,"* aligning it explicitly with a countercultural genre of short film manifestos in French militant cinema.[1] In *Réponse*, Varda's militancy takes the form of a multi vocal testimony that affirms the experience of womanhood as first and foremost a bodily one. The film posits that to be a woman is to have a vagina, breasts, and a feminine face, but it is also to deserve respect as more than the sum of these parts. A woman's body arouses heterosexual desire, and this desire fuels consumer society. Yet women desire, as well, and they demand the agency and the liberty to truly cultivate their desires.

The long shots of the mostly white female chorus delivering these messages in *Réponse de femmes* are eventually paired with reverse long shots of mostly white men who look on impassively, silently, and skeptically. They are a pointed reminder of the power and omnipresence of the male gaze. With the inclusion of these men as counterfoil, Varda encourages female unity in the face of patriarchal oppression. However, that unity is constructed on a set of assumptions that elide differences in the bodily experience of womanhood beyond size, maternity, marital status, and age. The film's proclamations are made by and to people who

assume each other's heterosexuality and the fusion of sex and gender. Together with the editing that illustrates them, these assumptions reinforce a binary organization of sexual orientation and identity, one that many viewers knew then and know today to be both scientifically and socio-culturally false. Given this, viewers may feel cut out rather than sutured into the supposedly united feminist front that Varda depicts.

Shorts like *Black Panthers* (1968) and *Plaisir d'amour en Iran* (Pleasure of Love in Iran, 1976) testify to the fact that, over the course of her career, Varda certainly glimpsed the racial diversity and the socio-economic inequity of feminism's global topographies. However, much of her feminist project and its translation into narrative film focused on selves and bodies like her own: white, European, middle-class, cis-gendered, and invested in heterosexual hegemony. Varda always located the origins of her feminism in her personal search for identity as a woman, and in her own body's negotiation of the roles of artist, lover, and mother.[2] Shaped by her generation's investment in auteurism, she made these origins the infrastructure for her filmmaking. Her emphasis on a feminism of individual, corporeal liberation that is forced to make an uneasy peace with conventional society leads T. Jefferson Kline to conclude that "what is most consistent in her approach to feminism is Varda's search for a 'middle way.'"[3] Even in her more controversial films like *Réponse de femmes*, Varda's feminist fables suggest, reluctantly, the moral of moderation.

If we as Varda's audience truly want to participate in a reinvention of Woman following the call issued in *Réponse*—or, for that matter, if we want to participate in a dissolution of Woman and the false binary to which the concept contributes— we must first understand how that moral of moderation operates in relation to female embodiment and appearance in Varda's films. We must investigate where, why, and how Varda's films articulate a longing to reinvent Woman while at the same time sustaining Woman's visual legacy. In the essay that follows, I examine Varda's fascination with archetypes from canonical European art history that have influenced how a woman's body appears.

I begin by describing the formalist milieu that crucially shaped all art historical education in postwar France, Varda's included. As David Summers has convincingly argued, Heinrich Wölfflin, Alois Riegl, Henri Focillon, and others pioneering the formalist tradition touted their analyses of form in an artwork as supposedly more scientific, more rigorous, and more universally neutral than the prior generation's biological or biographical art history of personal genius.[4] However, formalists never purged their methodology of the sexist notion that an artist's inherently masculinized force or genial spirit acts upon

a feminized base matter in order to capture it, organize it, distort it, or abstract it. They preserved and institutionalized this notion, embedding the exact same paradigm of gendered creation of form in the new terminology and frameworks they introduced.

Varda, too, preserved the notion that Woman is representation's field and matter in her films. She did this even as she explored with great sensitivity women's existential struggle in the face of it, as well as the more commonplace issue of women's resistance to their sexual objectification. She retrieved feminine forms from art history, repeating, alternating, and extending them—in particular those of Woman in repose and Woman as burden-bearer. The former defines women by an erotic access to rest, interiority, or absence, and the latter defines them by proud suffering and a destiny of emotional burdens. I highlight these two female forms across a sampling of Varda's films, assessing the impact they have on our broader understanding of her *oeuvre*. Instead of the "feminist politics of form," that Sandy Flitterman-Lewis identifies at work in Varda's filmmaking, I propose that a formalist politics of feminism is to be found there, one that precedes debates on Varda's feminist essentialism or antiessentialism.[5]

The (Gendered) Life of Forms

Between 1948 and 1950, Varda lived in Paris and took courses in literature and philosophy at the Sorbonne as well as courses in art history and photography at the École du Louvre. She recalled that during this period, philosopher Gaston Bachelard was one of the professors who most deeply influenced her artistic development.[6] Bachelard's approach to art, literature, science, and architecture was grounded in the belief that our understanding of the world is determined by the dialectical play of mental patterns, transmitted across generations. Our culture continually materializes these forms of thought in the creation of both scientific and fantastical conceptual schemas.

Among the wide array of thinkers who influenced Bachelard—and through him, Varda—was his contemporary, the formalist art historian Henri Focillon. The two men did not teach in the Sorbonne at the same time, but they were intellectual interlocutors before Focillon left France during the Second World War. Bachelard and Focillon shared the conviction that although formalism was a useful methodological tool for identifying and describing an individual artist's style, its far more important application was in tracing the universal metamorphoses of mythology, religion, and ideology through the images brought

to life by material, tool, and human hand in concert. Both men's work on form was influenced by biologist Jean-Baptiste Lamarck's theory of "transformism" and its enthusiastic adoption by French humanists and sociologists, the vitalism of philosopher Henri Bergson, and art historian Élie Faure's blended application of both to the discipline of art history. In particular, Faure's formalist approach dominated the discipline in France from the mid-twenties into the postwar era.[7]

In his best-known contribution to formalist art history, *Vie des Formes* (*The Life of Forms in Art*, 1934), Focillon celebrates the constant evolution of artistic forms across the centuries as something that cannot be truly explained with outmoded antitheses like matter/spirit, matter/form, or subject/form.[8] Yet repeatedly, in that same treatise and even more plainly in the shorter essay "*Éloge de la main*" ("In Praise of Hands,") that he also wrote in 1934, Focillon reinforces these traditional dualisms and their hierarchical relationship. Form results when spirit acts upon matter and a subject emerges from it. He positions the artist as "a new god" whose hand at work "teaches man to conquer space, weight, density and quantity," and "struggles with the very substance it metamorphoses and with the very form it transfigures."[9]

The artist's hand that Focillon describes as a synecdochal "living being" and the artistic renderings of hands that Focillon reproduces as examples in his text are masculine.[10] The exception is his reproduction of the Daphne painted by Piero del Pollaiuolo (1470–1480). However, Daphne's hands are only meaningful in their absence: they have been erased, transformed into laurel branches at the hand of her father. They cannot serve as a synecdoche for her creative force, and therefore become a more fitting symbol for "primitive man inhaling the world through his hands," reckons Focillon.[11] In such a way, Focillon and other art historians theorized formalism as an inexorable and inexorably gendered force spanning history, penetrating every culture.[12]

Recumbence as Female Form

The gendered life of forms fascinated Varda, as it did the French academicians in the institutions where she studied. She explained that Bachelard taught her the symbolic potential of envisioning "the *material* in people," or conceptualizing the existence and evolution of one through the other.[13] Evidence of this formalist training is abundant in her films: all of them portray the interrelational journeys of female protagonists as formal journeys at the same time. Yet Varda also knew that the conflation of certain kinds of material with certain kinds of people

reinforced social hierarchies. In her films, women must come to terms with the gendered roles they play as girlfriend, wife, sex object, or mother and also with their role as gendered essence in a system of depiction. The symbolically charged visuals that Varda created and recreated expose the operation of gender rules mid-enforcement. They serve as a kind of technical illustration for the life of female forms.

A brief consideration of artist Albrecht Dürer's well-known woodcut, *Der Zeichner des weiblichen Modells* (*Draftsman Drawing a Nude,* 1525) helps clarify Varda's formalist feminist strategy. Dürer's image was published in the posthumous, second edition of his treatise on Eucyldian geometry in art, the *Underweysung der Messung* (*Art of Measurement,* 1538). In it, a middle-aged, male artist employs a small, obelisk-shaped pillar and an evenly gridded screen made of a wooden frame and thread to plot out an ink drawing of a mostly nude, recumbent woman. She lies just opposite him and his screen, on the same drafting table. The artwork was among those in the Renaissance period to canonize Albertian perspective and the devices used for perspectival rendering.[14] It also helped canonize the use of a nude female model as both primary matter and visual field for artistic composition and invention.[15]

Dürer's woodcut betrays the sexism implicit in this dynamic of masculine artistic spirit forming feminine artistic matter. It is a *"prima facie* example of a male gaze."[16] The artist's perspectival screen divides the composition symmetrically into a feminine space of "pillows and folded linens and fecundity," and a masculine space of "scientific instruments, disciplined observation, and sterile containers."[17] What's more, the awkward position that Dürer has chosen for the female model makes the contours of her body available to both the artist at the head of the table and us, the viewers emplaced tableside. Her body is the focal point of "the sum of two different and potentially incompatible perspectives"[18] that control and partake of it, giving this straightforward technical illustration its heightened significance as "a complex lesson about cultural and sexual hegemony."[19]

Varda displaces Dürer's draftsman in writing her cinema. From his seat, she mirrors the female models she depicts, twisting to face the film audience. This move is metaphorical in her early films, executed in self-reflexive strategies, and literal in her later films, when she chooses to appear in front of the camera. In this way, Varda controls and partakes of the women who make up her subject matter, but also submits to and confronts spectators herself, emphasizing her subjective viewing position. This complex refraction of the gaze is part of what Flitterman-Lewis has powerfully termed, "the feminist dialectic of the woman seeing/the woman seen."[20]

Yet refraction is not rupture. Varda's "feminist dialectic"[21] operates within the same hegemonic apparatus of Dürer's draftsman: the phallic pillar and the gridded screen stay the same, maintaining the same "carefully prescribed area" in which Woman is representationally possessed.[22] Although Varda reveals the patriarchal structure that collapses representational space and the feminine, she also confirms and reproduces its formalist myth. She does so totally, tenderly, tragically, at that, because she clearly finds lasting poetry and poignancy in this myth. The dualisms at play in her films, her puns, her fondness for all varieties of chiasmus are often predicated on this traditional belief in woman's role as representation, and in the visual pain and pleasure that role imparts to the life of female forms in art.

From her filmmaking debut onward, Varda established an auteurist habit of citing the gender dynamics in Old Masters' paintings as well as their gendered representational regime.[23] Among the formal motifs in the art historical canon that she drew on most frequently was the very one that Dürer helped establish: woman recumbent, vulnerable, and sensual, "closed and dreamlike."[24] The character Dorothée (Dorothée Blanck) in *Cléo de 5 à 7* (*Cléo from 5 to 7*, 1962) gives voice to this female form after finishing her shift as a figure model for a class of art students. As she explains to Cléo, "When they're looking at me, I know that they are looking for something other than me. A form, an idea, I don't know. So, it's as if I were absent, as if I were sleeping. And you get paid for it," she concludes, smiling down at her wages.

Dorothée's unsentimental embrace of the identity of representational object is infused with the opaque surrender of models who helped compose *odalisques*, Mary Magdalenes, Ledas, Danaës, and so many other recumbent women in art history. Varda also sustains their form. In Varda's *L'Opéra-Mouffe* (Diary of a Pregnant Woman, 1958), Blanck had already portrayed woman in repose, recreating Diego Velázquez's *Rokeby Venus* (1647–51). She served not only as an avatar for a young Varda, but also as a generalized tribute to the eros of the feminine before and during pregnancy.

In *Le Bonheur* (Happiness, 1965), Varda uses scenes of erotic recumbence to superimpose protagonists Thérèse and Émilie. The film's *déjeuners sur l'herbe* are studied references to the pastel-hued Impressionism of an artist like Pierre-Auguste Renoir. Varda introduces a deep and discomforting bourgeois anxiety into these scenes of dappled, sun-drunk repose. As the women embrace François, one after the other, Varda's filmic brushstrokes deliberately blur them together, blending the female form back into the lushly pastoral setting, and suggesting both Woman's naturalism and impermanence.

Allusions to recumbence as female form are the glue that holds *Jane B. par Agnès V.* (Jane B. by Agnès V., 1988) together. In the film, Jane Birkin fulfills her self-professed need to please by appearing in a series of *tableaux vivants* at Varda's behest (Figure 2.1). Birkin recreates the sexually suggestive repose found in paintings by Titian and Francisco Goya, the languorous, Romantic muse as immortalized in the art of Dante Gabriel Rossetti, the blood-soaked *femme fatale* of 1940s' *film noir*, and more. In her thoughtful analysis of the reclining nude in the art of Varda, Catherine Breillat, and Nan Goldin, Emma Wilson suggests that the act of reviving this recumbent female form in the context of female and feminist artistic practice constitutes "a move away from the phallic, from verticality … an anti-patriarchal gesture … a move towards different modes of being, attachment, melancholy, anomie, and pleasure."[25]

This move, she explains, is made in the very movement of the female who is pictured. In *Jane B.*, for example, Varda's camera travels along Birkin's naked, lounging body in extreme close-up, surveying a hip, a waist, and a nipple, all subtly animated by Birkin's breathing. Wilson writes, "Her work is enriched by the precursor images to which she refers, but Varda claims freedom of association and repurposing, a liberty expressed in the very literal movement in and shaking up of the timeless still pose."[26]

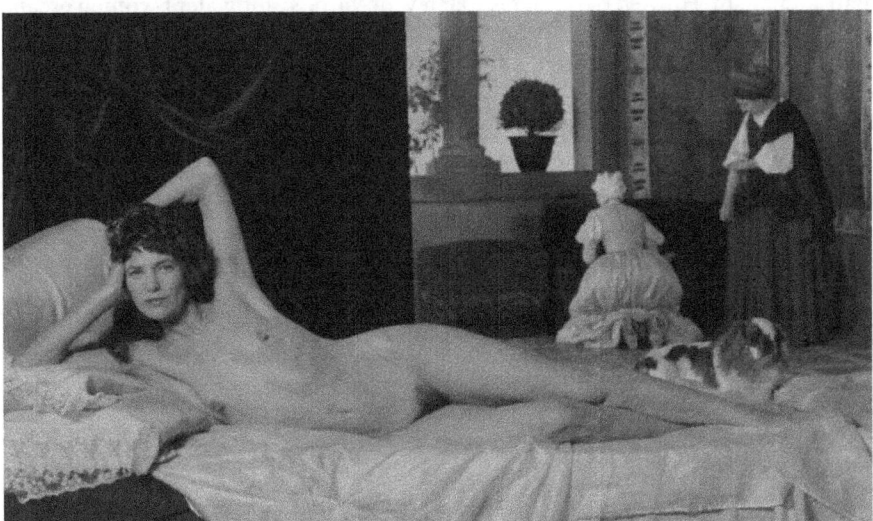

Figure 2.1 Jane Birkin as reclining nude, part of a series of pastiched tableaux vivants featured in *Jane B. par Agnès V.* (1988). Frame capture, Criterion DVD.

What, exactly, is freed, repurposed, and shaken up in the masterpieces that Varda restages with her female protagonists? Ultimately very little, as the art history of *tableaux vivants* confirms. Whether we choose to date the origin of the artistic practice to sacred liturgical dramas in the Middle Ages, to Diderotian theater melodrama, or to eighteenth-century pornography, it is clear that the notion of liberation is antithetical to the structural logic of *tableaux vivants*, which is concerned with suspension, instead.[27]

To reenact a still image is to suspend bodies in time and space, accentuating the tension between stillness and movement, between reality and simulation, between hyper- and remediation. The pleasure of aesthetic comparison is of paramount importance in this exercise. A *tableau vivant* can be repurposed in a subversive or liberating way if that tension is engineered for the purpose of immediately breaking it down—for example, if the actors are uncooperative, mismatched, or outright opposed to the framework they have been placed within, or if the mise-en-scène is laughably or chillingly unconvincing. This is not the case in Varda's *oeuvre*.

The point Varda made repeatedly by staging *tableaux vivants*—in particular of women in repose—was how seamlessly her female protagonists could be reincorporated into the representational tradition cited. Yes, her films exquisitely demonstrate the feminist ambivalence provoked by this effortless continuity of forms, and yes, ambivalence to patriarchy is indeed a valid kind of anti-patriarchalism. However, the fact is that few of Varda's ambivalent women escape unscathed: as they come to an awareness of how their image is made and their social identity prescribed, they also come to pay a steep price for any agency they try to exercise in the film narrative. Even Mona (Sandrine Bonnaire) in *Sans toit ni loi* (Vagabond, 1985), the film often heralded as Varda's most subversively feminist work, is framed by formalism from beginning to end. She is birthed from the ocean in allusion to Botticelli's *Venus* (1845–6), and she dies face up in the dirt in a Caravaggesque swirl of frozen clothing. In Varda's films, even when feminine desire and feminine interiority are indulgences granted in the image of a woman's outstretched body, the death sentence of patriarchy is always an implicit threat.

Encumbrance as Female Form

In the contrast between her drugged-out bliss and her hard-bitten backpacking, the character of Mona is a good example of the dialectical connection that

Varda drew between the female form of recumbence and a second female form: encumbrance. This latter is recognizable in her female protagonists who are demonstratively erect, possessed of a strength proportionate to the heavy physical and mental burdens they must carry. Varda treated these forms as two sides of the same coin, with recumbence often signaling the fleeting fulfillment of romantic love, and encumbrance the enduring loneliness of a love affair that has ended.

If we peer closely enough, we can find reason to trace back not just the one but both female forms under discussion here to Dürer's technical illustration *cum* demonstration of hegemonic masculinity. Perhaps his woodcut could be said to capture the nude model between both states: in repose, but just beginning to shift her weight onto the arm caught in fabric, sliding her knees sideways so that she can raise herself to a standing position. If so, then Dürer's nude shares a kind of symbolic pliability with Ariadne, a figure from Greek mythology that Varda fondly references in at least two of her films. Spurred by her love for Theseus, Ariadne gave him a sword and a ball of thread. With these in hand, he entered the Minotaur's labyrinth, killed the monster, and successfully navigated

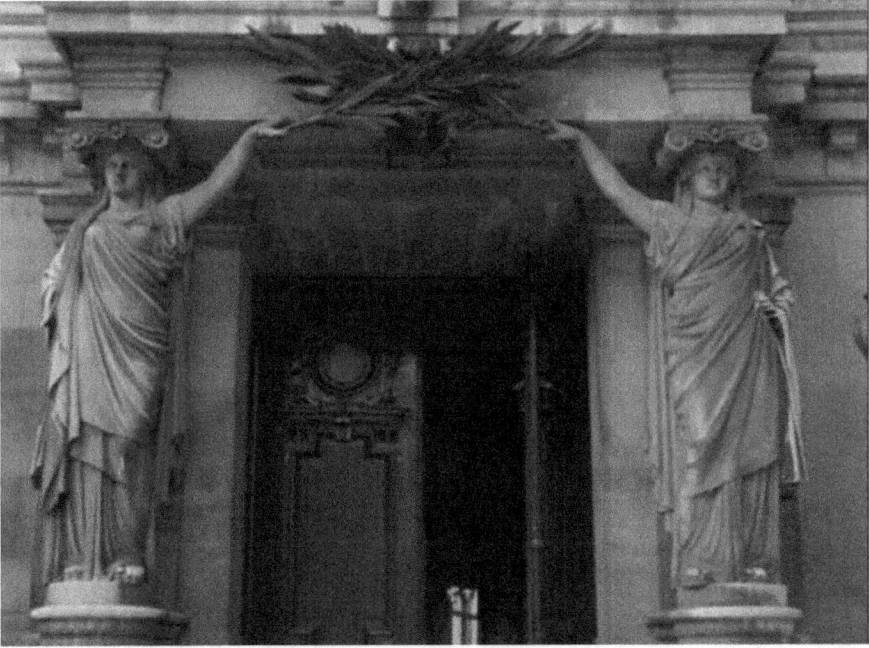

Figure 2.2 Woman as weight-bearing architectural ornament in *Les dites cariatides* (The So-called Caryatids, 1984). Frame capture, Criterion DVD.

his way back out. As enterprising, caring, and upright a woman as Ariadne was, Theseus did not love her back, and he soon abandoned her on the island of Naxos to languish in her grief and suffering. In the film *Documenteur* (1981), Ariadne's encumbrance is echoed in the motherly fortitude with which Émilie moves through L.A., and her recumbence in the stillness that overtakes Émilie's body when she lies naked and thinks about her estranged lover.

Encumbrance as female form was the basis for Varda's elegant short, *Les Dites Cariatides* (The So-called Caryatids, 1984), which celebrates the women in stone who hold up Parisian facades as architectural ornaments (Figure 2.2). Named after the women of Caryae whom the Greeks enslaved after the town was defeated in battle, Varda suggests that these encumbered women perform enduring representational labor as both the possessed and the unpossessable at the same time. They are forever held prisoners to the buildings that they must keep erect, but—"graceful and lascivious"—they also seduce. They forever accommodate the projections of Parisian poets like Charles Baudelaire, becoming angels, muses, goddesses, and Madonnas in the upturned eyes of those walking about beneath them. Varda, too, was in awe of the outsized beauty and sacrificial strength of these towering women in stone. Little wonder that, in 2017's *Visages Villages* (Faces Places), she and street artist JR decided that a fitting tribute to the burdens borne by solitary old ladies, unassuming waitresses, and dock workers' wives would be to make them into Caryatids, blowing them up photographically or hoisting them up into shipping containers as female totems.

Later in her career, Varda repeatedly aligned herself cinematographically with the female form of long-suffering encumbrance. In her film, *Les glaneurs et la glaneuse* (The Gleaners and I, 2000), Varda chose to model herself on the "proud and solitary female figure"[28] in Jules Breton's *La Glaneuse* (The Gleaner, 1877), even though the bowed backs of Jean-François Millet's *Les Glaneuses* (The Gleaners, 1857) are the standard for the act of female gleaning in art historical formalism. With this allusion, she suggested her continuance of that female form and of the more ancient activity of gathering what remains from another's harvest.

The genius of Varda's *Glaneurs* lies in its thesis that gleaning is the most apt descriptor for perceptual experience. As Domietta Torlasco asserts, Varda folds together the acts of filming moving images, narrating in language, and being flesh and blood.[29] This enfoldment allows for "the nebulous emergence of a subject that (unclear to itself) can only find its own image(s) in the outside of which it is made."[30] Torlasco uses the word "invagination" for the kind of enfoldment at work in Varda's filmmaking, but absurdly, she shies away from

the term's gendered or feminist essentialist implications.³¹ For Varda, however, a subject finding its filmic image outside of itself is a fundamentally gendered approach—so much so that *cinécriture*, the term she has invented for her own filmmaking, revolves around it. As Kate Ince explains, *cinécriture* describes nothing short of a "feminist phenomenology deriving from her woman-subject's desire, experience, and vision."³²

Ince adds an important critique: despite the fundamentally feminist nature of her artist's practice, Varda never consistently used *cinécriture* to underscore the ways in which femininity is culturally constructed.³³ Flitterman-Lewis disagrees entirely, claiming that the central concern in Varda's work has always been the "constructions of 'the feminine' as they are visually and culturally inscribed."³⁴ Can these differences of opinion on Varda's supposed essentialism or antiessentialism be reconciled? They can, in acknowledging the formalism that undergirds both kinds of moments in her films. As Ellen Rooney so wisely notes, "Essentialism is a dream of the end of politics among women, of a formal resolution to the discontinuity between women and feminisms. Antiessentialism may mimic this formalism, even as it seeks to diagnose it."³⁵

Varda's feminism is antiessentialist when it exposes the structural sexism of representational space, but it is essentialist when it holds female protagonists within that structure so that, reclining or upright, they constitute another inevitable link in the chain of classical female form. She is antiessentialist when the film narrative details the pleasures and the burdens of female form, and essentialist when that form's meaning is confirmed so exclusively by curves, genitals, heterosexuality, and whiteness.

Here, bell hooks' essay "Moving Beyond Pain" is deeply instructive. Although it specifically addresses the topic of Black female representation and identity, much of her intersectional analysis is more widely applicable. hooks writes that when a vision of feminism does not call for an end to patriarchal domination, it remains "a measure of our [women's] capacity to endure pain" instead of "a celebration of our moving beyond pain."³⁶ As hooks might agree, the biggest limitation in Varda's feminism is neither its essentialism nor its antiessentialism, per se. It is the persistence of female forms that anchor femininity to a definitional survival in the face of adversity, largely denying those who identify as female the opportunity to be represented as "fully self-actualized."³⁷

Amelia Jones points to the AIDS crisis of the mid-1980s through the 1990s and "the queer feminist intervention into feminist cultural theory" as two major paradigm shifts responsible for moving feminism "far away from the idea of 'female imagery' or 'female experience' as knowable entities."³⁸ Varda,

however, remained attached to these ideas, even as her estrangement from and reconciliation with spouse Jacques Demy brought both AIDS and queerness directly into her life. Although she repeatedly mourned his early death and commemorated his life in her filmmaking, she never grappled publicly with either issue. Perhaps this was out of respect for Demy's own silence on his sexuality and his fatal AIDS diagnosis. Perhaps it was due to her wariness of making the political too personal and the personal too political. However, understandable these explanations are, when we consider the power of her filmic depictions of bodily experience, we realize the magnitude of this lost opportunity.

Kung-Fu Master (1988) is Varda's only film that incorporates the subject of AIDS in a somewhat sustained manner. HIV/AIDS is in the news on French kiosks and English television. It is threaded through gay jokes that teenagers tell in the schoolyard and at parties. Later in the film, Julien (Mathieu Demy) rolls a London street pamphlet on AIDS into a message in a bottle, sealing the bottle's cork with wax and throwing it into the Atlantic. The message stays bottled up, it would seem: *Kung-Fu Master*'s transgressive love affair resolves in a gendered binary, in the "intimacy of female reciprocity"[39] between mother and daughter, and the pipsqueak machismo of the boy who came between them.

Because Varda did not create a feminist film imaginary that realized the potential of the feminine to be formless—or, for that matter, of form to be genderless—it is our challenge as her twenty-first-century audience to watch her films with our eyes open to that latent, if unrealized, potential. Embracing Varda's contributions to cinema and resisting her formalist feminism, we may as spectators continue to work toward, as Jones puts it, "a more progressive and convincing way to theorize how we occupy gendered/sexed bodies and a social scene of gendered and sexed spaces and representations."[40]

Notes

1 For more on the history of *cinétracts*, see Jennifer Stob, "*Détournement*, Social Space and the *Cinétracts* in Paris," in *Architectures of Revolt: The Cinematic City circa 1968*, ed. Mark Shiel (Philadelphia: Temple University Press, 2018), 35–65.

2 Agnès Varda, "Agnès Varda Talks about the Cinema." Interview with Mireille Amiel, trans. T. Jefferson Kline. In *Agnès Varda: Interviews*, ed. T. Jefferson Kline (Jackson: University Press of Mississippi, 2014), 72.

3 T. Jefferson Kline, "Introduction," in *Agnès Varda: Interviews*, ed. T. Jefferson Kline (Jackson: University Press of Mississippi, 2014), xv.

4 David Summers, "Form and Gender," *New Literary History* 24, no. 2 (1993): 265.
5 Sandy Flitterman-Lewis, *To Desire Differently: Feminism and the French Cinema* (New York: Columbia University Press, 1996), 222.
6 Agnès Varda, "The Underground River." Interview with Gordon Gow. In *Agnès Varda: Interviews*, 42.
7 For more on this subject, see Serena Keshavjee, "Natural History, Cultural History, and the Art History of Elie Faure," *Nineteenth-Century Art Worldwide* 8, no. 2 (2009): https://www.19thc-artworldwide.org/autumn09/natural-history-cultural-history-and-the-art-history-of-elie-faure.
8 Henri Focillon, *The Life of Forms in Art,* trans. Charles Beecher Hogan and George Kubler (New York: Zone Books, 1992), 95.
9 Henri Focillon, "In Praise of Hands," in *The Life of Forms in Art*, trans. Charles Beecher Hogan and George Kubler (New York: Zone Books, 1992), 165, 184.
10 Focillon, "In Praise of Hands," 157.
11 Ibid., 162.
12 Ibid., 165.
13 Varda, "The Underground River," 42.
14 Noam Andrews, "Albrecht Dürer's personal *Underweysung der Messung*," *Word & Image* 32, no. 4 (2016): 422.
15 Joanne G. Bernstein, "The Female Model and the Renaissance Nude: Dürer, Giorgione, and Raphael," *Artibus et Historiae* 13, no. 26 (1992): 60.
16 Allan Dunn, "The Pleasures of the Text: Volatile Visuality," *Soundings: An Interdisciplinary Journal* 85, no. 3/4 (2002): 223.
17 Grant F. Scott, "The Muse in Chains: Keats, Dürer, and the Politics of Form," *Studies in English Literature, 1500–1900* 34, no. 4 (1994): 783.
18 Bryan Wolf, "Confessions of a Closet Ekphrastic: Literature, Painting and Other Unnatural Relations," *The Yale Journal of Criticism* 3, no. 2 (1990): 197.
19 Scott, "The Muse in Chains," 784.
20 Flitterman-Lewis, *To Desire Differently*, 218.
21 Ibid.
22 Scott, "The Muse in Chains," 784.
23 Rebecca DeRoo, *Agnes Varda between Film, Photography, and Art* (Berkeley: University of California Press, 2018), 30, 35.
24 Wolf, "Confessions of a Closet Ekphrastic," 198.
25 Emma Wilson, *The Reclining Nude: Agnès Varda, Catherine Breillat, and Nan Goldin* (Liverpool: Liverpool University Press, 2019), 19.
26 Wilson, *The Reclining Nude*, 54–5.
27 Brigitte Peucker, *The Material Image: Art and the Real in Film* (Stanford: Stanford University Press, 2007), 30–1.
28 Kate Ince, *The Body and the Screen: Female Subjectivities in Contemporary Women's Cinema* (New York: Bloomsbury Academic, 2017), 67.

29 Domietta Torlasco, *The Heretical Archive: Digital Memory at the End of Film* (Minnesota: University of Minnesota Press, 2013), 44.
30 Torlasco, *The Heretical Archive*, 44.
31 Ibid., 27.
32 Kate Ince, "Feminist Phenomenology and the Film World of Agnès Varda," *Hypatia* 28, no. 3 (2013): 613.
33 Ince, "Feminist Phenomenology," 613.
34 Flitterman-Lewis, *To Desire Differently*, 243.
35 Ellen Rooney, preface to "In a Word: Interview" (1988), in Gayatri Chakravorty Spivak, *Outside in the Teaching Machine* (New York: Routledge, 1993), 2–3.
36 bell hooks, "Moving Beyond Pain," 2016. Accessed at http://www.bellhooksinstitute.com/blog/2016/5/9/moving-beyond-pain.
37 hooks "Moving Beyond Pain,".
38 Amelia Jones, "Essentialism, Feminism, and Art: Spaces Where Woman 'Oozes Away,'" in *A Companion to Feminist Art*, ed. Hilary Robinson and Maria Elena Buszek (Hoboken: Wiley, 2019), 164.
39 Sandy Flitterman-Lewis, "Magic and Wisdom in Two Portraits by Agnès Varda: *Kung-Fu Master* and *Jane B. by Agnès V*," *Screen* 34, no. 4 (1993): 309.
40 Jones, "Essentialism, Feminism, and Art," 164.

3

Gleaning Metaphors from Reality in the Documentary Films of Agnès Varda

Joseph Horsey

Agnès Varda's vibrant legacy encompasses a profound influence on cinema and documentary, in particular. Metaphor is at the center of her idiosyncratic, innovative approach, integral to the ways in which Varda's documentaries negotiate their themes and communicate their meaning. In her seminal film, *Les Glaneurs et la glaneuse* (The Gleaners and I, 2000), "gleaning"—in other words, retrieving what others have thrown away—becomes a multi-faceted metaphor. Through this, Varda is able to convey a great deal, including her attitude toward sustainability, social class, the materiality of filmmaking, and her role as documentary-maker. Within this concept of gleaning, she finds, or should that be she *gleans*, the metaphor that seems to make sense of what she does as a documentarian and as an artist.

This chapter will first discuss the point of conjunction between documentary and metaphor, and the role that metaphor plays in documentary's mediation of the real world. There will be a brief outline of the current state of metaphor theory that informs this work, explaining the terminology and format of applying Conceptual Metaphor Theory (CMT). The focus will then turn to Varda, examining the ways in which metaphor frames her role as filmmaker, particularly as she intends it to be interpreted, thereby encouraging the viewer's consideration of metaphor as a weapon in the documentarist's arsenal. With reference to many of her works, the chapter will then look primarily at *Glaneurs*, and Varda's metaphoric adoption of gleaning into her documentary filmmaking methodology. It will explore the question of how her role as habitual *glaneuse* brings a volatile, highly subjective form of truth to her documentaries. Varda's documentary work is by no means typical of the genre, and the intention of this chapter is not to reveal the importance of metaphor in her approach; that much is self-evident. The purpose here is to explore the numerous levels on

which metaphor is operating, in order to, on the one hand, characterize Varda's metaphoric methods, and thereby illuminate a neglected element of documentary film. On the other hand, this undertaking will aim to further the discourse on sustainability through Varda's work, by examining the nuanced ways in which metaphor and sustainability intertwine.

Metaphor in Documentary

The acclaimed American documentary filmmaker, Joshua Oppenheimer, has spoken at length about the role of metaphor in his filmmaking process. He describes how "in nonfiction cinema, you grow your metaphors like beloved plants in a tenderly looked-after garden […] you're growing the metaphor cinematically at every stage in the process, from the moment you're first sensing that it exists, to the moment that it really blossoms into something spectacular."[1]

It is difficult to think of a more applicable characterization of Varda's relationship with metaphor in her documentary-making. Metaphor permeates documentary in complex and profound ways. There is, however, a dissonance in the combination of a genre—documentary—defined by the positioning of its truth-claims, and a concept—metaphor—necessarily built around a falsehood; metaphors propose that A is B, when we know that A is not B. While explorations into the role of metaphor in film have been catalyzed, predominantly, by the influence of CMT in the 1980s, to date there is very little existing work on the subject of metaphor in documentary, and those that have taken steps into this area have done so tentatively or tangentially. Charles Forceville is one important example, whose influential work on metaphor theory includes an article on the metaphoric significance of journeys in Varda's films.[2] The general disregard in scholarship for documentary's relationship with metaphor may stem, on the one hand, from the traditional understanding of documentary as factual and sober, reaching for objectivity and, on the other hand, from the traditional perception of metaphor as a poetic, expressive decoration or embellishment. That surface contrast may have obscured the importance of metaphor in how documentary films are shaped, how they convey meaning, and how they translate the real world into the films we see. Varda constitutes only one particularly pronounced example of metaphor employed in a documentary context. In fact, metaphor plays a substantial role in documentary's rendering of the real world, across the spectrum of its various forms of representation.

Metaphor theory spans millennia, beginning with Aristotle in the fourth century BCE. He wrote that metaphor "consists in giving the thing a name that belongs to something else."[3] Metaphor has traditionally been understood as a linguistic device, but George Lakoff and Mark Johnson's highly influential text, *Metaphors We Live By*, represented a major shift in metaphor theory. Their CMT proposes, more broadly, that "*the essence of metaphor is understanding and experiencing one kind of thing in terms of another.*"[4] This experiential philosophy argues that abstract concepts like time and love, that are second nature to us as humans, are only possible to understand metaphorically, in terms of the perceptual and motor systems that constitute our embodied experience. It is from this prior understanding that our ability to interpret linguistic metaphor derives. This paradigm shift within metaphor theory has inspired and facilitated the study of metaphor in a far wider array of disciplines, including film and television. In Lakoff and Johnson's view, we construct and experience our reality through metaphor. As an indispensable component in how humans conceive of the world, function within it, and make sense of their own existence, they suggest that metaphors "may create realities for us."[5] Varda's reality or, at least, the way she chooses to depict it in her documentaries, is one positively steeped in metaphor. She epitomizes the filmmaker for whom the search for figurative connections is integral to the documentary project.

It is important to note here that Lakoff and Johnson's work has made cognitive linguistic terminology the standard in metaphor analysis, so that the "thing" we wish to understand through metaphor, is termed the "target domain." What they term the "source domain" is that element we use to say something about the target domain.[6] This terminology will be employed throughout the chapter. It is also worth noting the SMALL CAPITALS formulation that has become conventional in metaphor theory, where the underlying conceptual structure of the metaphor is articulated as TARGET IS SOURCE, as in TIME IS MONEY. That formulation will be used throughout this chapter where appropriate.

Metaphor Across Varda's Filmography

Varda's wide-ranging body of work often demonstrates a purposeful combination of fiction and non-fiction, or a complete disregard for the distinction, and metaphors develop within that blurring of boundaries. Even those categorized broadly as fiction films regularly incorporate non-fiction traditions. *Cléo de 5 à 7* (Cléo from 5 to 7, 1962) is a prominent example, where the street scenes

show Varda's observational camera meeting the eyes of real Parisian pedestrians, giving the viewer an insight into Cléo's perspective. As the fictional Cléo is dropped into our reality, the awkward juxtaposition of fiction and non-fiction becomes a metaphorical indicator of her alienation. Where Varda's work falls broadly into non-fiction—from early shorts like *O saisons, ô châteaux* (1958), and *Du côté de la côte* (Along the Coast, 1958), to feature-length documentaries like *Mur Murs* (1981), *Glaneurs,* and *Les Plages d'Agnès* (The Beaches of Agnès, 2008)—her approach is often unabashedly poetic, figurative, and highly self-reflexive. Far from being an accessory to her documentary style, the metaphoric relations Varda develops often take center stage over the films' ostensive subject.

For a documentary-maker like Varda, drawing figurative parallels from the raw material she records, and the reality she encounters, forms a pivotal part of both the investigative process, and the way in which narrative shape is given to the historical world. Following Lakoff and Johnson's theories, the metaphoric structures deeply embedded in how we experience and make sense of reality are already informing the way in which non-fiction filmmakers like Varda go about finding or imagining metaphoric formations within their encounter with that reality. Moreover, however authentic it may be, documentary's depiction of actuality is an abstraction from the real world that is its subject. That procedure, fundamental to cinema's indexical relation to the world, can be seen as metaphoric by its nature. Heightened by documentary's implicit inference that what is shown is a truthful depiction of the real world, the documentary version of reality can be seen as the source domain in a metaphoric formation where the target domain is the real world. With Lakoff and Johnson in mind, it could be said that documentary is occupied with the metaphoric rendering of a reality that is, itself, one we partially comprehend through metaphor.

At various points in Varda's career, she has encouraged a figurative interpretation of her filmmaking persona. *Daguerréotypes* (1976), for instance, appears to be a fairly straightforward observational documentary depicting a normal day for those living in Varda's neighborhood in Paris, albeit one in which Varda's cameras and crew are crammed into the corners of shops. Working within her limitations while looking after her son, Mathieu, who was a toddler at the time, inspired Varda's metaphoric conceptualization of the film:

> I started with the idea that women are attached to the home. So I attached myself to my home, literally, by imagining a new kind of umbilical cord. I attached an electric cable to the electric meter in my house which, when fully uncoiled, turned out to be 80 meters long. I decided to shoot *Daguerréotypes* within that distance.[7]

In this instance, the metaphor frames Varda's mediation of the world around her. It gives thematic shape to what might otherwise seem aimless. That impulse to not only encounter the world through documentary, but also metaphorize that encounter, understanding it as something transcending its ostensive meaning, is a notion that has prevailed throughout her filmography.

Varda's term, "*cinécriture*," is a further indication of that attitude, attempting to amalgamate the work of scriptwriting and directing into a single unified concept:

> The cutting, the movement, the point-of-view, the rhythm of filming and editing have been felt and considered in the way a writer chooses the depth of meaning in sentences, the type of words, number of adverbs, paragraphs, asides, chapters which advance the story or break its flow, etc.[8]

Cinécriture holds obvious similarities to other auteurist metaphoric conceptualizations of filmmaking, not least Alexandre Astruc's notion of the "caméra-stylo."[9] However, Angela Martin's suggestion that *cinécriture* can be understood as a way of distinguishing women auteur filmmakers, "to avoid having to go through and be marginalized by the arguments about the authorship theory," highlights the nuanced potential of metaphor in this context.[10]

Perhaps the most influential of these self-assigned metaphors, though, is the characterization of Varda as gleaner, in *Glaneurs* and its sequel, *Les Glaneurs et la glaneuse: deux ans après* (The Gleaners and I: Two Years Later, 2002). Establishing the idea of her role as "la glaneuse" shows an attempt to invoke a more profound, abstract metaphorization of her practice. The film encourages the viewer to understand one thing in terms of another, even if that other—gleaning—was likely something the viewer knew little about before seeing the film. A further metaphoric persona can be applied to Varda, as evidenced by these examples. We get the sense from how she communicates her perspective of reality, that her documentary-making is, perhaps above all else, a search for, and cultivation of, metaphors.

The Gleaning Metaphor

With *Glaneurs*, its French title alludes, from the outset, to the parallel that Varda intends to draw. Varda investigates the film's ostensive subject—the practice of gleaning, which typically refers to the salvaging of discarded food, materials, or items—through a variety of formal approaches. The film features interviews,

observational footage, archival footage, staged scenarios, and countless reflexive devices to create a collage of gleaning in its myriad forms. As Forceville's aforementioned article explores, this is framed as a road-movie or travelogue of a journey across France; a journey that draws on some foundational metaphors of its own. However, Varda's intention with *Glaneurs* is not merely to document the culture and practice of gleaning, but to frame it around her own filmmaking. As the title suggests, and as Varda declares in voice-over narration, "there is another woman gleaning in this film, that's me."[11]

Varda does show herself to be an avid gleaner of fruit, vegetables, ornaments, and the like, in the same sense as those she follows, though even these physical acts of gleaning she undertakes are repurposed as opportunities to make artistic statements. Rescuing a broken, handless clock from a pile of junk, before setting it as an ornament on her windowsill, she tells us in voice-over, "a clock without hands is my kind of thing. You don't see time passing."[12] Even this material strand of Varda's gleaning carries inherently metaphoric patterns, breathing new meaning into something by inviting us to view it in a different way. Varda imbues even her most traditional gleaning—emulating the women in the Jean-François Millet painting, *Des glaneuses*, by collecting discarded crops—with a significance beyond its perfunctory use.[13] Upon visiting the site where piles of apparently misshapen potatoes are discarded by suppliers, Varda collects heart-shaped potatoes with the same enthusiasm as those raiding the piles for food supplies, and her central visual metaphor is realized. Finding these heart-shaped potatoes is finding the beauty and meaning in that which has been deemed unusable, the wrong size or shape; it would later become the center of her *Patatutopia* art installation.[14] In a subsequent interview, Varda reflects upon the strict size specifications for potatoes to be sold, and the wider political ideology that insinuates, explaining that "all at once you get this little parable that in our society, everything that is odd-sized, irregular, you throw out." According to Varda, this encounter helped to develop the rationale behind her metaphoric approach; "that second day of filming brought me what would become the meaning of the film, for me. That is to say, waste in the form of a heart."[15]

However genuine this spontaneity, the film itself and Varda's extra-textual comments both celebrate the idea that a documentary's meaning can be found by chance. In this moment we are offered a metaphoric interpretation of both the object Varda finds, and the act of finding it. Whether or not finding the heart-shaped potatoes was genuinely serendipitous, and actually brought together the film's meaning for Varda, what is more significant is that her intention is clearly to emphasize the spontaneity of the encounter. As much as she attempts

to imbue this inanimate, oddly-shaped potato with meaning, it is the encounter itself—the searching for, the chancing upon, and the finding of the metaphoric connection—which is the enterprise Varda aims to inspire.

From a basis of physical, material gleaning, Varda then explores the more abstract inferences encompassed in what it means to glean, and this begins to emerge as the real focus. The concept of gleaning is applied to people, images, ideas, and the experience of reality, which all feed into the overarching ideology of her film, that there can be meaning and importance found in what might seem ephemeral. Varda involves herself in gleaning on a number of levels, allowing it to emanate through the film in various forms. Throughout, she draws a parallel between the physical act of salvaging and her particular brand of documentary-making, thereby cultivating a more profound, conceptual idea of the meaning in her work and her method. What begins with Varda performing a sequence to camera where she drops ears of wheat from her shoulder, then raises a video camera to her eye, builds toward an increasingly complex figurative comparison. As Ernest Callenbach explains, Varda develops gleaning as a "shimmering, shifting metaphor" for her own filmmaking method, through which she "gleans from the world a wildly miscellaneous collection of images, sounds, people, ideas."[16] By looking at her filmmaking in terms of gleaning, Varda draws attention to the possibilities of viewing the world with this receptive and inventive attitude toward metaphor. Callenbach here alludes to several important elements of the gleaning parallel. Firstly, the "miscellaneous collection" that constitutes the fruits of her gleaning is significant. In fact, the gleaning metaphor allows Varda to collect and, thereby, reflexively comment upon a number of the most important components of any documentary: the participants, the subject matter, the mode of address, the footage captured, and the filmmaker. Secondly, the "shimmering, shifting" aspect suggests that the central figurative thesis of *Glaneurs* actively calls attention to the inherent instability of meaning in both a metaphor's interpretation, and a documentary's.

One of the central metaphors might be written, in the CMT format, as VARDA'S DOCUMENTARY FILMMAKING IS GLEANING. In that sense, *Glaneurs* performs a fairly precarious act. Gleaning is not something with which Varda expects the average viewer to already be familiar, hence the ostensive impetus of the documentary, to educate the viewer about this particular practice. Varda simultaneously introduces gleaning, and incorporates it as the viewer's familiar source domain, through which we are asked to interpret her method as something more abstract than it may appear. Moreover, the VARDA'S DOCUMENTARY FILMMAKING IS GLEANING metaphor requires a prior conceptualization of documentary filmmaking as

something abstract enough to be open to Varda's embellishment. The implication is that while the typical documentary approach may choose "desirable" subjects, formulaic narratives, and famous or "important" participants, Varda not only wants to include the marginal, the ordinary, the "undesirable," but she hopes to disregard the hierarchy that sidelines them. It constitutes what Delphine Bénézet sees as Varda's "commitment to resist norms of representation and diktats of production."[17] Interpreting her economical method as something novel and innovative requires that it be contrasted with the norm in this way. As any documentary-maker finds their participants, Varda's are absorbed into her gleaning metaphor, and yet there is something of a contradiction in viewing Varda's now iconic filmmaking persona in this context, where the level of introspection and intimacy on display cannot help but make her the star of the film.

The gleaning metaphor aligns with the highly personal perspective Varda establishes as the film's posture, in order to muse on existential questions about her own life and her place in the world. She adapts the gleaning philosophy to the way in which she comes to terms with the ageing of her body, declaring in voice-over, "This is my project: to film with one hand my other hand."[18] She scans the wrinkles and liver spots on her skin, and the grey roots appearing beneath her red hair, with a sense of wonder. Mireille Rosello describes these sequences as a "fascinating mixture of self-centeredness and anti-narcissism," alluding to the paradoxical space that the film inhabits.[19] Varda does not despair at these signs of ageing. For her, they offer just another stimulus to find beauty and fascination in that often resisted or maligned process, and to probe the fundamental question of what we accept and reject as a society. She revels in these transformations, and invites the viewer to share her perspective on ageing and its physical effects, by framing it within this context of gleaning. In this sense, Varda aligns her physical self with the misshapen potatoes. This might be the documentary's most poignant idea, of Varda folding herself into the film's meaning as something gleaned, or gleanable, in the making of the documentary.

The most complex innovation of *Glaneurs*, though, is in the bidirectionality of the central metaphoric parallel. As the film progresses, Varda reflects characteristics drawn from the metaphor back in the other direction. We are encouraged to view gleaning, in terms of what we now understand about her filmmaking, as something more profound than just collecting or salvaging. Noël Carroll has written on the capacity for metaphor in film to encompass a bidirectionality or symmetry in how viewers interpret the source and target domains of any non-verbal metaphoric formation.[20] Carroll takes the example of the iconic camera/eye superimposition in Dziga Vertov's *Man With a Movie*

Camera (1929), which, Carroll contends, constitutes a visual metaphor that can be read in either direction as THE EYE IS A CAMERA or THE CAMERA IS AN EYE. However, as Forceville contests, the interpretation of metaphor can only occur if the source and target domains can be clearly distinguished, because they "play fundamentally different roles in the metaphor."[21] The apparent reversibility of an example like the camera/eye composite should be read, therefore, as two separate metaphoric constructions, and Varda's gleaning/filmmaking formations are no different; VARDA'S DOCUMENTARY FILMMAKING IS GLEANING and GLEANING IS VARDA'S DOCUMENTARY FILMMAKING.

Indeed, the central comparison made by Varda in *Glaneurs* is dynamic and cumulative, and, as Rosello observes, "stops short of proposing a simple equation between the two."[22] In fact, the film resists such symmetry at every level. The developing metaphoric connection between Varda's filmmaking and gleaning serves to expand and embellish our understanding of both. Gleaning grows into an abstract concept that requires metaphors for us to understand. The very act of gleaning, and perhaps the idea of sustainability by inference, both become something creative, impassioned and inquisitive. Sustainability, with gleaning as its metonym, becomes metaphorically aligned with perceiving the world in metaphoric terms. To glean and, thereby, to live sustainably, is to breathe fresh significance into something discarded, by viewing it in a different way. Exemplified with her repurposed handless clock, Varda presents gleaning as an inherently metaphoric practice, in that the salvaging of items infuses them with new meaning. This back-and-forth between these ever-developing source and target domains creates an ongoing interchange of ideas which, for Varda, is at the heart of the documentary project.

As each idea develops the other through metaphor, *Glaneurs* alludes to the inevitably subjective feedback loop of documentary-making. Our perception of reality shapes our interaction with the real world, and therefore the way in which our camera is able to capture it. This, in turn, influences how we conceive of our reality, and so on. Varda's imaginative and metaphoric approach to documentary reflexively challenges the fallacy that documentary can depict the real world with any kind of privileged access to objectivity.

The Dance of the Lens Cap

Examining the metaphor at the center of *Glaneurs*, Homay King explains that Varda "counts herself among these gleaners, but what she collects are images [...]

using her digital camera as receptacle."[23] One moment in particular epitomizes the idea of the footage chosen for the film as something gleaned by Varda, invoking the question of what we decide has enough value to commit to film (or, in this case, digital video), and how we decide it. Varda's much-discussed dancing lens cap sequence consists of an extended shot of what she claims to be accidental footage, having left her handheld camera recording while holding it by her side, with its lens cap dangling wildly in front of the lens; "I forgot to turn my camera off, which is why we get the dance of the lens cap."[24] The soundtrack accompanies the shot with energetic jazz, inviting the viewer to share her appreciation of both the kinetic delight of the shot, and its unpredictability. The sequence takes on the form of something like a surreal, avant-garde dance routine, played for comedy within the film's context. Aside from what Varda views as the shot's aesthetic potential, the example is notable for so obviously consisting of material which would be discarded as unusable by most filmmakers. As Rosello suggests, "Varda plucks images from a reality where others had seen only banalities or ugliness."[25] As much as the shot is framed as rescued footage, in a sense, gleaned from the figurative cutting-room floor, its very presence in Varda's film transforms it, metaphorically, into something else. The un-authored character of the footage only heightens that realization, that its inclusion by Varda, and therefore its status as something worth our attention, turns it from something accidental or contingent into something with an intended meaning.

This dancing lens cap is important for another reason. For Varda, working with a digital video camera for the first time, and the shooting freedom which that brings, creates the possibility for this footage to be captured. With the development of the technological means available to Varda comes a development of her artistic, metaphoric possibilities. Without the privileging of a certain attention to quality and pertinence that come with the financial pressures of shooting on celluloid, Varda's filmmaking interrogates those requirements. The film both finds value in images that would otherwise be discarded and simultaneously questions the way in which we assign value to images. In this context, the lens cap shot, in itself, holds its own paradox. As King explains, "*The Gleaners and I* is a profoundly materialist film, that is, a film about the conservation of tangible resources—yet it is made in the least material of available image formats, digital video."[26] Indeed, it is positively a celebration of the new liberties brought about by shooting digitally. Moreover, the existence of the lens cap footage relies upon Varda's complacency and her mistake. The implicit message here is that mistakes can be productive and exciting when viewing the real world through the perspective of metaphor. It is the ostensibly accidental existence of the shot

that she aligns with the gleaning idea. The presence of the sequence, in the film, becomes a metaphor for questioning and resisting the impulse to dismiss our mistakes or flaws. Moreover, and this may constitute Varda's prevailing message with *Glaneurs*, the sequence implies a willingness to greet the unexpected and to find fulfilment in embracing the chaotic unpredictability of life.

The sequence perfectly exemplifies the eccentricity and eclecticism of Varda's reflexive transposition of that reality into her documentary. Yet embracing disorder in such a way cannot help but impose its own order and shape. The implicit assumption when we encounter metaphor is that it should serve to bring coherence and tangibility to something we might not otherwise understand coherently. The practice of finding, as opposed to creating, a metaphoric formation, as Varda's film clearly evidences, reframes this relation between metaphor and coherence. Varda's documentaries distinctly foreground their metaphors, providing a fertile case study for analyzing this largely unexplored point of conjunction. Varda's malleable, experimental attitude toward documentary-making brings an openness to metaphor's possibilities.

Glaneurs is a kind of virtuoso flourish, showing where metaphor can lead us in documentary film. As much as Varda uses the gleaning metaphor to articulate the importance of sustainability in how we live our lives, she also employs sustainability as a metaphor for understanding the way that *thinking metaphorically* can bring meaning and significance to our experience of the world we inhabit. A sustainable attitude is not only one that may allow us to live more ethically, or more efficiently, but it is one that, as Varda suggests, can be seen as inherently metaphoric, and therefore one that offers a more profoundly meaningful relationship with our world. Varda's legacy encourages a co-operation between metaphor and documentary, and offers a powerful metaphoric understanding of what documentary is. Her resonating proposition is that all documentary-making is gleaning and, in that sense, is an inherently metaphoric practice.

Notes

1 Joshua Oppenheimer, "Master Class: Joshua Oppenheimer," *YouTube*, 1:13:34, January 28, 2015. https://www.youtube.com/watch?v=wJ9_EWfJ8Dc.
2 Charles Forceville, "The Journey Metaphor and the Source-Path-Goal schema in Agnes Varda's Autobiographical 'gleaning' Documentaries," in *Beyond Cognitive Metaphor Theory: Perspectives on Literary Metaphor*, ed. Monika Fludernik (London: Routledge, 2011).

3 Aristotle, *The Complete Works of Aristotle: The Revised Oxford Translation*, ed. Jonathan Barnes (Princeton NJ: Princeton University Press, 1984), 2332.
4 George Lakoff and Mark Johnson, *Metaphors We Live By* (Chicago: University of Chicago Press, 1980), 5.
5 Ibid., 156.
6 George Lakoff, "The Contemporary Theory of Metaphor," in *Metaphor and Thought*, ed. Andrew Ortony (Cambridge: Cambridge University Press, 1993), 207.
7 Agnès Varda, in Delphine Bénézet, *The Cinema of Agnès Varda: Resistance and Eclecticism* (New York: Columbia University Press, 2014), 23.
8 Agnès Varda, in Alison Smith, *Agnès Varda* (Manchester: Manchester University Press, 1998), 14.
9 Alexandre Astruc, "The Birth of a New Avant-Garde: La Caméra-Stylo," in *The New Wave: Critical Landmarks*, ed. Peter Graham (Garden City: Doubleday, 1968), 17–23.
10 Angela Martin, "Refocusing Authorship in Women's Filmmaking," in *Women Filmmakers: Refocusing*, ed. Jacqueline Levitin, Judith Plessis and Valerie Raoul (New York: Routledge, 2003), 35.
11 Varda, Agnes. *The Gleaners and I*. Zeitgeist Film Release. 2001.
12 Ibid.
13 Jean-François Millet, *Des glaneuses*, 1857, Musée d'Orsay, Paris.
14 Agnès Varda, *Patatutopia*, 2003, Venice Biennale, Venice.
15 Agnès Varda, in Kelley Conway, *Agnès Varda* (Urbana: University of Illinois Press, 2015), 150–1.
16 Ernest Callenbach, "The Gleaners and I (Les Glaneurs et la glaneuse)," *Film Quarterly* 56, no. 2 (December 2002): 46–7.
17 Bénézet, *The Cinema of Agnès Varda*, 6.
18 Varda, *The Gleaners and I*.
19 Mireille Rosello, "Agnès Varda's *Les Glaneurs et la glaneuse*: Portrait of the Artist as an Old Lady," *Studies in French Cinema* 1, no. 1 (January 2014): 35.
20 Noël Carroll, *Theorizing the Moving Image* (Cambridge: Cambridge University Press, 1996), 221.
21 Charles Forceville, "Visual and Multimodal Metaphor in Film: Charting the Field," in *Embodied Metaphors in Film, Television, and Video Games: Cognitive Approaches*, ed. Kathrin Fahlenbrach (New York: Routledge, 2016), 19.
22 Rosello, 30.
23 Homay King, "Matter, Time, and the Digital: Varda's *The Gleaners and I*," *Quarterly Review of Film and Television* 24, no. 5 (September 2007): 421–9.
24 Varda, *The Gleaners and I*.
25 Rosello, "Agnes Varda's *Les Glaneurs et la glaneuse*," 32.
26 King, "Matter, Time, and the Digital," 421–9.

4

The Nude Auteur, Denuding Filmmaking

Ayça Çiftçi

In the final period of her life, Agnès Varda deepened her ties with her long-time fans while also reaching wider audiences. In fact, Varda's increasing popularity began in 2000, when *Les Glaneurs et la Glaneuse* (The Gleaners and I) attracted wide interest and marked her comeback. This was a notable point in Varda's cinema also because, with this documentary film, she initiated a more direct dialogue with her audience, which she further cultivated in her later films. Varda's narration of her own cinema in *Les Plages d'Agnès* (The Beaches of Agnès, 2008) marked another turning point in her career, when she began turning her critical eye on her own past work. In *Visages villages* (Faces Places, 2017), which she made with photographer and visual artist JR, she again turned the camera to herself, and the wide online promotion of this film brought Varda to a younger generation and made her a social media star. In her final film *Varda par Agnès* (Varda by Agnès, 2019), released shortly before her passing, she engaged in a direct conversation with her audience, narrating herself for the last time.

In Varda's final years, as her significance in the history of cinema became more acknowledged, her films more frequently revisited and appreciated, this heightened cultural presence also coincided with the rise of the Me Too movement. As we listened to Varda's story through her own voice and revisited her filmography together with her, we also witnessed a widespread questioning of the myths of "master directors" and established discourses around the concept of the *auteur*. Triggered, in part, by the thoughts evoked in this historical overlap, this chapter aims to reflect upon how Varda's persona as a director and her performance of authorship differ from the traditional image of the *auteur*. While the longstanding critique of auteurism's inherent androcentrism has found renewed force in the days of Me Too, this issue had already been debated by a number of feminist film scholars.[1] If we revisit Varda's films in the mindset of these theoretical debates, and in echoing the more widespread, public discussions of the Me Too movement, which characteristics of her cinema would

come to the fore? This chapter mainly pursues this question and suggests that Varda might be a model for questioning the dominant cultural and theoretical codes in relation to the concept of *auteur*, since she offers us a tangible alternative to what we criticize and challenge.

While Varda stepped into cinema in an era and geography that gave birth to auteur theory, and even contributed to this debate with her conception of *cinécriture*, Varda used her position as an *auteur* to disrupt, renew, and transform the concept. For Varda, productive through the last phase of her life, contributed to the history of cinema not only through her films, but also by offering a possibility for another kind of *auteur*. In an attempt to explore her distinctive performance of authorship, this chapter examines the uniqueness of Varda's intensely personal cinema, as well her representation of cinema itself through her highly self-reflexive films.

Looking at Others

"I'm playing the role of a little old lady, pleasingly plump and talkative, telling her story. And yet, it's others I'm interested in; others I like to film." So begins Agnès Varda's autobiographical film *Les Plages d'Agnès*, which she narrates while walking backward on the beach, barefoot. These opening lines not only signal the structure of this particular film, in which she narrates herself through other people, but they also lead us toward one of the creative essences of Varda's cinema in general. How she understands herself and others in an intertwined way, as she directly explains and exemplifies in this autobiographical documentary, is an approach that also shaped her earliest films.

Her first short film, *L'Opéra-Mouffe* (Diary of a Pregnant Woman, 1958), exhibits most of the characteristic features of her cinematic perspective that would be solidified in her later work. Varda structured the film as a diary of a pregnant woman, and in a typical Vardian approach, this structure originates from personal experience: she was herself pregnant with daughter Rosalie at the time of filming. This convergence and interplay between life and cinema are also feminist intervention, representing the subjective perception of a pregnant woman. Furthermore, the way *L'Opéra-Mouffe* merges documentary and fiction and its playful sense of humor is again specific to Varda. The film has two layers: documentary footage of the streets of Paris and fictional fragments from the life of a couple in love. The documentary scenes show close-ups of the food

and vegetables being sold on the market stalls in Rue Mouffetard, Paris, and the people in the street to buy them. A pair of hands cut open a large gourd—after a match cut with the belly of a pregnant woman—and remove its seeds, for instance. The pregnant woman who directs the gaze focuses on images she associates with pregnancy and birth.

Throughout the documentary segments, the camera also closes in on faces of people at the marketplace. Through the pregnant Varda's camera-eye, the audience exchanges stares with several people—a motif that also reappears throughout her filmography. Her experience of pregnancy influences the way Varda perceives those faces; conversely, she uses this formal setup to allow others to perceive her experience. In her later productions, too, Varda often emphasizes that turning one's face outward can help them look inward. Considering how, in *Les Plages d'Agnès*, she includes others in her narrative in order to understand and express herself, we can identify a continuity in Varda's point of view toward her life and her cinema from 1958 to 2008.

While others are viewed through the prism of impending birth in *L'Opéra-Mouffe*, they are seen through the prism of possibly impending death in *Cléo de 5 à 7* (Cleo from 5 to 7, 1962). Cleo, the protagonist, is a young and beautiful singer about to learn whether or not she has cancer; we go through this painful waiting period together with her and observe how it changes her. The mise-en-scène in the first half of the film—in other words, the universe of Cleo—is besieged by mirrors. We see her examining herself at every opportunity, with pleasure, taking her time. She takes refuge in mirrors to escape from the idea of death: at the beginning of the film, when a fortune teller foretells her death, she overcomes the shock thanks to a mirror she comes across on her way out of the building. While eyeing her own image admiringly, she says, "Ugliness is a kind of death. As long as I am beautiful, I'm even more alive than the others." Cleo thus brings into mind John Berger's understanding of sexual difference in terms of exchanges of looks; he talks about how a woman's self is "split into two" since "a woman must continually watch herself. She is almost continually accompanied by her own image of herself."[2] He says, "Men look at women. Women watch themselves being looked at."[3] In this first half of the film, Cleo embodies Berger's proposition—or, in Laura Mulvey's words, she keeps an eye on her own *to-be-looked-at-ness* at every opportunity.[4]

At the film's midpoint, Cleo storms out of her apartment, angry that the people in her inner circle have imprisoned her in a cliché. This aimless journey through the streets of Paris begins Cleo's transformation; as Janice Mouton describes it,

> [W]hen Cleo enters the Montparnasse café le Dôme in her new role of flâneuse, she notices everything in this rich sidewalk café: posters on the bulletin board, paintings on the walls, tables, chairs, a pinball machine, a jukebox, a newspaper rack. She seats herself momentarily at a small table, positioned next to a floor-to-ceiling column covered in mirror mosaics, a mirrored surface into which, for the first time, Cleo does not look. In becoming part of the café world, she ceases to be a spectacle on display, for herself or for anyone else.[5]

Further underscoring her self-transformation, when she meets her friend Dorothée and they start walking together, Dorothée drops her mirror. Once again, we see a mirror image of Cleo in the film, this time reflected in the shattered pieces on the ground. Roy Jay Nelson observes that this is the last mirror we see in the film, which suggests that "Cleo has broken free of her enslavement to mirrors."[6] He notes, "mirrors, which are strikingly omnipresent in the first two-thirds of the film" are "totally absent from then on."[7] So we can say that, the moment she dashes to the street while trying to cope with the idea of death, as she gets away from the people close to her, she also gets away from mirrors; when she exits her house, her living space, she exits herself, too.

Along with Cleo, the film's form also changes: documentary elements start to dominate the fiction, recalling the street footage in *L'Opéra-Mouffe*. As Cleo roams the streets of Paris on her own; enters and exits cafés; walks; mingles with crowds; watches people of different kinds, listens to their conversations, and examines their faces, in Varda's own interpretation, she becomes "the looking subject" rather than "the looked-at subject."[8] Varda represents the great transformation of her character by showing how she begins to look at and listen to other people, wondering their stories and being open to their influences.

Varda imbues the act of looking at others with transformational power in *Cléo*, thereby presenting a central attitude in her cinema as the cure for this iconic character. Varda's cinema is filled with portraits of countless people, both intimate friends and total strangers: the residents of her neighborhood in *Daguerréotypes* (1976), her old friends from the time when she worked as a photographer in *Ulysse* (Ulysses, 1983), Louis Aragon and Elsa Triolet in *Elsa la rose* (1965), Jane Birkin in *Jane B. par Agnès V.* (Jane B. by Agnès V., 1988), her uncle she recently met in *Uncle Yanco* (1967), her great love and life partner Jacques Demy in *Jacquot de Nantes* (1991) and *L'univers de Jacques Demy* (The World of Jacques Demy, 1995), people collecting discarded stuff in *Glaneurs*, her friend JR and so many people they met during their journey in *Visages villages*. Dominique Bluher's observation that "one could rewrite her entire filmography

in terms of portraiture" is quite felicitous, as her self-portrait in *Les Plages d'Agnès* is a picture completed with so many other portraits inside it.⁹

As in *Cléo*, the mise-en-scene in *Les Plages d'Agnès* is marked by mirrors, but here, Varda transforms their function. In *Cléo*, the mirror symbolizes being imprisoned in a specific image of one's self; Cleo looks in the mirror at every opportunity in order to "watch herself being looked at." In *Les Plages d'Agnès*, though, Varda seeks ways of expressing herself without getting caught up in her own image, and she uses mirrors to visualize this escape from a unified self. At the beginning of the movie, in initiating a performance of remembering the past, she places a number of mirrors on the beach. In multiplying the mirrors, she also multiplies her image, limiting the mirror's potential to confine a person to a single image as in *Cléo*; she uses the mirrors to look at the multiple Vardas inside. This foregrounds a self-portrait of a director who bears many existences inside her, not one who is fixed through a single image or narrative.

Then she plays another visual trick with the mirrors: by moving them a little, for an instant, the mirror shows somebody else's face, offering a reflection of other people contributing to the film. This can be seen as a visual metaphor for Varda's approach to this autobiographical narrative: in the rest of the film, just like changing the frame of a mirror with a little touch, while narrating her own story, she will twist and turn framework of the narrative to include others in the picture. Claiming that "it's others she is interested in; others she likes to film" at the beginning of a film with her own name in its title, Varda then uses the mirrors to bring together everyone who came into contact with any or all of the Vardas. As a result, the mirrors in this film do not frame the portrait of a "master director," deified in isolation, separate from her surroundings.

Getting Naked

A little boy sitting on the beach, naked; a bit farther away, a naked man looking at the sea with his back to us, and in the foreground the corpse of a goat. Taken by Varda at the beach of Calais in 1954, before she started making films, this photograph is the point of departure for the short documentary *Ulysse*, which revisits the people in this photograph, her own life at that time, and the events in the world on the day she took this photograph. The film also shows Varda already putting into dialogue one work of hers with another, a practice that she revived in earnest in the last phase of her life. Adding to the mirrors that

mark the fiction in *Cléo* and the autobiography in *Les Plages d'Agnès*, *Ulysse* also indicates another leitmotif in Varda's cinema: nakedness.

When Varda asks Fouli Elia, whose youth we see in the photograph, to talk about the photograph years later in *Ulysse*, Elia is again standing naked next to his office table. There is no reference to this little joke, but Elia says Varda used to like photographing naked bodies and then we see several more early nude portraits. When she became a filmmaker, Varda carried the image of the naked human body from her photographs into her films. In *L'Opéra-Mouffe*, for instance, her cast of nudes includes a couple in love and her own pregnant body. In *Réponse des Femmes* (Women Reply, 1975), a group of naked women talk about their bodies, facing the camera. Yet Varda is passionate about nakedness not only for the sake of its visual image. What makes nakedness interesting for her is its metaphorical potential.

In an interview on *Cléo* Varda says, "Cléo is for me typically a character who is not naked."[10] To clarify this, she states that, to her, nakedness represents lowering one's guard and standing before others defenselessly. As part of Cleo's transformation in the second half of the film, she must learn "how to get naked" metaphorically. Nakedness is also a topic directly addressed by the characters in the film. Cleo's friend Dorothée makes a living by posing as a nude model for art students, and Cleo visits her while she is posing at an atelier. As they chat about Dorothée's work, Cleo admits that she could never pose naked. A more metaphorical nakedness comes in her encounter with a soldier who is about to go to war in Algeria. Over the course of the agonizing time when Cleo waits for her test result and Antoine his deployment to Algeria, they chat, the idea of death lingering in both of their minds. One of the themes in their lengthy conversation is, again, nakedness. Cleo's relationship with this stranger she has just met is very different from her relationships with the people in the first half of the film. This is how Varda describes them: "They are both defenseless, having lowered their guards. People can communicate only when they are at such a state." In embracing her newfound role as a "looking subject" rather than a "looked-at subject," Cleo must also embrace nakedness. As she has learnt to look at and take interest in others, she has also learnt how to open herself up to others.

With the same metaphorical resonances, nakedness is among the defining characteristics of Varda's cinema. Observing public responses to her death, Kennedy-Karpat stresses that the way people shared "personal memories and private feelings" about Varda and valued her as a source of inspiration went "beyond standard measures of respect."[11] The evident emotional bond of her audiences to Varda as a person can be interpreted in relation to the nakedness

of her intensely personal cinema. Passionate admirers of her films begin to love Varda herself with the same passion, since watching her films is like meeting and spending time with Varda. A chronological journey in her filmography makes it possible to follow what she was preoccupied with, who she emotionally bonded with, what appealed to her, what infuriated her, what entertained her, what worried her in different periods of her life. Varda is not just a director behind the camera, whom we get to know by seeking her traces in the films and following her interviews; she is indeed one of the characters of her cinema. In a number of her films, especially her documentaries, Varda also appears in front of the camera; when she turns the camera over to herself and makes herself a part of her films, she tries to be as "naked" as possible—in an effort to lower her guard, make her privacy visible, and not to hide her weaknesses and fragility.

Her comeback film *Glaneurs* is a prime example of this vulnerability, as Varda explores the multi-faceted concept of gleaning. She appears in this film that she shot with a small, hand-held digital camera, which was new to the market then, and declares that her way of making movies is similar to the practice of gleaners: "You pick ideas, you pick images, you pick emotions from other people, and then you make it into a film." However, this similarity between filmmaking and gleaning is not the sole motivation behind her appearance; it is also an ethical choice that has to do with the moral responsibility she feels toward the people in her film: "I felt that I was asking so much of these people to reveal themselves, to speak to me, to be honest with me, that I should reveal something of myself, too."[12] Nakedness is, thus, an ethical issue. In her view, if she expects people she is curious about, gazing at, and finally representing, to expose themselves in her films, then she should be willing to be as "naked" in front of the camera as they are.

Throughout the documentary, between the episodes focusing on gleaners, brief fragments show Varda turning the camera on herself. Over a close-up of herself brushing her thinning hair with greying roots, she says "My hair and hands keep telling me that the end is near." Then the camera moves toward a close-up of her hands, and she begins to examine the signs of old age on her hand. "This is my project - to film one hand with the other hand. To enter into the horror of it. I feel as if I am an animal; worse, I am an animal I don't know," she says. The "nakedness" she displays in front of the camera while revealing not only her aging body but also her intimate emotions and thoughts about aging transforms and deepens the relationship she builds with both her audience and the people she has portrayed.

The relationship between nakedness and ethics in *Glaneurs* is also evident in Varda's video installation *Quelques veuves de Noirmoutier* (The Widows of

Noirmoutier, 2004). Bringing together fourteen different videos of fourteen widows talking about their late husbands and their mourning, Varda appears as one of those widows in the installation, sharing her experience of losing her great love Jacques Demy. She interprets and narrates her experience by likening it to and bringing it together with those of others, rather than isolating it or making it unique.

In this regard, the coming together of the interest in others and the principle of nakedness is an aspect that makes Varda's cinema special. Her curiosity about others, which is one of the fundamental elements of her creativity in cinema, is not of a kind that keeps the other away from herself, positioning herself as the subject and the other as the object, or defining the other as one that does not resemble her to create a hierarchy between the other and "me," or scrutinizing the nakedness of the other as one fully dressed. Varda acts upon her curiosity in a way that also assumes ethical responsibility for the intimacy of what she finds.

Denuding the Filmmaking Process

Varda tries to denude her cinema as much as, or along with, herself. The self-reflexive elements in her films do not bear an aggressive tone, nor do they attempt to awaken the audience or didactically impose a lesson; rather, they render filmmaking processes—and cinema in general—more accessible, understandable, and relatable. Delphine Bénézet suggests that Varda's adoption of a commercially available digital camera to shoot *Glaneurs* offers a subtle rejection of the élite film school model of authorship: "Varda's emphasis within the film's narrative on the ease with which the digital camera records situations and testimonies is undoubtedly an invitation to demystify the technical apparatus associated with filmmaking."[13] Her self-reflexive deployment of the digital camera disrupts the mysterious and inaccessible state of filmmaking, and hence, that of the director. Above all, Varda's likening of her way of filmmaking to the practice of gleaners is a means of demystifying filmmaking and rejecting a special position for cinema and the director.

At one point in *Glaneurs*, we see footage shot when the camera was accidentally left running; the lens cap dangles in the frame. In her voice-over, Varda explains: "I forgot to turn off the camera that day. That's why we are watching the dancing lens cap," and we hear a jazz song in harmony with the chaotic dance of the lens cap. Both this playfulness and sense of humor are typical of Varda. Yet, at the same time, this joking lightness in revealing her "mistake" and even making this

"mistake" a part of the finished work, demystifies filmmaking and places Varda in a position beyond the conventional *auteur* image.

This little joke in *Glaneurs* also shows Varda's keen sense of coincidence. In a roadside junk shop, she comes across a painting that combines the two oil paintings at the center of the documentary. While she exits the shop holding this painting in her hand, we hear her joyful voice-over: "This is not a film trick. We did stumble upon this painting." In several interviews, Varda declares how much she likes the serendipity that emerges during the making of her films, and how she changes her films during shooting in line with them. For example, when talking about the making of *Sans toit ni loi* (Vagabond, 1985), she says, "It's happened fifty times on the set that things or people or chance encounters generated ideas we could use right on the spot."[14] In *Les Plages d'Agnès*, she delightfully recounts how in *Documenteur* (1981) she integrated into the background of Emilie's story a real incident of a man and woman fighting, instead of pausing the shooting.

In Varda's documentaries, the whole narrative, in general, is formed as a journey, granting these coincidental encounters formative power in the narrative structure. From *Uncle Yanco* to *Jane B. par Agnès V.*, from *Daguerréotypes* to *Visages villages*, Varda incorporates the making of the film into the film itself; it feels as if the film comes into being in a process we witness, even participate in. An example to this is again *Glaneurs*. Heart-shaped potatoes in the heap of potatoes discarded as they have been deemed unmarketable due to their shape or size attract the attention of Varda. These potatoes remind her of the Good Heart Charity Meals; she contacts them, and afterward, films the volunteers picking up those potatoes. She takes home those heart-shaped potatoes from the heap and narrates how she shot them with her digital camera. As she makes this whole process a part of the film, the audience has the impression that the meaning and the narrative are set in front of their eyes. This approach to cinema both demystifies filmmaking and invites the audience into a dialogue, which Varda takes to a more direct level in *Les glaneurs et la glaneuse ... deux ans après* (The Gleaners and I: Two Years Later, 2002), the follow-up to *The Gleaners and I* that includes responses to and extensions of the film's themes as created by the viewers of the first film.

The journey-film structure, which Varda deploys frequently, refuses closure in favor of openness to interaction, and thus transformation. Varda's use of the same structure in an autobiographical narrative like *Les Plages d'Agnès* renders her style of presenting herself and her cinema unique. At a point in her journey during this film, Varda goes to her childhood house, meets the man now living there, shows interest in his miniature trains, and includes her conversation with

him in the movie. She makes this brand-new acquaintance a part of her own story, her autobiography; in *Les Plages d'Agnès*, Varda tells her own story even as the story continues while being told. Looking back into the past does not pause the present. The self-portrait in *Les Plages d'Agnès* therefore does not build a fixed image of a director, but rather a director's self-portrait in transformation while—and due to—being drawn.

Transforming the Canon

Cybelle H. McFadden stresses that "while on the one hand, Varda does have a place in French film history as the grandmother or the precursor to the French New Wave, she has not been elevated to the same status as François Truffaut or Jean-Luc Godard" and she continues by noting that "Varda's first film, *La Pointe Courte* (1954, released in 1956) has not been canonized in the same way as *400 coups* and *À bout de souffle* have, for example, and was not available in DVD format until 2008."[15] Interpreting *Les Plages d'Agnès* as "Varda's self-canonization into French cinema," she writes, "Varda takes the task into her own hands: her curatorial inscription in *Les Plages d'Agnès* claims her place in French cinema, filling in the gaps left by film historians and critics."[16] Undeniably, Varda made a strong intervention in her own historiography through her final movies. However, in canonizing herself, Varda was also transforming the canon.

Certain tendencies of Varda observed in her films and discussed throughout this chapter, such as, narrating herself through others, disclosing the sources of her creativity, demystifying filmmaking processes, acknowledging the labor of others in her films, rejecting isolation from her subjects as well as her audiences, and getting naked before the eyes of her audiences, can all be seen as strategies she developed in search of creative ways of renouncing the authority attributed to the *auteur* position. This is why *Les Plages d'Agnès* is such an extraordinary self-portrait: it is a director's portrait that seeks to give up the director's privileged position and authority.

Considering the relationships between canonization and "master director" myths and between those myths and the patriarchy, Varda's unique position in the canon has a tremendous impact. We have a portrait that enables us to understand why we love Varda's films so much and why loving her films is intertwined with loving Varda herself. It is a self-portrait declaring that "an alternative *auteur* is possible." At a time when we question whether being authoritarian, powerful, and uncompromising should be necessary personality

traits in a director, and whether the history of cinema should be dominated by mysterious and inaccessible creators, she has offered us a gift: a portrait of an *auteur* of another kind, perfectly timed.

Notes

1 Catherine Grant, "Secret Agents: Feminist Theories of Women's Film Authorship," *Feminist Theory* 2, no. 1 (2001); Kaja Silverman, "The Female Authorial Voice," in *Film and Authorship*, ed. Virginia Wright Wexman (New Brunswick: Rutgers University Press, 2003); Janet Staiger, "Authorship Approaches," in *Authorship and Film*, ed. A. Gerstner David and Janet Staiger (New York: Routledge, 2003); Angela Martin, "Refocusing Authorship in Women's Filmmaking," in *Women Filmmakers: Refocusing*, ed. Jacqueline Levitin, Judith Plessis, and Valerie Raoul (Vancouver: UBC Press, 2003); Brooke Rollins, "'Some Kind of a Man': Orson Welles as Touch of Evil's Masculine Auteur," *The Velvet Light Trap* 57 (Spring 2006); Geneviève Sellier, *Masculine Singular: French New Wave Cinema* (London: Duke University Press, 2008); Diana Holmes, "Sex, Gender and Auteurism: The French New Wave and Hollywood," in *World Cinema's 'Dialogues' with Hollywood*, ed. Paul Cooke (London: Palgrave Macmillan, 2007); Patricia White, *Women's Cinema, World Cinema: Projecting Contemporary Feminisms* (Durham, NC: Duke University Press, 2015); Priya Jaikumar, "Feminist and Non-Western Interrogations of Film Authorship," in *The Routledge Companion to Cinema and Gender*, ed. Kristin Lene Hole et al. (London and New York: Routledge, 2017).
2 John Berger, *Ways of Seeing* (London: British Broadcasting Corporation, 1972), 46.
3 Ibid., 47.
4 Laura Mulvey, "Visual Pleasure and Narrative Cinema," *Screen* 16, no. 3 (1975).
5 Janice Mouton, "From Feminine Masquerade to Flâneuse: Agnès Varda's Cléo in the City," *Cinema Journal* 40, no. 2 (2001): 10.
6 Roy Jay Nelson, "Reflections in a Broken Mirror: Varda's Cléo de 5 à 7," *The French Review* 56, no. 5 (1983): 740.
7 Ibid., 735.
8 Mireille Amiel, "Agnès Varda Talks about the Cinema," in *Agnès Varda: Interviews*, ed. T. Jefferson Kline (Mississippi: University Press of Mississippi, 2014), 73.
9 Dominique Bluher, "The Other Portrait: Agnès Varda's Self-Portraiture," in *From Self-Portrait to Selfie: Representing the Self in the Moving Image*, ed. Muriel Tinel-Temple, Laura Busetta, and Marlene Monteiro (Oxford: Peter Lang Publishing, 2019), 48.
10 Pierre Uytterhoeven, "Agnès Varda from 5 to 7," in *Agnès Varda: Interviews*, ed. T. Jefferson Kline (Mississippi: University Press of Mississippi, 2014), 10.

11 Colleen Kennedy-Karpat, "Agnès Varda and the Singular Feminine," in *Female Agencies and Subjectivities in Film and Television*, ed. Diğdem Sezen et al. (Cham, Switzerland: Palgrave Macmillan, 2020), 12.

12 Melissa Anderson, "The Modest Gesture of the Filmmaker: An Interview with Agnès Varda," in *Agnès Varda: Interviews*, ed. T. Jefferson Kline (Mississippi: University Press of Mississippi, 2014), 174.

13 Delphine Bénézet, *The Cinema of Agnès Varda: Resistance and Eclecticism* (New York: Wallflower Press, 2014), 60.

14 Françoise Wera, "Interview with Agnès Varda," in *Agnès Varda: Interviews*, ed. T. Jefferson Kline (Mississippi: University Press of Mississippi, 2014), 125.

15 Cybelle H.McFadden, *Gendered Frames, Embodied Cameras: Varda, Akerman, Cabrera, Calle, and Maïwenn* (Maryland: Fairleigh Dickinson University Press, 2014), 23.

16 Ibid., 38.

Part Two

Connections

5

Women Directors on the Edge of Hollywood: Agnès Varda/Shirley Clarke in and beyond *Lions Love* (1969)

Zizi Li

Upon its initial release, *Lions Love (... and Lies)* (1969) stood as one of Agnès Varda's least-regarded films.[1] Set in Hollywood in 1968, at the time of Robert Kennedy's assassination, the film follows the life of three countercultural hippie icons—Jerry Ragni, Jim Pado, and Viva—living in a rental house and waiting for stardom. Playing herself, New York filmmaker Shirley Clarke joins the trio to negotiate her contract with a studio. *Lions Love* is partially an auto-fiction inspired by Varda's own troubled experience with the Hollywood film industry after she moved to the United States in 1967 to join her husband Jacques Demy, who secured a contract with Columbia Pictures for what would become *Model Shop* (1969). Columbia Pictures executive George Ayres approached Varda to work on a project about American hippies, *Peace and Love*, which fell through after the studio refused to give her final cut.[2] Varda ended up making *Lions Love* for one-tenth of Demy's one-million-dollar budget.[3]

Little has been written in the English language on *Lions Love*.[4] Existing scholarly work focuses on Varda's intermedial references to Pablo Picasso, René Magritte, and Andy Warhol. However, this focus overlooks the possible implications of the relationship between Varda and filmmaker-as-actress Clarke in *Lions Love*. Most scholars never go beyond remarking that Clarke was playing herself or serving as an alter ego for Varda. This chapter argues for a reading of *Lions Love* that centers how Varda's and Clarke's individual experiences meet and unfold amid the social, political, and industrial movements and turmoil in the late 1960s.

During this same period, Hollywood studios reacted to their financial slippage in part by appealing to young moviegoers, who engaged in "cool" countercultural activities, and by participating in the Francophile turn to recruit

"chic" French auteurs.⁵ In large part through this casting, *Lions Love* uses self-reflexivity as social critique to expose the challenges facing women directors. Varda's casting of Clarke intentionally foregrounds women directors' personal experiences of structural exclusion in the 1960s, even as the women's liberation movement and other countercultural forces were underway.

The Varda/Clarke dialogue weaves together their on-screen portrayals and off-screen experiences. When I watch the film, I hold onto the brief, precious moments of interaction and overlapping between Varda and Clarke, two of the few working women directors who managed to release feature-length films in the 1960s even if outside or at the periphery of commercial film industries. *Lions Love* is not only an example of Varda's intermedial modes of filmmaking, but also a vehicle whereby we can unpack how women filmmakers in the late 1960s moved through *and* were trapped in-between various spaces. On one hand, *Lions Love* is a liminal space that encapsulates the interactions between various media circles, in particular among Hollywood, the French New Wave, and the New American Cinema. On the other hand, *Lions Love* serves as a contact zone through which we can explore how women's experiences in the late 1960s have been unfolded and refolded, structured by the crossing of lines and collapsing of spaces as experienced by alienated, gendered bodies. The specificities of Varda's and Clarke's experiences are examined against the larger context of cultural convergences, collisions, and formations in the film industry. Seeing these formations as examples of the "contact zone"—proposed by Mary Louise Pratt as a "social space where disparate cultures meet, clash, and grapple with each other"—allows a critical engagement with the film's negotiation of marginality and exclusion.⁶ Viewing *Lions Love* alongside paratexts such as published interviews and autobiographies also re/constructs Varda's and Clarke's experiences in between industries, communities, and movements. This study thus offers an integrated approach that blends production cultures research, film history, cultural history, and women's studies to understand *Lions Love* as a reflection of women filmmakers at a time when Hollywood attempted to trifle with the youth counterculture and the French New Wave against a broad backdrop of countercultural and liberation movements.⁷

Varda, the French New Wave, and Hollywood

Albeit often referred to as the grandmother of the French New Wave, Varda was not among Hollywood's initial French recruits. As previously mentioned,

Varda moved to Hollywood when Demy directed *Model Shop*—a film that continued his thematic interest in "elusive love" and fairy tale construction.[8] But as Alison Smith notes, Varda "never secured a major studio deal, despite a number of efforts and near misses."[9] Hollywood may have been more inclined to work with Demy for his love of Hollywood musicals and fabrication of apolitical, escapist spectacle, whereas Varda was more socially conscious and hence more risky as a studio investment. Furthermore, as the lone woman in the New Wave, Varda held a marginal position in this Parisian boys' club, making her work less financially promising and culturally attractive compared to the potential that Hollywood found in her male peers.

While Varda has been long associated with the New Wave, she was "always outside its inner circle" and, in her own words, "seemed to be there by mistake, feeling small, ignorant and the only woman among the guys from *Cahiers*."[10] In a 1982 interview, Varda explained:

> I was never a member of [the] group. Pioneer, as they say, before the New Wave, I was entirely self-taught, not part of the film culture. I *was* in the wave of the New Wave. [...] But I'd never really belonged to [the] group so there was a tendency to forget me and exclude me. [...] I was just plain forgotten. [...] That really hurts.[11]

Smith suggests two reasons for this exclusion: first, Varda never worked for *Cahiers*, and secondly, Varda oftentimes "abandoned" narrative in favor of investigating image-form, through her work in documentary and photography.[12] That is, Varda had a different understanding of and relationship to cinema compared to *Cahiers*-bred contemporaries such as Jean-Luc Godard and François Truffaut. Some critics refer to a "Groupe Rive Gauche" within the New Wave, a sub-movement that puts Varda alongside Alain Resnais and Chris Marker; others see the Rive Gauche as an entirely separate entity.[13] Claire Clouzot has gone as far as positioning the Rive Gauche in opposition to the New Wave.[14] Unlike the *Cahiers* club's focus on "personal angst among the (male) Parisian middle class" against the *cinéma de papa*, Rive Gauche directors devoted deeper attention to sociopolitical themes and are known for their essay film practices.[15]

Like the French New Wave's multiple and sometimes conflicting components, the 1960s American counterculture also had two strands: on the one hand, there were those who were actively engaged in political, on-the-street protest; on the other, there was the counterculturalist, who engaged in a personal journey of self-actualization by fleeing to live in communes.[16] Youth classics of the 1960s, especially *Bonnie and Clyde* (1967) and *Easy Rider* (1969), were

partly successful because they captured and spoke to the ideals of rebellious youth on a journey of personal growth; they were aware of the social revolution but were not actively engaged in the protests. Put differently, these two films invoked the countercultural movement, but from a safe remove, by focusing on characters engaged in self-discovery. In this sense, Hollywood's countercultural films did not stray far from their classical narrative tradition, a conformity that decontextualized, aestheticized, and depoliticized them.[17] In its bid for the youth audience, Hollywood also made several films about campus revolution, such as *The Strawberry Statement* (1970) and *Getting Straight* (1970). In the face of mounting pressure from the government and the military, Hollywood producers "quickly tried to deemphasize the politically oppositional potential of some of these productions by focusing attention on individual, character-driven elements of the movies."[18] Hollywood's recruitment of New Wave directors was an extension of its strategy to incorporate the aesthetic lifestyle choice of the American counterculture.

The peripheral position of Varda in the New Wave both as a woman director and as a part of the Left Bank group directly translated into her (lack of) stake in Hollywood. Importantly, the kind of political awareness and social engagement captured in Varda's works was a bad fit for Hollywood's more superficial interest in profiting off of the chic and rebellious French culture. While Hollywood was looking to alternatives to expand its appeal, its profitable future would ultimately rely on the continuation of state and capitalist domination through maintaining existing socio-economic and cultural relations. Hollywood's backing away from Varda (and, later, campus revolution films) speaks to the centrality of its capitalist practices. Only projects that could be commodified and aestheticized were considered commensurable and worthy of investment.

In addition to wariness about radical politics, Hollywood's fiscal conservatism has often been used an excuse to exclude women directors from American filmmaking. From the mid-1930s to the mid-1960s, Dorothy Arzner and Ida Lupino were the only two women directors who secured work from the Hollywood studios, and both struggled to find it. Aspiring women filmmakers were forced to move to less commercial, yet no less discriminatory spaces, including public television stations, independent collectives, and art galleries. Shirley Clarke, Juleen Compton, and Storm de Hirsch were directing American independent features in the 1960s; their status as women and their daring style created additional barriers to industrial and critical respect in independent film circles, and even more so in Hollywood.[19] In the late 1960s, against the

backdrop of the women's movement, it was ironically difficult for Varda to secure work even as her male counterparts in the New Wave were welcomed by the industry with open arms. According to Maya Smukler, 1967 was the first time in almost forty years when the number of women directors in the commercial US film industry began to increase.[20] So when Varda was negotiating her deal with Columbia Pictures, the environment in Hollywood had only just started gradually accepting more women directors; therefore, it is not surprising that Varda had trouble securing final cut. Hollywood films have to be done a certain way and, to use de Hirsch's words, "women were certainly never approached as directors."[21]

Varda/Clarke in *Lions Love*

Similar to Varda's position in the French New Wave, Clarke felt marginalized in a community that she helped develop. While directing dance films and abstract expressionist city symphonies in the 1950s, Clarke played a formative role in the New American Cinema movement influenced by cinema verité and European new wave cinemas. In 1958, Clarke and her peers—Willard Van Dyke, D. A. Pennebaker, Richard Leacock, David and Albert Maysles—established Filmmakers Inc., a co-op that served the independent film community in New York with production and networking support.[22] Clarke ventured into feature filmmaking in the early 1960s with the critically acclaimed *The Connection* (1961), an adaptation of a play about heroin-addicted jazz musicians, and *The Cool World* (1964), the story of a Black teenager in early 1960s Harlem. Clarke co-founded the New American Cinema Group (NACG, aka the Film-Makers Coop.) in 1960 with Jonas Mekas and twenty other filmmakers to raise money to produce and distribute avant-garde and independent films.[23] *The First Statement of the New American Cinema Group* (1962) called out the moral corruption, aesthetic obsolescence, thematic superficiality, and temporal boredom of Hollywood and other mainstream cinemas, positioning itself in opposition to the Hollywood system and instead advocating for alternative methods of financing, budgeting, distribution, and exhibition.[24] In the mid-1960s, Clarke, Jonas and Adolfas Mekas, and Lionel Rogosin started the Film-Makers Distribution Center to distribute their features in commercial situations.[25] In an interview with Lauren Rabinovitz in the early 1980s, Clarke shared her anger toward being excluded while making essential contributions to the movement:

> During the period that Jonas and I were running Film-Makers Coop and Film-Makers Distribution Center, he was putting together the Anthology Film Archives. Then in 1967 after Film-Makers Distribution Center had folded, I turned around and read in a magazine that Anthology Film Archives had not only officially started but that the list of filmmakers whose work would be in the archive did not include me. [...] I got very upset, absolutely furious. [...] the main problem was that the selection committee was five guys, and there was all this animosity going on among the filmmakers as well as a great deal of vying for place. I had a great deal of anger, and there's a part of me that still has it.[26]

Frustrated by her unsustainable financial situation, her films' limited access to a broader audience, and her exclusion from the New York underground film circle, Clarke turned to Hollywood in the late 1960s and early 1970s—a period that coincided with Varda's short stint in Los Angeles. Flying out to Los Angeles for the filming of Varda's *Lions Love* in 1969, Clarke embarked on her journey in and around Hollywood. Around this time, Varda not only struggled in her negotiations in Hollywood but also in France. Her documentary *Black Panthers*—originally scheduled to be broadcast on the French television show *Five Headlines*—was pulled from the lineup at the last minute with concerns of its radical politics; Columbia Pictures also denied her final cut on *Peace and Love*.[27] These frustrations are echoed in two scenes in *Lions Love* that focus on the fictionalized Clarke's difficulties with financing and creative autonomy, specifically the power of final cut on her film. Character Clarke's experience with Hollywood mirrors Varda's experience as a woman director trying to obtain final cut from the studio making her movie. Clarke would soon face her own, similar problems seeking work as a director in Hollywood in the 1970s. Clarke shared her experience at a 1975 American Film Institute event:

> People ask me why I haven't made Hollywood films. I reply, "If I were a man, I might have tried to be Orson Welles." But as a woman and an artist, it's impossible. Producers think of us in childlike terms, as cute, or sweet, or cunning. During a meeting it's always "honey" or "sweetheart" they don't take us seriously.[28]

As Varda and Clarke converge in *Lions Love*, it creates a Brechtian moment of disorientation that collapses the fictional and real-world frustrations of these two women directors in Hollywood. It speaks to the larger social and cultural obstacles they faced in the late 1960s and 1970s.

Another woman behind the camera for *Lions Love*, assistant director Lynne Littman, also faced challenges in her career. After graduating in 1962, Littman started a secretarial position at WNET in New York and worked up to an associate producer for *Black Journal* in 1968.[29] Littman met Varda via a mutual friend,

moved to Hollywood in 1969 to join the production of *Lions Love*, and remained in LA afterward, joining KCET and spending the 1970s making documentary shorts. However, it would be another decade after *Lions Love* before Littman was able to direct her first feature film *Testament* (1983). Littman disclosed in an interview:

> I never worked in Hollywood. This one got picked up by Hollywood, but probably would never have been made there. Cable would never have given me production money on a gamble [...]. I'd never directed a film. I'm a woman. And the material is completely difficult.[30]

Varda/Clarke/Littman's various efforts to forge alliances with other filmmakers ultimately failed to help them secure work as directors in Hollywood. At the same time, their exclusion from these groups attests to the forced fluidity women filmmakers of this moment obtained in the 1960s and beyond as they straddled different media industries to find their footing. Nonetheless, *Lions Love* provided an opportunity for these three women to express their solidarity and their mutual frustration with being excluded from holding positions of power in Hollywood and elsewhere.[31]

Notably, in an attempted suicide scene in *Lions Love* (Figures 5.1 and 5.2), Varda and Clarke break the fourth wall by exchanging opinions, clothes, and positions. Clarke is about to make a phone call when she sees a bottle of sleeping pills. After taking just one pill, she turns to the camera (and Varda) and explains her unwillingness to commit suicide on camera (or in life):

> I'm sorry. I just can't do it Agnès. I'm sorry. I'm not an actress and I wouldn't take pills anyway. [...] I certainly wouldn't kill myself about not being able to make any goddamn movie. As far as I'm concerned, if I never make another movie the rest of my life, it's alright with me. The only thing I really care about is if something awful happens to my daughter Wendy. Anything else is just absolutely—I don't care. [...] I know I said I would, but I just can't. I'm sorry. Not for any Hollywood producers.[32]

This scene, which is a complete rupture of the fourth wall, provides a glimpse of the behind-the-scene dynamic unfolding between the two women directors. Considering Varda's tendency to blur the line between fiction and nonfiction, it is hard to gauge whether this scene is a real documentation or constructed representation. Just like what character Clarke said when she was on her way from the airport to Viva's place: "I don't know the difference between whether I'm in a movie or making a movie, you know. Which comes first: the movie or reality?" Nonetheless, the imaginary conceit retreats in this scene and we witness

Figure 5.1 Director Shirley Clarke, playing herself in *Lions Love ... and Lies* (1969), attempts to act out a suicide scene with a drug overdose upon Varda's request.

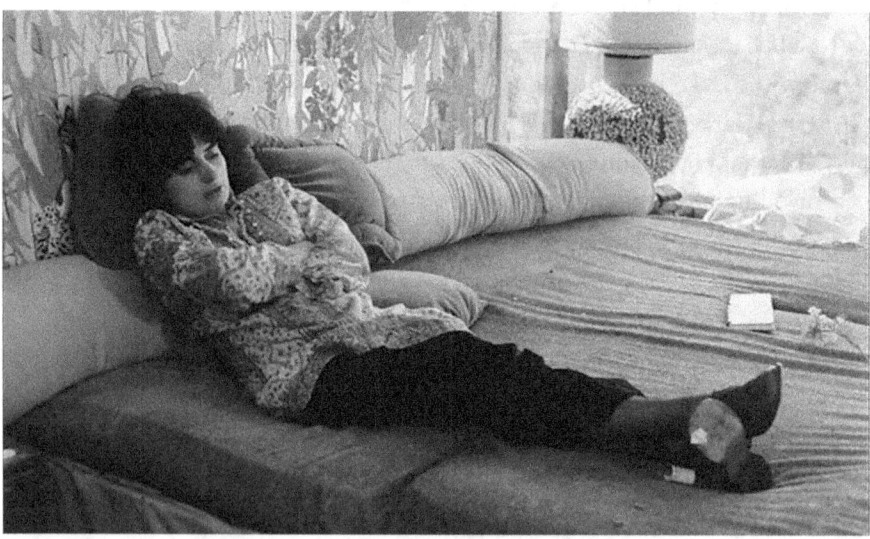

Figure 5.2 Agnès Varda, wearing Clarke's outfit, carries out the same scene, lying on the bed after swallowing an excessive number of pills in *Lions Love ... and Lies* (1969).

their frank conversation about the challenges they face in Hollywood. In a film that is in part about Hollywood's unreality, Varda slips in a brief breakdown that exposes some real emotions and interactions taking place behind the scenes of this movie and probably countless others that women were making

in a stubbornly unaccommodating industry. As Clarke and Varda debate the question, Varda intervenes and temporarily takes over Clarke's on-screen role. The scene evokes the uncanny by unmasking the fictional conceit in favor of portraying the emotional bonds and frictions between these two women. However, in the end, after Varda steps back into the role of director, Clarke, once again, in character, downs the entire bottle of sleeping pills. Such a "detour" is kept as a slippage between the fictional reality on screen and the behind-the-scene exchanges between these two women directors, giving audiences a glimpse into the collaboration between Varda and Clarke. *Lions Love* provides a vision of what a collaborative, transnational feminist praxis could look like in film production, through the un/folding and re/layering of Varda/Clarke's struggles with creative and economic control in Hollywood and elsewhere as two individual women directors were forced to navigate across industries, movements, and groups.

Varda and Clarke came into filmmaking with prior art experiences (photography and dance, respectively) and self-identified as "artist-filmmakers" with creative control of their materials and arts.[33] Yet the harshness of monetary/industrial reality did not allow for such "luxury." In *Lions Love*, character Clarke rehearsed the difficulty of working with Hollywood regarding the size of crew, budget, and values before her meeting with the producers. She boldly stated: "I can tell that they're afraid of me because we're not talking about the same thing." Notably, during the meeting scene, the camera only showed three male producers arguing among themselves. Either Clarke was not allowed in the room, or her marginal position left her literally outside the camera frame. Regardless, the negotiation did not benefit Clarke. Nor did it benefit Varda, who would go on to produce all of her own films after co-producing *Lions Love* with Max Raab, which "didn't go quite so well":

> I want to be paid to do what I do best, which is to write and direct. I tend to hide the fact that I'm out of work by becoming both the employer and (unpaid) employee on the set. After ten, twelve years of such badly disguised unemployment, I have had enough! [...] As a filmmaker, I could say 'Everyone loves me, but no one wants me'![34]

The lack of respect and support from film industries turned Varda into a "virtuoso budget-cruncher" as she sharpened her producing skills.[35] Some have pinpointed the desire for artistic control and independence as the main reasons why Varda could not find financial support, but Littman rebuts such logic by highlighting the paradox in a sexist film industry that makes the very trait for

which Varda was rejected the same trait that was rewarded in her male New Wave contemporaries.[36] While it is commonly acceptable—if not encouraged—for men to demand artistic control yet still attract financing, women directors lacked this privilege and instead looked to adjacent industries for opportunities: public television for Varda and Littman, independent collectives and film schools for Clarke. Women filmmakers deemed radical did not have much chance in less-commercial spaces either. Varda, for instance, stopped being a darling of "state-founded films and liberal productions" once she spoke against social ills.[37] She did not secure funding for many projects; French television refused to broadcast several of her films such as *Black Panthers* (1968) and *Nausicaa* (1970).[38] Varda frankly comments, "with each film I have to fight like a tiger."[39] In other words, French public television joined Hollywood in considering Varda too risky and radical for their financial and political futures.

My reading of *Lions Love* captures Varda's and Clarke's encounters of sexist practices and experiences of rejection, alienation, and compromise against the backdrop of the women's liberation movement. It is an attempt to open up future directions to discuss women's experiences in filmmaking. For Clarke, who had been working with men exclusively and "didn't even know other women filmmakers," *Lions Love* was arguably the turning point for her career.[40] Rabinovitz sees Clarke's social protest cinema in the 1960s as prefeminist in that Clarke "displaces her sense of marginalization and Otherness onto a cinema of expressionistic urban alienation and the physical bodies of social outcasts and misfits—personified by African Americans, homosexuals, and drug addicts."[41] Before she moved to Los Angeles and "became active in women's groups and found out where other women were coming from," Clarke had felt she could only empathize and identify with the problems of other minority groups.[42] That is, she used varying stand-ins for her own feelings and experiences as "an alienated woman who doesn't feel part of the work and who wants in" because she didn't think anyone would be interested in her personal life as a woman.[43] What does it mean for Clarke to be a woman filmmaker after joining the women's movement and collaborating with other women filmmakers? For Varda, what does it mean to be absent from France during the tumultuous year of 1968, and engaging instead with American feminist theories and movements? How did this transnational experience with English-language scholarship on intellectual and militant feminism, "the 'women in the movement', the American radicals, or theorists, then the French women after May 68" inform Varda's later works and career?[44] Though not explored in this essay, these questions linger and call for answers in future writings and discussions.

The microhistory presented as part fact and part fiction in the self-reflexive and collaborative film *Lions Love* offers a slice of Varda's and Clarke's experiences. It presents a contact zone where disparate media industries, cultural movements, and individual experiences meet, clash, and grapple with the sociopolitical upheaval of the late 1960s. Looking back from the twenty-first century, as both Varda and Clarke have received posthumous recognition for their work, it is all the more important not to downplay or erase their lived experiences as talented yet marginalized women directors. Analyzing the convergence of Varda and Clarke in *Lions Love*, an overlooked film in Varda's filmography, foregrounds their experiences of exclusion from the varying industries and movements they inhabited as driven but marginalized artists. In *Lions Love*, Varda continued troubling the fiction-documentary border, allowing the reality of being a woman filmmaker in the male-dominated industry to seep into her fiction.

The collaboration in *Lions Love* also made feminist conversations and personal growth possible. Clarke had previously observed how the heroes in Varda's earlier works had been men, and "her women may or may not be what brings them to their salvation, or whatever."[45] While Varda's participation in the 1972 Bobigny demonstrations was commonly considered as the launching point for her more overtly political feminist engagements, this chapter reminds us that the late 1960s was an important step in Varda's growing understanding of radical movements, feminist theories, and activisms.[46] This was a period of radicalization and growth, which led to her 1970s and 1980s films that centered women with diverse experiences and framed their narratives on feminist interactions. The rocky process that eventually produced *Lions Love* was a collaborative feminist space that allowed for productive conversations, disagreements, and solidarities.

Notes

1. Variety Staff, "Lions Love," *Variety*, December 31, 1968, sec. Film Reviews; Jonathan Hoops, "Lions Love," *Film Quarterly* 23, no. 4 (Summer 1970): 60–1.
2. Agnès Varda, *The Beaches of Agnès (Les Plages d'Agnès)*, Documentary, 2008.
3. Kevin Thomas, "Life Comes First, Films Second for Agnes Varda," *Los Angeles Times*, September 7, 1969: Q63.
4. J. Brandon Colvin, "Explaining Varda's *Lions Love*: A European Director Responds to an American Cultural Marketplace," *Studies in French Cinema* 16, no. 1 (January 2, 2016): 19–31; François Giraud, "Intermediality and Gesture: Idealising the Craft of Filmmaking in Agnès Varda's *Lions Love (… and Lies)*," *Studies in French Cinema* 19, no. 2 (April 3, 2019): 122–34; Marion Schmid, "Painterly Hybridisations," in

Intermedia Dialogues: The French New Wave and the Other Arts (Edinburgh, UK: Edinburgh University Press, 2019), 86–126.

5 Aniko Bodroghkozy, "Reel Revolutionaries: An Examination of Hollywood's Cycle of 1960s Youth Rebellion Films," *Cinema Journal* 41, no. 3 (2002): 38–58; Sasha Archibald, "End of the End of the End: Agnès Varda in Los Angeles," *East of Borneo*, September 15, 2014.

6 The original discursive context refers more to highly asymmetrical relations, like colonialism. Mary Louise Pratt, "Arts of the Contact Zone," *Profession*, 1991, 34.

7 Archibald, Bodroghkozy and Diana Holmes, "Sex, Gender and Auteurism: The French New Wave and Hollywood," in *World Cinema's "Dialogues" with Hollywood*, ed. Paul Cooke (London, UK: Palgrave Macmillan, 2007), 154–71.

8 Caroline Layde, "Jacques Demy: Personal Worlds," *Senses of Cinema*, 2003, http://sensesofcinema.com/2003/great-directors/demy/.

9 Alison Smith, *Agnès Varda* (Manchester, UK: Manchester University Press, 1998), 7–8.

10 Smith, *Agnès Varda*, 7; Agnès Varda, *Varda par Agnès* (*Cahiers* du cinéma, 1994), 13: "Moi j'étais là comme par anomalie, me sentant petite, ignorante, et seule fille parmi les garçons des *Cahiers*." Quoted in Smith, *Agnès Varda* with the English translation in the footnote.

11 Françoise Aude and Jean-Pierre Jeancolas, "Interview with Agnès Varda," in *Agnès Varda: Interviews*, ed. and trans. Thomas Jefferson Kline (Jackson, MS: The University Press of Mississippi, 2014), 117.

12 Smith, *Agnès Varda*, 7.

13 Ibid; Richard John Neupert, "On the New Wave's Left Bank: Alain Resnais and Agnès Varda," in *A History of the French New Wave Cinema* (Madison, WI: University of Wisconsin Press, 2007), 299–354; Dudley Andrew, "On Certain Tendencies of the French Cinema," in *A New History of French Literature*, ed. Denis Hollier (Cambridge, MA Harvard University Press, 1989), 993–1000; Robert Farmer, "Marker, Resnais, Varda: Remembering the Left Bank Group," *Senses of Cinema*, no. 52 (2009).

14 Sandy Flitterman-Lewis, *To Desire Differently: Feminism and the French Cinema* (New York, NY: Columbia University Press, 1996), 262.

15 Ginette Vincendeau, *The Companion to French Cinema* (London, UK: Cassell-BFI, 1996), 110.

16 Fred Turner, *From Counterculture to Cyberculture: Stewart Brand, the Whole Earth Network, and the Rise of Digital Utopianism* (Chicago, IL: University of Chicago Press, 2008).

17 Bodroghkozy, "Reel Revolutionaries," 46.

18 Ibid., 41.

19 Ally Acker, *Reel Women: Pioneers of the Cinema, 1896 to the Present* (New York, NY: Continuum, 1991); Louise Heck-Rabi, *Women Filmmakers: A Critical Reception*

(Metuchen, NJ: Scarecrow Press, 1974); Karyn Kay and Gerald Peary, eds., *Women and the Cinema: A Critical Anthology* (New York, NY: E. P. Dutton, 1977).
20. Maya Montañez Smukler, *Liberating Hollywood: Women Directors & the Feminist Reform of 1970s American Cinema* (New Brunswick, NJ: Rutgers University Press, 2019), 2.
21. Shirley Clarke and Storm de Hirsch, "A Conversation," *Film Culture*, 1968.
22. Smukler, *Liberating Hollywood*, 19.
23. Melinda Ward, "Shirley Clarke: An Interview," in *The American New Wave 1958–1967* (Minneapolis, MN: Walker Art Center, 1982), 18; Lauren Rabinovitz, "Shirley Clarke and the Expansion of American Independent Cinema," in *Points of Resistance: Women, Power & Politics in the New York Avant-Garde Cinema, 1943–71* (Champaign, IL: University of Illinois Press, 2003), 92–149.
24. Film-Makers Coop, "A Brief History," accessed March 26, 2021. http://film-makerscoop.com/brief-history/.
25. Ward, "Shirley Clarke: An Interview," 18.
26. Lauren Rabinovitz, "Choreography of Cinema: An Interview with Shirley Clarke," *Afterimage*, December 1983, 10.
27. Philippe Carcasonne and Jacques Fueschi, "Agnès Varda," in *Agnès Varda: Interviews*, ed. and trans. Thomas Jefferson Kline (Jackson, MS: The University Press of Mississippi, 2014), 102–7.
28. Shirley Clarke, interview at the American Film Institute, 1975, Harold Lloyd Master Sminars, Louis B. Mayer Library, Los Angeles, quoted in Smukler, 21.
29. Joshua Glick, *Los Angeles Documentary and the Production of Public History, 1958-1977* (Berkeley and Los Angeles: University of California Press, 2018), 91.
30. "Lynne Littman," IMDB, n.d., https://www.imdb.com/name/nm0003313/?ref_=tt_ov_dr.
31. Lynne Littman, "Portrait of a Vagabond: An Appreciation of Agnès Varda," *IDA*, 2002, https://www.documentary.org/feature/portrait-vagabond-appreciation-agnès-varda.
32. Agnès Varda, *Lions Love (... And Lies)*, Fiction, 1969.
33. Aude and Jeancolas, "Interview with Agnes Varda," 110.
34. Ibid., 108–9.
35. Littman, "Portrait of a Vagabond."
36. Ibid.
37. Mireille Amiel, "Agnès Varda Talks about the Cinema," in *Agnès Varda: Interviews*, ed. and trans. T. Jefferson Kline (Jackson, MS: The University Press of Mississippi, 2014), 75.
38. Ibid., 76.
39. Barbara Quart, "Agnès Varda: A Conversation," in *Agnès Varda: Interviews*, ed. and trans. T. Jefferson Kline (Jackson, MS: The University Press of Mississippi, 2014), 137.

40　Smukler, *Liberating Hollywood*, 21.
41　Rabinovitz, "Shirley Clarke and the Expansion of American Independent Cinema," 93.
42　Smukler, *Liberating Hollywood*, 21–2.
43　Ibid.
44　Amiel, "Agnes Varda Talks about the Cinema," 72–3.
45　Clarke and de Hirsch, "A Conversation."
46　Varda partook in these demonstrations in Bobigny that protested against the French court's guilty verdict in an abortion case concerning an adolescent girl who was raped and chose to abort. See: Thomas Jefferson Kline, "Introduction," in *Agnès Varda: Interviews*, ed. and trans. T. Jefferson Kline (Jackson, MS: The University Press of Mississippi, 2014), xiii; Amiel, 76.

6

Agnès Varda and Ursula Le Guin in Dialogue: The Narrator's Carrier Bag

Ruken Doğu Erdede

Varda's essay film *Les Glaneurs et la glaneuse* (The Gleaners and I, 2000) documents the lives of people who glean or salvage what others have abandoned or thrown away. Varda takes a tour of France with her digital camera, traveling the streets of Paris and rural communities while collecting objects and images to create a critique of overconsumption that she frames visually through art. The notion of gleaning works as a metaphor for an essay filmmaking practice that weaves collected images together in a way that gives them equal weight. This stands in stark contrast to the classical narrative structure, which assumes a hierarchical relationship between images. The notion of gleaning also subverts anthropological narratives on the origins of human civilization, which assign a primary place to the hunter/killer male at the expense of the gatherer female.

In this respect, the essay film structure in *Glaneurs* responds to Le Guin's essay "The Carrier Bag Theory and Fiction" where she shifts the focus from the lone hero engaged in conquest to the gatherer female who weaves.[1] After outlining the relationship between masculinist, violent narratives of human civilization and the themes and aesthetics of literary fiction Le Guin proposes an alternative, feminist narrative structure through the metaphor of the bag or sack. By connecting Varda's take on gleaning—as subject, theme, and metaphor that designate the film's aesthetic strategy—to Le Guin's proposal to build narrative in the form of a carrier bag, this chapter suggests that the essay film form has the capacity to deploy such structures in the service of feminist and ecological reorganization and re-articulation of film aesthetics.

Le Guin and Varda: Pointing to the Problem

Le Guin suggests that the anthropological narrative of the male hunter/hero frames the core of narrative around killing and conquest, but she observes that this narrative is nearing its expiration date. This is not because the story has lost its appeal, but rather the matrix within which it operates, characterized by the oppression, domination, and expropriation of other humans, animals, and nature is facing extinction since "we've all let ourselves become part of the killer story."[2] With this remark, Le Guin not only engages with ecocritical discourse surrounding human and other biological extinction—a trend that has only accelerated in the new millennium[3]—but she also calls attention to how narratives and artistic forms play a role in "the culture driving from killing."[4] She analyses how stories persistently relate to the arc of the dominant civilization narrative, tracing humankind from its "violent roots" to the contemporary, man-made, ecological disaster.

Tracing the gendered dynamics of this story, Le Guin argues that the archetype of classic narrative comes from the hunting story of the first humans. Men hunt with sticks and spears, fight with nature and animals, and they return home with both a carcass and a story; in this scenario, women and children are passive bystanders, there to receive the spoils of the hunt as well as the hunters' tales. This story sees killing as the fundamental act on which human culture is built, and it regards nature as a field in which to practice violent conquest of other living beings. Le Guin observes that both the content and the form of the male hero's story instrumentalize and desubjectify women, children, and non-human subjects. Just as the story narrates acts of violence, the formal aspects of these stories also exert symbolic violence, like the spears and arrows of hunter-male-heroes, "starting here and going there and THOK! hitting its mark (which drops dead)."[5] These narrated events follow a linear, cause-and-effect relationship that leads itself forward and ends in the direction of the main protagonist's aims. Therefore, human civilization narratives from a masculinist, violent perspective that "[elaborate] upon the use of long, hard objects for sticking, bashing, and killing"[6] have conditioned our imagination to see certain actions as inherently worth telling, and certain methods then become the ideal form for how we tell them. Consequently, the stories and aesthetic forms that thematically or aesthetically maintain this anthropo-, andro-, and hero-centric model contribute to the persistence of cultural forms that destroy the ecosystem.

Against this background, Varda's *Glaneurs* meets Le Guin's essay in its recording of the social and environmental results of this destructive narrative;

that is, the landscapes and lived experiences of a capitalist and consumerist society whose structures exacerbate social injustice and ecological harm. The film demonstrates in fairly stark terms the coexistence of overconsumption and poverty/hunger and presents people putting to use the refuse, waste, and byproducts of rampant consumerism. Varda calls these people "present-day gleaners" and associates them with the impoverished peasants in rural France who collected grain in the fields after the harvest. In the film, she juxtaposes the humble gesture of picking up food from leftover piles with evidence of thoughtless waste: after showing people gleaning edible scraps from open-air food markets in Paris, Varda shows gleaners in the countryside—a homeless man, a single mother, volunteers from a community food bank—picking through tons of potatoes that its growers admit are regularly dumped in fields to rot because they are unsuited for distribution: too big, too small, too misshapen for standardized supermarkets. Varda shows through her interviews how contemporary market logic for this farm-grown produce lacks any consideration for the social and environmental costs of its waste.

While Varda captures and criticizes the destructive aspects of the current socio-economic conditions, she aligns herself with the gleaners: specifically, as a gleaner of images. This not only demonstrates her social conscience as an artist but also underscores how her alternative aesthetic functions as part of her critique of capitalism. In *Glaneurs*, Varda films different subjects and weaves together images in a way that gives each of them equal weight as a part of the collection. There is no linear hierarchy; there is no cause-and-effect, but rather a more systematically inscribed relationship between wasteful practices and their costs to society. This not only rejects the masculinist, conventional, goal-oriented narrative, it also designates the second dialogical point between *Glaneurs* and Le Guin's carrier bag: an alternative, feminist narrative structured like a bag.

The Carrier Bag

Even before Le Guin advanced her proposal for a new narrative structure, anthropologists Sally Slocum and Elizabeth Fisher had observed that alternative stories about the origins of human civilization have been ignored in favor of "giving hunting the primary place in the reconstruction of human evolution."[7] Offering her own alternative, Slocum suggests that the "two earliest and most important cultural inventions were containers to hold the products of gathering, and some sort of sling or net to carry babies."[8] Elaborating on Slocum's argument,

Fisher proposes a name for this recalibration of social priorities: "The Carrier Bag Theory of Evolution" based on women's and children's gathering activities. "I submit women's invention of the carrier bag," Fisher writes, "as the take-off point for the quantum advance which created the multiplier effects that led to humanity,"[9] a theory that centers women's and children's gathering over male hunting. More recent work in anthropology has further developed this stance, which narrates a different origin of human civilization and gives women and children credit for socializing based on mutual aid and cooperation.[10]

Inspired by these arguments, Le Guin suggests that fiction adopt the form of a bag—a tool of gatherers, whose goal is collective sustenance—rather than an arrow, a tool of conquistadors bent on violent domination. Developing the anthropological roots of the idea, Le Guin specifies that a bag-like narrative would gather various objects and events that are cast out from "the killer story," that is, the stuff of daily life creating interactions between beings and things. Bags are open, curved, pliable; they create space while conforming their shape to the items they contain, and the gaps between these items are often as influential as the items themselves. The form of a bag ensures that the interaction of these elements will create a narrative that seeks neither "resolution nor statis but continuing process."[11] The goal is not closure, but continuation; time will not follow "the linear, progressive, Time's killing arrow mode,"[12] but rather develop through recurrence and repetition. Moreover, this narrative form produces no heroes in the classic sense; instead, it involves various subjectivities and more equitable encounters between them.

Viewed through this lens, Varda's designation of gleaning as both subject and strategy of artistic creation makes *Glaneurs* an example in practice of a bag-narrative. Jake Wilson notes how the film follows Le Guin's model, understanding "narrative not as progress towards a goal but as an open-ended gathering of disparate elements."[13] Regarding Varda's takes on the gleaning image and structuring *Glaneurs*, Timothy Corrigan observes that the film has a significant place in history of essay film in inviting "essayistic art and filmmaking [to] become kinds of representational gleaning,"[14] making the film unusually open to structuring itself as a bag. Within this context, I contend that essay film is aesthetically and rhetorically invested with significant potential to resist linear and masculinist narrative structures. Varda's *Glaneurs* offers a prime case study in how successful this approach can be.

The essay film, originated from the same genre in literature, refers to a personal and politically engaged mode of filmmaking that subverts conventions in myriad ways. Drawing on Theodor Adorno's "The Essay as Form" (1958),

Laura Rascaroli argues that essay films are characterized by their "discontinuity" and "juxtaposition."[15] Unlike classical narrative films and more straightforward documentaries, essay films deploy non-linear narrative structures to piece together fragments so that "new meaning is allowed to form."[16] The fragmented temporality in an essay film combines with disparate filmic elements (visuals, sound, speech) that are juxtaposed to reveal novel ideas, emotions, and affects that give space and voice to various subjectivities and posit new, anti-hierarchical interrelationships between them. These aspects of essay films all correspond to the features of a bag-narrative.

Varda's gleaning of images, which are refashioned into an essay film, is akin to Le Guin's self-description as a writer lugging a carrier bag full of material to turn into novels. Yet, looking at both artists, it is not only their practices that resemble one other, but also what they carry in their sacks. Le Guin emphasizes the importance of carving a place for subjects that are cast out from hero stories: women, children, animals, and other earthlings. Similarly, in *Glaneurs*—as in earlier films like *L'Opéra-Mouffe* (Diary of a Pregnant Woman, 1958), *Daguerréotypes* (1976), *Mur Murs* (1981)—Varda's practice focuses on people pushed to the margins of society: the unemployed, the homeless, the immigrants. As Flitterman-Lewis observes, "Varda gives voice to those who have none."[17] In addition to marginalized people, she also features extraneous and misfit objects, like heart-shaped potatoes, a dog wearing a boxing glove on its neck, or "dancing scissors." *Glaneurs* contextualizes its titular subject through bricolage editing, intersperses this main thread with everyday encounters that seem irrelevant to the main subject. However, their placement reveals through juxtaposition with the gleaners new ideas and emotions that create the film's unique signature. Comparing her images to a set of "travel notes,"[18] with a wide range of subjects and events, Varda's video camera turns into a metaphorical travel bag, making sense of the voyage in retrospect and in its fullest possible context.

The film's subversion of linear time is another alternative narrative strategy. Although the film was shot in a specific time period, from September 1999 to May 1, 2000, the fragments are not edited chronologically. The handless clock that Varda found and brought back to her home symbolizes this condition: the numbers are in place, but the timepiece is broken, the mechanism designed to mark the passage of time in objective, uniform intervals is absent. Freeing itself from linear chronology, like the handless clock, *Glaneurs* introduces different kinds of time: "the midnight ritual of dumpster-dividing, the cyclical intervals of the tides, the too-late timing of overripe fruit, the meandering time of a vagabond's walk through fields and the anticipatory time of a painting's

unveiling."[19] In doing so, the film introduces subjective perceptions of time in a manner that refuses time measured by conflict and competition. Rejecting this conventional understanding, where the hero makes the most of the time he has to come out the victor, the film familiarizes different senses of time: fruits and vegetables ripening for harvest, different gleaners wandering the fields or streets in search of cast-off treasures. These moments illustrate the existence and the movements of humans and other earthlings, not heroes.

Varda's anti-masculinist narrative stance was established very early in her career, and is particularly visible in *L'Opéra-Mouffe*. This short film portrays a nonlinear exploration of the thoughts and feelings of a pregnant woman: specifically, Varda herself, who at the time of filming was pregnant with her daughter Rosalie. While also underscoring the physical resemblance of the pregnant female body to a carrier bag, the film's aesthetic similarity with *Glaneurs* points to a particular ecological tendency that runs through Varda's entire filmography. Varda's juxtaposition of fragments in *L'Opéra-Mouffe*—such as a pregnant woman's belly and a pumpkin cut in half, or dissolves from the surface of vegetables to human skin—resemble the metaphorical human/non-human organization of images in *Glaneurs*. And, as in *Glaneurs*, in *L'Opéra-Mouffe* she pulls her subjects from the margins of society: the neighborhood drunks, the impoverished, the children in the street. The common thematic and aesthetic features of both films underline the political character of Varda's films, which offer a feminist and ecological reorganization and re-articulation of film aesthetics.

An Ecological Aesthetics and Politics

In her book *Agnes Varda: Between Film, Photography, and Art*, Rebecca J. DeRoo argues that the political nature of Varda's films has been overlooked: "Across her career, Varda inserted politics and social commentary covertly, by orchestrating a range of tacit visual references not explicitly acknowledged in her films' narratives."[20] DeRoo's remark invites a reconsideration of the relationship between aesthetics and politics. Politics, as Bauman understands it, consists in politicizing the actual society with a view to explicating its possibilities.[21] In this context, the aesthetic is the matrix within which new sensual experiences of stories about alternative worlds can be formed.[22] As the killer story is nearing its expiration, Le Guin calls for an alternative story "which maybe people can go on with when the old one's finished."[23] So as to rationalize alternative ways of

interrelatedness between humans and the world, she suggests resorting to art and aesthetics. Hence, the aesthetic creations of new ideas and sensual experiences can activate politics for an alternative lifeworld.

In *Glaneurs,* Varda's aesthetic and political engagements align with Le Guin's perspective by using film aesthetics to criticize contemporary politics from a feminist and an ecological standpoint. Timothy Morton describes ecology as a phenomenon that "includes all the ways we imagine how we live together. Ecology is profoundly about coexistence" that weaves a complicated net of relationships between humans as well as "other beings—animal, vegetable, or mineral."[24] Significant in this regard, humans' awareness of their connection with other beings unsettles conventional categories of subjectivities. Ecological thinking requires us to be self-reflexive about ourselves and the others, possibly causing an uncanny affect, "as if we were caught in something."[25] A self-reflexive scrutiny into ourselves leads us to an unsettling realization of our similarities and differences with "strange" others. Based on this understanding of ecology, Le Guin's call for an alternative narrative is in fact a proposition for an ecological aesthetics. Demolishing the hero's pedestal and, instead, setting humans and other earthlings alongside one another in a non-hierarchical narrative would run counter to conventional formulae, but it would allow for novel and more equitable encounters between beings.

What ideas and affects might emerge once we turn away from the male hero story and imagine this kind of encounter instead? The essay film offers a viable form for such a narrative, and Varda's *Glaneurs* presents us a compelling and prominent example of this alternative form. There is a remarkable sequence that registers this departure from heroic storytelling: it starts with a close-up of figs and ends with a close-up of Varda's aging hands. After listening to gleaners who salvage food for survival, Varda visits groves and vineyards where gleaning is forbidden. She notices that many fruits are left to rot. After picking a few figs from the branch and tasting their "heaven like taste," she says, "They don't allow the gleaners because they do not want to be nice." With the taste of figs on her palate and the awareness that people in need will not enjoy this taste, Varda begins to capture/glean images of these fruits and vegetables before they completely rot away. A close-up on overripe figs cuts to rotten cabbages left in the field, then to a close-up on cabbages under a purplish light. The camera slowly glides through the leaves of cabbages, and under the eerily colored light, the veins of the leaves take on a striking appearance. Then the film cuts to close-ups of different plants, gliding on their surfaces, showing details that appear both strange and familiar at the same time. With the veins, holes, and color

differences on their leaves and bodies, they seem as if they are more alive. The difficulty and necessity of the gleaners' access to these plants combined with these close-up shots invite us to see the other, in this case plants, with new eyes.

This renewed approach to looking continues in the fragments that follow, when Varda arrives home and notices some subtle changes. One is a patch of mold growing on the ceiling due to a water leak. Varda appreciates its aesthetic form, comparing it to "a landscape or an abstract painting," then cuts to close-ups of mold in the ceiling, framing them with gilded frames. Varda associates these images to the paintings of Tàpies, Cai Guo-Qiang, and Borderie, then she looks at postcards featuring close-up details of Rembrandt's paintings. She puts her hand on the postcards and says: "Now, it is my hands' turn in close-up." As she glides the camera over her hand's skin, she explains that her project in *Glaneurs* is "to film with one hand my other hand. To enter into the horror of it. I find it extraordinary. I feel as if I am an animal, worse, I am an animal that I do not know." Varda's comment on the extreme close-up of her skin indicates a moment of seeing oneself from another point of view. As Varda's gaze gets closer to her own skin, her subjectivity as a human starts to blur. Thus, the film repeats the close-up technique three times, in a way that introduces animate and inanimate subjects in the sequence mentioned above: the plants, the mold, and lastly Varda's hand. This aesthetic rhetoric establishes a metonymic relationship between these fragments, and invites us to look at the other and oneself with new, defamiliarizing eyes. In doing so, the plants' textures recall the skin of other beings; the tissue of mold brings to mind abstract paintings; and Varda's skin is compared to both the plants' veins and the mold's tissue in a way that reveals unfamiliar aspects of existence.

Juxtaposing different surfaces to create metaphorical connections also happens in *L'Opéra-Mouffe*. The cut between a pregnant woman's belly to a pumpkin being cut into half registers this kind of uncanny interrelation in comparing a woman to a pumpkin, and her unborn child to pumpkin seeds. Such visual metaphors encourage an ecological and feminist understanding; furthermore, like *Glaneurs*, this film also deals with socio-economic problems, although with a comparatively limited scope. The socio-economic focus sharpens in *Glaneurs* to articulate exploitative social and economic relationships that exacerbate injustice in Paris and rural France. This is in line with Gwyn Kirk's arguments about the overlapping aspects of capitalism and patriarchy in framing "otherness" to "[oppress] both women and nature, but also people of color and poor people worldwide."[26] Kirk and other feminist scholars and activists—including Silvia Federici, Nancy Fraser, Greta Gaard, Johanna Oksala,

and many others—propose a path for action that accounts for this cross-cutting, destructive impact of capitalism across multiple social categories, combining feminist and ecological struggles against capitalism for a more just world.

Both Le Guin and Varda are concerned with how narratives can either reinforce or resist this multi-layered, systematic oppression. While Le Guin's mind is on how the "male hero killer story" has permeated prose fiction, Varda's work in nonfiction film shows that the carrier bag metaphor can also shape how we understand and narrate the lived experience. Her aesthetic strategy and thematic focus forge a political path that shows a way out from the current man-made disaster. The final sequence of *Glaneurs* conveys this new path in a clear, memorable way with a touch of a Vardian joy. She introduces us to a man collecting leftovers from the marketplace. He holds a graduate degree in biology, yet sells papers and magazines to make money. He lives in a shelter where the majority of the residents are African immigrants and teaches them to read and write voluntarily at night. "Meeting that man," Varda states, "is what impressed me the most. And the time it took to find out about his nocturnal and voluntary activity in a suburban basement." From this contemporary Parisian gleaner, the film cuts to the basement of the Museum of Villefranche as two women bring out the nineteenth-century painting by Hedouin, "Gleaners Fleeing from the Storm." Varda calls this moment the second highpoint. They carry the painting outside for Varda to film it in daylight. Suddenly, the wind starts to blow, making it seem as though the gleaners in the painting are fleeing from the storm in real time, as if the painting had dissolved to bring the scene to life. The boundaries between life and representation, and the past and the present begin to blur. Hence, another sequence where we see art making room for chance, and how everyday encounters evoke novel ideas and affects.

By relating these two seemingly disparate moments as the highlights of the film, Varda evokes a spirit of solidarity and connection that transcends temporal and spatial boundaries as well as the boundaries of representation. She presents the urban gleaner and the immigrants' teacher as heirs to the peasant women who collect the leftovers of the harvest to meet their families' needs. *Glaneurs* registers the rooted oppression that produces social injustice. While at the same time, however, it acknowledges the fact that the ways in which we account for this injustice has changed over time. In valorizing the victims of this injustice, the film rejects stories that would justify or excuse its persistence. Instead, alternative stories emerge from intersections outside of linear time and hierarchical relationships to make unexpected connections such as plants that look like human skin, mold framed as art, and Varda's own skin that makes her

feel like an animal. This new gaze, though it may be as brutal as it is insightful, pushes us to see and imagine outside of conventions.

"It is the story that makes a difference," says Le Guin.[27] While the "killer story" has framed the narratives on the origin of human civilization, an alternative narrative may potentially change the course of history. Le Guin's proposal of an alternative, feminist narrative through the metaphor of the carrier bag—and how Varda's oeuvre of non-fiction films, especially *Glaneurs*, corresponds to Le Guin's perspective—invites us to revisit the interrelatedness of aesthetics and politics. The artistic dialogue between Varda and Le Guin may be a starting point for alternative narratives that produce and organize our knowledge about ourselves and others. Their wise and joyful artistic practices highlight the importance of everyday encounters, beginnings, and becoming; weaving together a matrix where variable stories, subjectivities and forms can occur. *Glaneurs* is a benchmark of an anti-capitalist, ecological and feminist reorganization and re-articulation of aesthetic experience. Now that the old, "killer story" is coming to an end, this aesthetic vision may serve as an engine for reorganizing politics, economics, and culture for a just life, shared with others.

Notes

1. Ursula K. Le Guin, "The Carrier Bag Theory of Fiction," in *Dancing at The Edge of The World*, ed. Ursula K. Le Guin (New York: Grove Press, 1989), 168.
2. Ibid., 171.
3. See, for example, the Extinction Studies Working Group http://extinctionstudies.org/about/ and *The Journal of Ecocriticism* https://ojs.unbc.ca/index.php/joe/index.
4. Le Guin, "The Carrier Bag Theory of Fiction," 170.
5. Ibid., 169.
6. Ibid.
7. Sally Slocum, "Woman the Gatherer: Male Bias in Anthropology," in *Toward an Anthropology of Women*, ed. Rayna R. Reiter (New York: Monthly Review Press, 1975), 43.
8. Ibid., 45.
9. Elizabeth Fisher, *Woman's Creation: Sexual Evolution and The Shaping of Society* (New York: McGraw-Hill, 1980), 56.
10. J. M. Adovasio, Olga Soffer and Jake Page, *The Invisible Sex Uncovering: The Roles of Women in Prehistory* (New York: Routledge, 2016), 3. In this study writers support the theory of Slocum and Fisher. They observe that "female humans have been the chief engine in the unprecedentedly high level of human sociability, were the

inventors of the most useful of tools (called the String Revolution), have shared equally in the provision of food for human societies, almost certainly drove the human invention of language, and were the ones who created agriculture," 3.

11 Ursula K. Le Guin, "The Carrier Bag Theory of Fiction," in *Dancing at The Edge of The World*, ed. Ursula K. Le Guin (New York: Grove Press, 1989), 170.
12 Ibid., 170.
13 Jake Wilson, "Trash and Treasure: The Gleaners and I," *Senses of Cinema*, December, 2002, https://www.sensesofcinema.com/2002/feature-articles/gleaners/.
14 Timothy Corrigan, *The Essay Film: From Montaigne, After Marker* (New York: Oxford University Press, 2011), 71.
15 Laura Rascaroli, *How The Essay Film Thinks* (New York: Oxford University Press, 2017), 26.
16 Ibid., 32.
17 Sandy Flitterman-Lewis, "Varda: The Gleaner and the Just," in *Situating the Feminist Gaze and Spectatorship in Postwar Cinema*, ed. Marcelline Block (New Castle: Cambridge Scholars Publishing, 2008), 219.
18 Agnes Varda, *The Gleaners and I* press kit (Zeitgeist Film Release, 2001).
19 Homay King, "Matter, Time and Digital: Varda's The Gleaners and I," *Quarterly Review of Film and Video* 24 (2007): 425. https://doi.org/10.1080/10509200500536322.
20 Rebecca J. DeRoo, *Agnes Varda between Film, Photography, and Art* (Berkeley: University of California Press, 2017), 6.
21 Zygmunt Bauman, *In Search of Politics* (Cambridge: Polity Press, 1999).
22 Jacques Rancière, *The Politics of Aesthetics* (London: Bloomsbury Academic, 2013).
23 Le Guin, "The Carrier Bag Theory of Fiction," 171.
24 Timothy Morton, *Ecology without Nature: Rethinking Environmental Aesthetics* (Cambridge, Massachusetts: Harvard University Press, 2009), 4, 8.
25 Ibid., 25.
26 Gwyn Kirk, "Standing on Solid Ground: A Materialist Ecological Feminism," in *Materialist Feminism: A Reader in Class, Difference, and Women's Lives*, ed. Rosemary Hennessy and Chyrs Ingraham (New York: Routledge, 1997), 349.
27 Ursula K. Le Guin, "The Carrier Bag Theory of Fiction," in *Dancing at The Edge of The World*, ed. Ursula K. Le Guin (New York: Grove Press, 1989), 171.

Part Three

Environments

7

Passion, Commitment, Compassion: *Les Justes au Panthéon* by Agnès Varda

Sandy Flitterman-Lewis

Somewhere in Chapter 3 of *Les Plages d'Agnès* (The Beaches of Agnès, 2008), Agnès Varda's autobiographical celebration of her eighty years, she discusses her childhood and early youth in the port town of Sète. The sequence is redolent with Varda's characteristic blend of personal revelation and social observation, something that defines her unique experimental voice. But this sequence is far from the typical nostalgic reverie that we encounter in so many autobiographical works. Embedded within the account of the family's move to Sète during the great exodus of the Second World War—a collection of sunny images of houseboat life and joyful games (plus the typical Vardian ironic shock shot of a man exposing himself)—is a sequence in which Varda describes, in detail, her 2007 installation at the Pantheon in the heart of Paris. Commissioned to commemorate the placement in the Pantheon's crypt of a plaque honoring the many "Righteous" who saved Jewish children during the War, it was part of the inaugural ceremonies attended by survivors and scholars of the Shoah and dignitaries from around the world, as well as the general public. The honorees, by now mostly deceased, were the 2,600 French individuals, some known and many anonymous, who made it possible that three-fourths of the Jewish population survived the French variant of the Shoah, which saw the deportation of 76,000 Jews to Auschwitz and other extermination camps. For sixty years these rescuers remained invisible until President Jacques Chirac made the decision to honor them in the marble crypt alongside martyred resistance leader Jean Moulin. He asked Agnès Varda (whose relation to the tragedy was somewhat limited as a fourteen-year-old girl who didn't personally know many, if any Jews) to create an installation for the dedication ceremony. Her dazzling solution is a breathtaking combination of historical recognition and minutely detailed, intensely personal fictive vignettes, which inscribe a distinctive female voice and sensibility in this institutional hall celebrating great men (Figure 7.1).

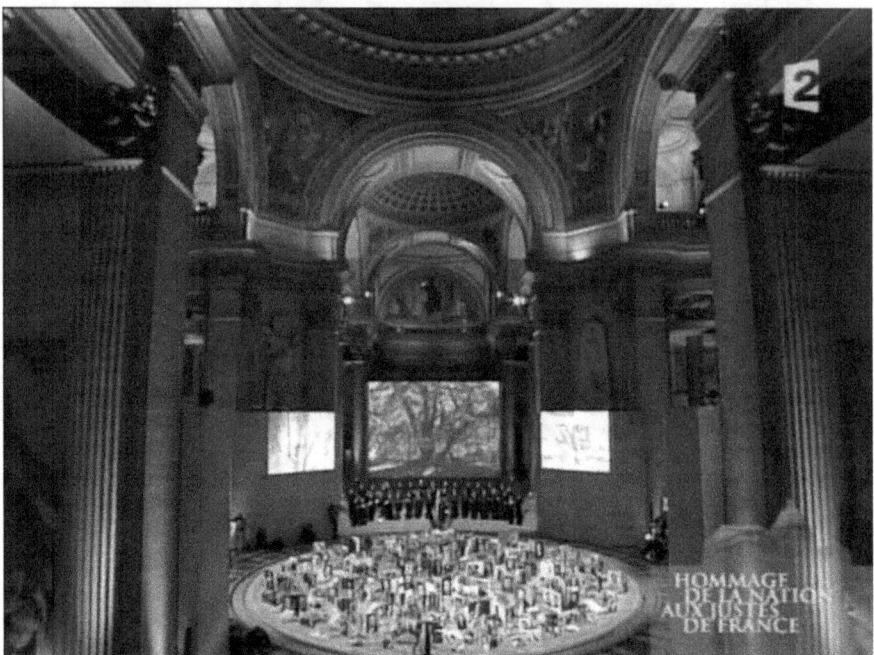

Figure 7.1 Television channel France 2 shows the interior of the Pantheon as Varda's installation of film and artifacts honor *les Justes* (the Righteous) with an arrangement that makes full use of the ceremonial and patriotically inflected space. Footage included in *Agnès Varda: L'intégrale* box set (Ciné-Tamaris, 2019).

While the installation was intended to last one weekend in January, the lines outside of the Pantheon after the official opening led to an extension of two more weeks, and Varda later reproduced a version of the installation for the Festival d'Avignon in July of 2007. As all installations are fleeting, lacking extensive documentation and existing for a finite period of time, it is very difficult to grasp their process and reception. In fact, in the third phase of her six- and-a-half-decade career, Varda embraced this form for its spectatorial freedom, its liberated possibilities of invention, and its radical reformulation of the cinematic experience. For *Les Justes au Panthéon* (The Righteous at the Pantheon, 2007) Varda displayed photos of the rescuers and some of their fictional counterparts on the floor of the Pantheon. Surrounding them, a ten-minute film loop of fictive scenes of rescue was projected on four screens: two in color, and two in the black-and-white newsreel style of the Second World War era. As she describes it, she wanted to create an evocative, fragmented, historical, and subjective vision: "Memories, faces, landscapes, feelings. Yesterday, and today as well."[1] In the

program for the ceremony she adds, "While they are watching this double film on separate screens, I wanted [the visitors to the Pantheon] to experience many fragmented feelings, bits of emotion linked both to History and to certain key images of our collective memories."[2]

For a long time one could only access this short film through an Internet search. Then it was finally made available in Varda's 2017 *Toute Varda* box set, placed among an eclectic collection of surprise features that also includes a recipe for *chard au gratin* and a 35 millimeter strip from one of her films, *Les cent et une nuits de Simon Cinéma* (A Hundred and One Nights, 1995), a comprehensive and joyful survey of cinematic history. Whereas the installation itself is elusive, Varda offers an ingenious solution in *The Beaches of Agnès*: she embeds the installation and her creative process within an account of personal memory in her autobiographical film. By manipulating temporalities and making the installation part of her own subjective and creative history, Varda invents a way to personalize the historical and to immortalize the ephemeral.

In keeping with Varda's taste for proliferating forms, *The Beaches of Agnès* was soon accompanied by an illustrated text. This book is in the collage mode that Varda loves: references and associations are encouraged since they go beyond the fixity of the cinematic form. The complete text of Varda's ubiquitous voice-over is reproduced along with a relatively random selection of images from the visual track, virtually detached from their predetermined and immutable relation to the soundtrack, in favor of what co-editors Freddy Denaës and Gaël Teicher call "narrative importance or visual force."[3] In suggesting readings that ebb and flow like the tides that are the central metaphor of *Beaches*, they aim to

> respect the fluidity of the text, with no indication of the place or person who speaks [in conversation with Varda], leaving the spectator/reader the liberty to zigzag between the words and visual indices, in order to reconstruct one's own memory of the film, between the simple pleasure rendered by the text of a writer and that offered by the film by the same Agnès Varda, cineaste.[4]

This perfect interaction of image and text with spectatorial pleasure and imagination is part of the Vardian *ars poetica* and, as such, profoundly illustrates the intention and practice of her installation in the Pantheon. The created environment of the installation, embedded in the film and mirrored in the book, thus reverberates with simultaneous visions and sensations, allowing the individual subjectivity of the viewer/reader to merge with a felt sense of history.

In this mode, Varda addresses her historic work, her work of history, from the standpoint of personal engagement. This section of the book and the film

are titled "Plages de Sète" (Beaches of Sète). This section matches text with four photogrammes of Varda walking backward on the beach (and literalizing the cinematic effort to evoke her childhood). She begins with a precise memory: "In school we had two obligations: to wear the blue-checked Vichy pinafores and to sing praises for old Marshal Pétain." The girls sing, their song resonant with the spirit of the period, "Maréchal, nous voilà," evoking the triad "Travail, Famille, Patrie" that replaced "Liberté, Égalité, Fraternité" in Vichy France. More wartime memories, which lead to a short recollection of camping with the Girl Scouts, and the realization, years later, that some of the girls were led to freedom in Switzerland because, unbeknownst to Varda at the time, they were Jewish.[5] This then allows Varda to turn, appropriately, to the installation that she created in the Pantheon.

> Fifty years later I made a short film on the horror that was inflicted on the Jews and also on those named the Righteous, because they saved thousands of children. They were peasants, pastors, and priests, school principals, and ordinary folks ... I placed their photographs and those of anonymous others on the Pantheon's floor below several screens. Viewers saw the vile spectacle of French gendarmes arresting Jewish children, forcing them toward the extermination camps. To speak of it and to film it, even in fiction, makes me shudder.[6]

The book's editors have chosen three images taken from the ten-minute loop to illustrate these words. Each medium close-up depicts a kepi-wearing gendarme arresting Jews. On the next page are photos of two of the actual "Righteous" selected from the many photos Varda had chosen from the Musée-Mémorial de la Shoah's archives and elsewhere—portraits of Jean Kroutz and Jeanne Vallat. Finally, a full-page image of the installation in its entirety, including one of the images of arrest on the giant screen, emphasizes the singularity of the armed state against the vast and populous throng of ordinary French rescuers (yesterday) and of viewers (today).[7] Still, the flow of the film itself is more comprehensive, for it is with the actual screening of *Beaches* that the historic impact of the installation is strongest. In the program for the Pantheon ceremony, Varda chooses her words with precision: "Three hundred archival photographs, posed on the floor like open books; two films on four screens, in the style of Occupation newsreels or fictional and fleeting vignettes, and a large tree projected on a screen at the back of the nave."[8] Varda's characteristic interest in dialectics creates what she calls a "double-récit"[9] the Righteous and the children, photo-portraits and cinema, vibrant nature and solid marble (Figure 7.2). The same precision is shown in the images she chooses (from the abundance in the installation's film loops) to accompany her description in *Beaches*, where page numbers no longer pose a limit.

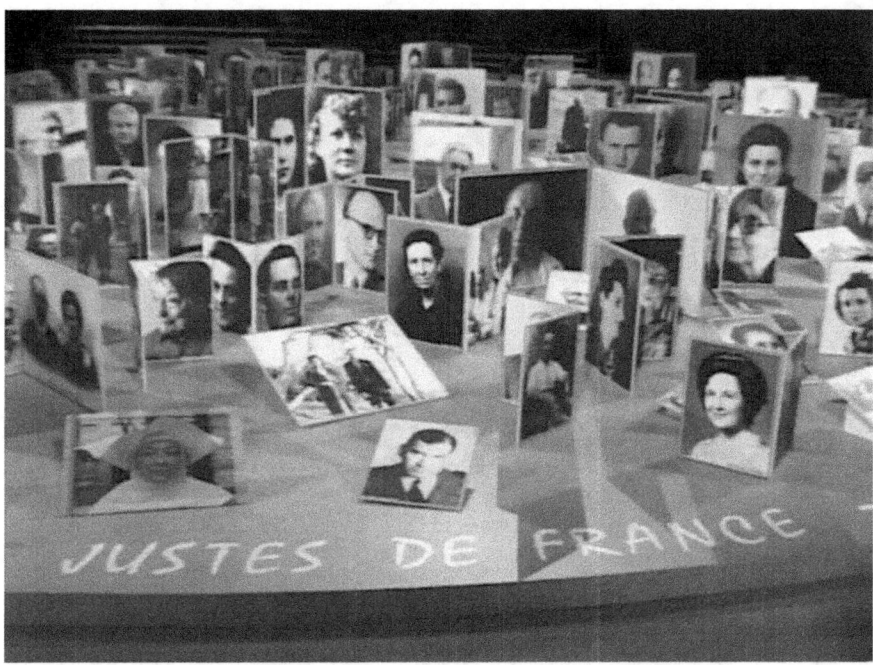

Figure 7.2 Detail of selected historical artifacts and photographs on display at Varda's commemorative installation *Les Justes au Panthéon* (The Righteous in the Pantheon, 2007). Included in *Agnès Varda: L'intégrale* box set (Ciné-Tamaris, 2019).

The transition from recollection to installation is achieved with the sudden and stunning appearance of the most recognized symbol of the Shoah in France: the yellow felt star inscribed with the word *Juif* (Figure 7.3). Offered in close-up alongside a pair of tailor's scissors while patient hands sew stitches, this symbol of the process of social exclusion, normalized isolation, and eventual deportation of Jews under the Occupation is our entry into the world of the Righteous and Varda's composition. The yellow star, imposed by the Decree of 29 May 1942, required all Jews over the age of six to visibly declare their difference from the so-called authentic French population. In Varda's cinematic artistry it signals both the world of personal memory that spans decades, from youthful insouciance to artistic intervention, and the imperative of public recognition that the installation represents. For *Les Justes* in the Pantheon, the star appears early on in the film loop, an abrupt and vivid transition from the familiar black and white newsreel footage of Nazis under the Arc de Triomphe, swastika-adorned buildings, and, significantly, a phone booth with the admonition *Accès interdit aux Juifs*. The Magen David belongs to a series of what Varda calls "key images," images whose iconic significance telegraphs a collective meaning: a tree

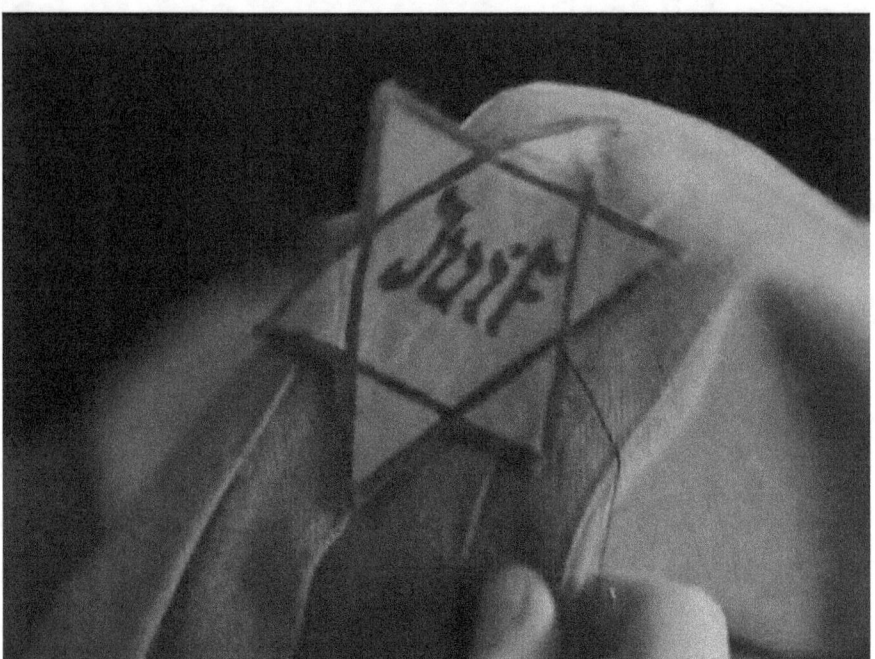

Figure 7.3 A close-up on a yellow Star of David being affixed to a piece of clothing, part of the film loop projected in *Les Justes au Panthéon*. Included in *Agnès Varda: L'intégrale* box set (Ciné-Tamaris, 2019).

whose burst of red leaves suggests the Burning Bush, a stamp on an identity card marking *Juif*, a false baptismal certificate, a suitcase, a basket of food, a child's blanket, and so forth. There is also a wordless sound collage of familiar noises, such as shouts, train whistles, typewriter clacking, farm animals, and in one scene, a Yiddish lullaby. After a brief discussion of the historical background, I will return to a description of the installation itself.

Passion

Agnès Varda has always been one to explore and document the diverse lives and social realities of those whose experience differs from hers. With curiosity as her lodestar, she transforms the investigative gaze, and even the gendered gaze, into a compassionate engagement with the Other. Varda's interest in people (the fishermen of Sète, the merchants on her street), in politics (Black Panthers, Cuba, women's rights), in different social contracts (bourgeois marriage, popular

muralist groups, scavengers), and always in children and families of all kinds has informed every part of her oeuvre from photography to film to installation art. And although there is a constant sociological refrain, her films are far from the traditional inquiries of sociology. In fact, the perpetual movement from the publicly factual to the subjective and intimate, the border between them continually contested, is something that defines her art. In the Pantheon, this blending becomes the key to the power of the installation, for here, Varda's passion for a history that is in one way not her own becomes a shared passion for collective history and its contemporary ramifications.

That *Les Justes* focuses on Jewish children and their rescuers is not an arbitrary choice. What has come to be known as the "War Against Children" in Occupied France literally began on 16–17 July 1942, a date that has been called the "hinge" of the Occupation for its status as turning point in both the persecution and rescue of Jews. The roundup of entire Jewish families—for the first time—led to the widespread phenomenon of "hidden children" and the many forms of heroic rescue that worked in the shadows and on the margins of the established lines of resistance. Their recognition was only gradual; it can be said to have culminated in the 2007 ceremony in the Pantheon where Varda's installation celebrated, in an unexpected and enduring way, those people hidden from history. The Vel' d'Hiv, the name given by historians to the sudden but systematically prepared roundup of Jewish men, women, and children by French police, is shorthand for the Vélodrome d'Hiver, the glass-domed winter cycling stadium where over 1,400 Jews were held for a week without food or water before being deported to their deaths in the east. Previously only "suspect" foreign Jewish men were sought for deportation, so the unexpected arrest of women and children, two-thirds of the detainees, put Jewish children in particular in immediate danger. Weeks passed while French and German officials discussed what to do with the children once the parents were deported. This "bartered brood" became the singular endangered population, such that when the arrested children finally followed their parents, from whom they had been separated in the holding camps, all Jewish children in the general French population were placed in danger. At the same time, networks for rescuing Jewish children were organized, clandestine safe houses were formed, and relays of escape and underground flight were mapped out. Thus, given Varda's traditional concerns, it is no surprise that her installation honoring the thousands of French rescuers would also emphasize the relations between these heroes and their juvenile charges. In her hands, the celebration of the Righteous becomes the honoring of Jewish memory at the same time; while most of the rescuers are very old or

no longer alive, the children that were saved are living memorials to the human capacity for goodness and ethical behavior.

Figure 7.4 For *Les Justes au Panthéon*, Varda filmed actors reenacting specific, documented acts of heroism, framing these shots especially from the children's perspective. These scenes were projected in four loops on screens suspended around the nave of the Pantheon as part of the installation. Included in *Agnès Varda: L'intégrale* box set (Ciné-Tamaris, 2019).

Commitment

Varda's commitment to make the stories of the Righteous palpable, to combine the images of real people with those in her fictions, and to evoke the silences of the hidden children themselves materialized in a set of ingenious solutions to the problem of historic memory. In order to honor the rescuers in her installation, she populated the floor of the Pantheon with their portraits, some in black and white (real rescuers), some in color (their fictive counterparts), creating a sort of carpet of righteousness through which the viewer/participants could wander. She conceived of her installation as an invitation to meditate and to contemplate,

along the lines of her praise of artist Christian Boltanski, whose installations Varda said made her feel like "walking through the work instead of standing before it like a picture."[10] In addition to the floor of portraits, as noted, Varda created four film loops (two in black and white, two in color), the former taking on the status of historical documents while the latter was comprised of vignettes of rescue capable of being perceived instantaneously by a casual, intermittent glance. There is a logic to these distinctly different loops, the black and white providing the distanced documentary vision of objective history, while the color images render in close-up the subjective detail of personal experience. The effect is similar to Varda's very first feature film, *La Pointe Courte* (1954), which pairs documentary footage of the fishermen of Sète with a fictional couple's marital concerns, as the viewer moves back and forth between the stories. Here, as Varda intends, the viewer moves from the distanced observation of historical record to the more intimate detail of personal memory. In thirteen momentary anecdotes we find (1) a little boy hidden under the protective sleeve of a nun as a Jewish tailor and his family are herded into a police van; (2) a young mother with a suitcase who leaves her two small children at a house in the countryside of the "Zone Libre"; (3) a baptismal certificate signed by a priest; (4) two young Jewish women chatting while a man registers as a Jew at the City Hall; (5) two children shaking apples from a tree while they silently indicate *no* to some inquiring gendarmes; (6) the passage of baskets filled with food in the mountains, a detail in close-up; (7) a little girl given to the protective arms of a peasant woman; (8) children playing in a huge tree in the country as a Yiddish song wafts from their perch; (9) adults talking in front of a church while a man gets on his bicycle with a mission of warning; (10) the travel from village to farm by the man on his bicycle; (11) children on a playground being told in a whisper to hide; (12) children at an outside farm table being rushed into a hayloft to hide; (13) the arrival of the Gestapo, the capture and deportation of two trapped children being marched to a waiting car, and the arrest of their protectors. Each episode ends with a photograph and name of one or two of the Righteous, as the color portrait of each fictional counterpart fades. And yet, it is undeniably the story of Jewish children that Varda tells, finding a way to create, within the prescribed ceremonial honoring the Righteous, a sense of the haunted reality of these children whose experience has been historically erased. The double register—fiction/actuality, French rescuers/Jewish children—a hallmark of Varda's artistic practice, is most evident in the way that she approaches the plight of the children, in an oblique movement that changes them from abstractions to living beings. These actors are no longer characters, but they are attitudes, gestures, and ideas

concretized in the space of an instant, telling the double story of the rescuers and the rescued. Varda explains: "I wanted to tell this story with a certain naturalness, making the viewer feel the childhood of these little ones, their loneliness, the omnipresent fear, but also the discovery of the countryside."[11]

Compassion

I have noted elsewhere that Varda's *Les Justes* conveys an overwhelming presence of "empathetic reciprocity," the recognition of a common network of caring relations that holds us all together.[12] The varied filmed vignettes are exquisite, emblematic gems of hiding and rescue, each radiating compassion in a different circumstance. Within the grandeur of the majestic hall, the installation celebrates intimate, individual acts of loving kindness.[13] Varda's work, in each one of her self-identified phases as photographer, cineaste, and visual artist, foregrounds a relational aesthetic that embraces artist, viewer, and subject in a social bond born of a compassionate commitment to humanity. "Nothing is banal if you film with empathy and love," declares the cineaste in her final film, *Varda par Agnès* (Varda by Agnès, 2019), and, in retrospect, this underlines the contemporary imperative for moral action evoked by her installation in the Pantheon.

And interestingly, our return to the very site of the dedication ceremony delivers an unexpected sisterhood, for among the attendees were two exact contemporaries of Agnès, Simone Veil and Marceline Loridan-Ivens, two Jewish women, each with a specific and moving story about her teenage experience of the War. These three French women of profound humanistic conviction, all aged fourteen at the time, joined in honoring people of conscience who had been hidden from public recognition for decades. It could be said that an accident of fate dictated their reunion, ten years before Veil's death, eleven years before Marceline's, and seven and a half decades after the event that inevitably binds them: the Shoah. Feminist icon Simone Veil (neé Jacob), a Holocaust survivor, created the Fondation pour la mémoire de la Shoah and was its first president. When she was Minister of Health, she agitated to legalize contraception and abortion in France, the final law was named "la loi Veil" in her honor. When she was ceremoniously buried in the Pantheon with her husband in 2018, thousands of people attended in the sweltering heat. Her Auschwitz number was prominently displayed in the ceremony and in the crypt.

Marceline Loridan-Ivens (neé Rozenberg), that diminutive ball of energy with a wild halo of red hair, is increasingly recognized as one of the most prolific

witnesses of the Shoah, having been a prisoner in her teenage years and filming and writing about her experience of familial losses literally up until the day of her death. Her public life is framed, start (*Chronicle of a Summer* [*Chronique d'un été (Paris 1960)*, dir. Edgar Morin and Jean Rouch, France, 1961]) to finish (her 2018 novel *L'amour après*, cowritten with Judith Perrignon) by the intimate, searing memory of loss, a yearning to survive, and a commitment to remember. After her husband, documentarist Joris Ivens, died in 1989, Loridan made her first and only fiction feature at age seventy-five, *The Birch-Tree Meadow* (*La petite prairie aux bouleaux*, 2003). The film takes its name from the translation of Birkenau, the concentration camp where Loridan was imprisoned and where her father was murdered. At the time of Simone Veil's induction into the "hall of great men," Loridan said, "I felt like all the girls of Birkenau entered the Pantheon."[14]

Finally, it turns out that after Veil's death, a short video was circulated that had Simone and Marceline sitting on a bed, characteristically laughing and reminiscing about their time together as teenagers in Auschwitz-Birkenau. This is a visual reminder of Marceline's wild sense of humor that not only helped others to survive, but also survived the war itself. Agnès Varda documented and commemorated the reality that they, as Jewish children, lived. Each of them (Varda in the manner of Beate Klarsfeld) has left us a legacy of feminine solidarity, social commitment, and boundless compassion.

The Red Kitchen, the Atelier, and the Courtyard

From the joyful solidarity of *One Sings, the Other Doesn't* (*L'une chante, l'autre pas*, 1977), with its celebration of female friendship and positive social action, to the mature recognition of the sanctity of memory and the profound understanding of women's historical power evoked by *Les Justes*, Agnès Varda has been the heartbeat of a dedicated feminism that transcends the particularity of specific films and situations. For her valedictory film she came up with her own triad of guiding principles: "inspiration," "création," "partage" (sharing). She speaks of the trio in detail in *Varda by Agnès*, where she outlines her artistic procedure for "exciting the creativity of each person ... [her] privilege as a director."[15] First, there is the raw material, the starting point, images and ideas gleaned from an eclectic and varied life. Then, there is the artistic process, the making of the finished work, a construction molded out of knowledge and dreams. Finally, there is—most importantly—sharing, the ability to give that work to others and to start a conversation, the desire of the spectator and the artist's pleasure

as well.¹⁶ Thus, it was with a particular sense of joy that I realized that there was a correspondence between Varda's trio of watchwords and mine. Varda's inspiration matched my idea of passion; her creation evoked my idea of artistic commitment; and her sharing involved my idea of compassion. An invisible affinity, something I have felt about Agnès for years, materialized for me in the writing of this essay. And so I invoke the rubric of this section. The Varda-Demy house on the rue Daguerre was filled with variety, color, and light; articles recognized from her films populate the space. A clock without hands, a heart-shaped potato, a photograph of her mother in the garden, even the cats. As she notes in the booklet accompanying *The Beaches of Agnès*, "The house in Paris. Workplace, lifespace, and homebase, for the whole family. The courtyard is its epicenter, with over fifty years of history to tell. To help tell it, the courtyard was rebuilt on a set, looking as it did in 1951, and after."¹⁷

I go even further with the creative triangulation: the kitchen is the scene of ideas, something's always cooking; the atelier is the scene of work, resembling a medieval workshop and reminding Varda of Demy; and the courtyard is a special scene of sharing, a place to exchange ideas in the casual setting of food and friendship. Anyone who's seen a picture of Varda or met her in person knows immediately that she has an exquisite sense of color: purple and mauve scarves, patterned ethnic tunics, unusual combinations of fabric and design. This extends to her surroundings: vibrant pink and Greek blue in the courtyard, bright red tile in the kitchen. This kitchen is something stunning to see, this defiance of established norms and a refusal to conform to the conventional feminine space. At the same time, Varda adapts this space of cultural givens to her own vision, one of unexpected vibrancy and joyful novelty. Varda has invited us into her atelier in many of her films, the clutter always reminding us that visual ideas often emerge in creative chaos. Most notably, in *Les glaneurs et la glaneuse* (The Gleaners and I, 2000), she lets this space create parallels with the wide variety of gleaners and environments that she has explored throughout the film (Figure 7.5).

But most important to me personally is that leafy courtyard where one sunny day in June of 2007, Agnès and I had tea while she explained her installation in the Pantheon in January (Figure 7.4). She told me about the ordinary people who hid or saved Jews during the War and about the children who so intrigued her, and, leaping about in time from her youth to the present moment, she delighted in telling me about her experiences and her process. She even showed me the maquette, with a kind of anticipatory excitement because she was going to mount the installation in Avignon. Some time after the conference in Rennes where I presented my paper, Varda made *The Beaches of Agnès* with the aforementioned

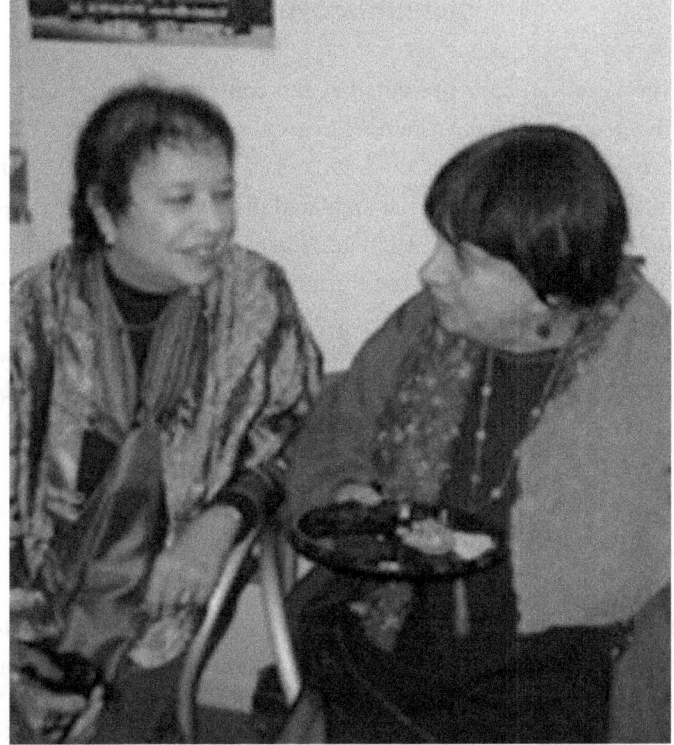

Figure 7.5 Sandy Flitterman-Lewis with Agnès Varda in Rennes, November 2007. Photo courtesy of Sandy Flitterman-Lewis.

inclusion of that very installation. When I saw her afterward I congratulated her on noting *Les Justes* in the film and she responded, characteristically, "Et les juifs!" From my perspective today I marvel at the way in which *Les Justes* has moved from a footnote in the Varda canon (difficult to see and not necessarily noted in discussions of her installations) to a memorable position of prominence and visual power in one of her most personal masterworks.[18]

And finally, for me, the most wonderful example of Varda's "partage" is her inscription in the book that contains the French version of my essay on *Les Justes*. *Agnès Varda: Le cinéma et au-delà*, is a collection of the papers presented at a conference in her honor in November of 2007.[19] I asked Agnès to sign my copy when she was in New York, and without a moment's hesitation she invoked the empathetic relay that is so central to her work, the *I* of creation and the *you* of reception in a productive back and forth that reverberates with perpetual connection. She wrote: "Chère Sandy FL, Merci pour ta vision de mon travail. Agnès V."

Acknowledgments

This is a version of a paper presented at the conference Gender Equality and Sustainability: Agnès Varda's Sustaining Legacy, nicknamed "Virtual Varda" as a result of its move online due to Covid-19, hosted on March 28, 2020, at İstanbul Bilgi University; another version has appeared in *Camera Obscura*'s special issue *Future Varda*. I am grateful to Alain Kleinberger for initially sending me his short video of the installation, which inspired this essay. I am also grateful to Lilliane Jolivet for her endless patience with my French. I would like to dedicate this essay to my twin sister Sharon and her husband David in gratitude for their help in its preparation. And thanks, as ever, to my husband Joel for his poetic insights.

Notes

1 Armelle Héliot, "Les Justes au Panthéon," *Le Figaro*, 22 December 2007. Here I want to mention two corrective points, suggested to me by Nancy Lefenfeld, author of *The Fate of Others: Rescuing Jewish Children on the French-Swiss Border* (Clarksville, MD: Timbrel Press, 2013): "In France the term *les Justes* is basically synonymous with those designated by Yad Vashem as *Righteous Among the Nations* (formerly called *righteous gentiles*). It does not encompass Jews who were themselves engaged in the work of saving other Jews. Networks of Jews worked hand in hand with networks predominantly Catholic or Protestant or Quaker, etc. Also (in spite of my title) I have long argued that the word *rescue* is a poor one to use for talking about this subject. I advocate using the term *humanitarian resistance* instead."
2 *Hommage de la Nation aux Justes de France*, program for the installation at the Pantheon, January 18, 2007, 7.
3 *Les Plages d'Agnès: Texte illustré* (Montreuil: Les Editions de l'Oeil, 2010).
4 Ibid., 2.
5 Ibid., 14–16.
6 Ibid., 43.
7 Ibid., 17–19.
8 *Hommage* (Pantheon), 7.
9 This term is from a personal conversation, although Varda has said similar things in various interviews.
10 *Agnès Varda: From Here to There* (*Agnès de ci de là Varda*, France, 2011).
11 *Hommage aux Justes de France*, program for the installation in Avignon, July 7–27, 2007.

12 Sandy Flitterman-Lewis, "Varda: The Gleaner and the Just," in Marcelline Block, ed. *Situating the Feminist Gaze and Spectatorship in Postwar Cinema* (Newcastle upon Tyne: Cambridge Scholars Publishing, 2008), 214–25.
13 The Book of Ruth, an ancient Hebrew text, is part of the Bible, as is the Book of Esther, the only two Books attributed to women. The Book of Ruth is included in the third division of the Writings of the Hebrew Bible. As I write in another essay on *Les Justes*: "The Book of Ruth has another title, *The Book of Chesed* (loving kindness, *caritas*, compassionate tenderness—there is no exact translation) because it is about relations of generosity and kindness among human beings, inspired in the Book of Ruth by women's caring for each other." Flitterman-Lewis, "Varda," 222.
14 She says this in *Marceline, une femme, un siècle* (Marceline. A Woman. A Century, dir. Cordelia Dvorak, France/Netherlands, 2017).
15 Quoted on the display accompanying the Varda retrospective at Film at Lincoln Center, December 2019–January 2020.
16 This is a rough approximation taken from the same beautiful and engaging display.
17 Sleeve notes, *The Beaches of Agnès*, Cinema Guild DVD.
18 An even stronger sign of Varda's increased appreciation of this installation is its placement in her final film, *Varda par Agnès* (2019), where she describes it in detail in the penultimate sequence, leaving a profound impression of its enduring importance, to her and to us.
19 Antony Fiat, Roxanne Hamery, and Éric Thouvenal, eds., *Agnès Varda: Le cinema et au-déla* (Rennes: Presses Universitaires de Rennes, 2009).

8

Urban Environments and Agnès Varda's *Genius loci*

Zeynep Demirhan and Colleen Kennedy-Karpat

Since the 1960s, subjective and social experiences have brought nuance to architectural and environmental theorists' understanding of physical space. Focusing on the relationship between humans and their environment allows spatial thinking to transcend the corporeality of place, underscoring instead the social values that inhere to a particular "spirit of place," especially though not exclusively in residential districts. The concept of *genius loci*, following architectural historian and theorist Christian Norberg-Schulz, has been adopted as a shorthand for the distinctive atmosphere that transforms space into place. In Varda's filmography, a place is an essential approach, establishing several relations between her subjective presence and the immersive environment. Depending on geography and her lived body experiences, she has underscored the surrounding inhabitants' identity, culture, and history: in other words, their *genius loci*. In her Parisian movies *L'Opéra-Mouffe* (Diary of a Pregnant Woman, 1958), *Daguerréotypes* (1976), and *Les Dites Cariatides* (The So-called Caryatides, 1984), Varda has focused on the daily life of particular locales and environmental objects through her personal, embodied experience. In contrast, *Uncle Yanco* (1967) and *Mur Murs* (1980) depict her encounters on the Pacific Coast where, far away from her home, she has externalized the identity of local characters by framing the spirit of place. Both sets of films deliver a sense of *genius loci*, but at differing degrees of personal remove from Varda's own experience.

In his book *Genius Loci: Towards a Phenomenology of Architecture*, Norberg-Schulz framed the phenomenology of place through history and photographs taken in cities around the world, including Prague, Khartoum, and Rome. His elaboration on the phenomenon of the place begins by comparing natural and man-made worlds, drawing on Heideggerian concepts such as "earth," "sky," and "dwelling."[1] In natural places, where the earth or sky is dominant, reality

is shaped existentially; on the other hand, humans can shape their own places through experimentation with "settlements" and "landscapes," which form the foundation for a structural definition of place that could be analyzed using notions of "space" and "character."[2] In Norberg-Schulz's words, "All places have character, and that character is the basic mode in which the world is given ... The character is determined by the material and formal constitution of the place."[3] The character of place is shaped by immersive and conventional elements such as lights, motifs, windows, doors, walls, roofs, and facades—all of which are types of boundaries. From Norberg-Schulz's perspective, these elements impose an intangible but unique character that changes from one place to another.

Expanding on this concept of place, Norberg-Schulz associated with it the term *genius*, recalling an ancient Roman belief that every "independent" being or place has its guardian spirit or essence that gives it life, a belief that has persisted since ancient times.[4] Building on Haddad's processes of visualization, complementation, and symbolization—all of which are based on the Heideggerian concept of "gathering"—Schultz argued that visualization becomes the most important means of place concretization, for locations where nature offers less must be improved through architectural interventions.[5] The process of a structured world could thus originate in *gathering* and *genius loci*, building an aggregation that defines the identity, history, and culture of a place. Norberg-Schulz connects the concept of "gathering" to that of "dwelling," which frames the human encounter with the environment:

> When man dwells, he is simultaneously located in space and exposed to a certain environmental character. The two psychological functions involved, may be called 'orientation' and 'identification.' To gain an existential foothold man has to be able to *orientate* himself; he has to know *where* he is. But he also has to *identify* himself with the environment, that is, he has to know *how* he is a certain place.[6]

Regarding the human relationship to environment, orientation is the function and identification is the status of man's being-in-the-world.

In the existential dimension, the lived body and its identification create both physical and mental awareness of environmental objects. Underscoring this body-object relationship through feminist phenomenology, Jenny Chamarette observes that life experiences in the immersive environment are perceived corporeally, meaning that the subject-object connection is embodied through specific subjectivities.[7] Such expressions of feminist phenomenology are particularly resonant in cinema studies, Chamarette argues, because of the

range of relationships between viewing subjects and screen subjects—that is, between body and image, between subject and other.[8] Citing Laura U. Marks and Vivian Sobchack, Chamarette observes that "this notion of a mutually enfolded, deeply contextualized relation between the lived body and the orientations of its attention to the world indicate an always already present embodied relation to film."[9]

Such relationships are often reflected in the work of feminist filmmakers, indelibly marked by their own perceptions of the world. Thanks in large part to her long and varied career, Varda's films have embodied her life as a woman, her aging, and her existential experiences. Even if some representations seem more personal than impartial, Varda created reciprocity between her subjectivity and the environments in which she worked, and some of these environments went on to define her filmography.

Parisian Familiarity

Varda's attention to the vitality of urban life established intimate relationships between particular locales and her lived body, situating herself within the frame as both resident and filmmaker. As her longtime home, Paris figures most prominently in these urban representations, and in *L'Opéra-Mouffe*, *Daguerréotypes*, and *Les Dites Cariatides*, Varda used her familiarity with specific locations as a gateway to broader observations about the urban environment and its role in the social, economic, and political life of the city and its people. Each of these films features local characters who give the settlement its unique identity, and therefore frame its *genius loci*.[10]

The autobiographical, highly oneiric essay film *L'Opéra-Mouffe* views Paris through Varda's eyes while she was living along the Rue Mouffetard and pregnant with her daughter Rosalie. While the French title emphasizes the centrality of place, the English title given to this short film, *Diary of a Pregnant Woman*, underscores pregnancy rather than geography as the film's organizing concept. Visual juxtapositions bring forth sensual contradictions between the hope a pregnant woman feels and the hopeless spectacle that surrounds her in the street—or, as Varda herself phrased it, "how one can be at the same time pregnant, blessedly happy, and yet also aware that life is also about misery and aging, which are more than anywhere else omnipresent in the Rue Mouffetard."[11] The film imbues this place with intimacy by filming in 16 mm, capturing images that Varda then sets to an eclectic, energetic score by Georges Delerue. Chapter

headings break the film into discrete sections and give some clues about how to interpret the images. The Rue Mouffetard's *genius* bursts forth in visions of quotidian activity, in all its ambivalence and even its unpleasantness; interspersed among documentary vignettes, Varda also includes fictional sequences that reflect her physical and mental states. Dominated by street markets and foods, Varda also shows people's faces, their habits, and their daily lives: walking in the street; talking to one other; even lying on the ground out of poverty, drunkenness, or both. Far from an idealization of her surroundings, the recognition of the neighborhood's more unsavory traits also represents the *genius loci*.

Varda also embodies her temporality as a pregnant woman through the spatiality of the street, associating her body with the place it inhabits. Rejecting an idealized representation of pending maternity, Varda presents "a startling and occasionally disturbing poetic exploration of the imagination of the pregnant woman" (Conway). In so doing, Varda visualizes the intersubjective connection between place and personal, sensual perception. Her awareness of her own lived body and her environment constitutes what Kate Ince sees as "a feminine dialectic" that emerges in *L'Opéra-Mouffe* through two relationships: one between the pregnant Varda and the people in the street; and the other in "the contrast between physical well-being and poverty."[12] The film's fictional young lovers underscore this latter relationship, where their luxuriant nudity and evident pleasure in each other's company contrast with their dilapidated surroundings. Ince understands Varda's dialectic of privileged places and sensory observation through film phenomenology, but the same combination of place and observation also conveys Varda's sense of the rue Mouffetard's *genius loci*.

Varda reveals intensified apprehension about giving birth in an unreliable environment through abstract portraits of vegetables. The opening shots represent a pregnant woman's fear through a graphic match of Varda's pregnant belly with a similarly round pumpkin, which is then cut with a large knife and its seeds summarily removed. The final chapter heading, "Des Envies" (On Cravings), brings the attention back to food, suggesting a pregnant woman's unusual food consumption with close-up framing of butcher's offal, and a woman enthusiastically munching rose petals straight from the stem. The spectrum of feeling—including contradictory feelings—in these brief sequences visually connects Varda's experience of pregnancy with her day-to-day encounters.

Nearly two decades later, in *Daguerréotypes* (1975) Varda responds to a different set of maternal limitations by exploring another Parisian location: the rue Daguerre, where Varda had been living and would continue to live until her death. Coincidentally, the street is named for Louis Daguerre,

the mid-nineteenth-century inventor of an early photography process, a serendipitous alignment of Varda's geography with her artistic calling. The demands of caring for her now-teenaged daughter as well as her second, much younger child, Mathieu, inspired Varda to shoot a documentary about her own neighborhood with the help of an eighty-meter extension cord that could take her no further than the end of her own block: a metaphorical umbilical cord. Varda's self-imposed, but externally motivated limitation thus correlates her own body and her experience of parenting a small child with the constricted but experientially rich space in which she aimed to film.

Daguerréotypes captures the daily lives of Varda's working-class neighbors—butchers, bakers, tailors, haircutters, and driving instructors—using long takes and voice-over to reveal intimate details of their lives (Figure 8.1). She also intertwines her own subjectivity with her interest in others. In the second half of the film, after showing the magician Mystag's poster hung on a café window, she intercuts his performance with local laborers' gestures and actions. For instance, after the beginning of the magic show, Varda shows the baker

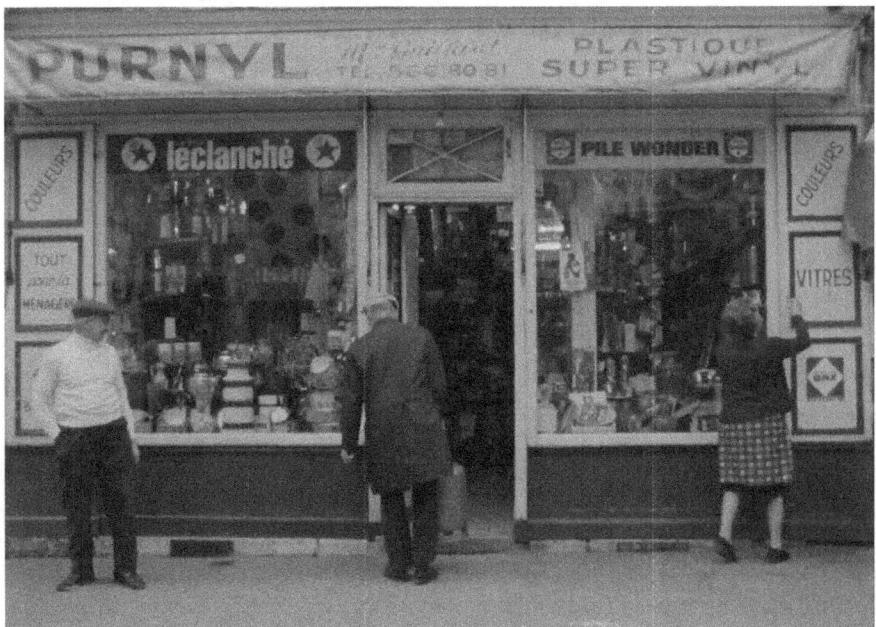

Figure 8.1 A recurring theme in *Daguerréotypes* (1975), Varda's study of her residential street in Paris, is the workday routine and what allows people to escape from it. Shopkeepers open for the day's business with practiced gestures and terse but friendly greetings to delivery workers and other passersby.

rearranging the embers in his oven, then cuts back to the magician holding a torch before putting it into his mouth. After the butcher cuts the bone-in meat, the illusionist cuts himself in his show. Such juxtapositions not only demonstrate Varda's proclivity for association; they also visualize her subjective presence: the illusionist uses the shop owners as performers on stage just as Varda uses the same workers in her film to perform—as it were—their environment.[13] Thus, the *genius loci* here thus takes on a collective tone.

This collectivism also extends to the whole city of Paris, with Varda's documentary using the specificity of her home street as a metonym that outlines the broader circumstances of the city's modernization. From 1968 to 1977 the Beaubourg neighborhood was reconfigured to allow for the construction of the controversial Centre Pompidou, which was constructed to be Paris's hub for contemporary art. DeRoo claims that in filming *Daguerreotypes*, Varda engaged Lefebvre's critique of the conversion of the city under Hausmann, drawing parallels between these nineteenth-century renovations and the changes undertaken in the 1970s.[14] The consequences of both Hausmann's and Pompidou's urban transformations hit working and middle-class inhabitants the hardest, and Varda's focus on individual shops in working-class Beaubourg aimed to convey the ripple effect these changes were having across all of Paris.

During this environmental upheaval, the inhabitants of the rue Daguerre, most of whom had come to Paris as part of a broader rural-urban migration, maintained their quiescence to these changes in part through personal nostalgia. By looking at their old photographs and family histories, Varda's film integrates her subjects' past roots with their tumultuous present. In doing so, she portrays the cultural and historical essence of rue Daguerre as a collection of individual, past experiences that are united through sharing a community in the present.[15] Throughout the film, Varda bears witness to their lives without overly intimate prying. She captures different relationships between shop owners, customers, and products by following the shopkeeper's gestures, which also reveal moments of almost unnatural stillness, as with the butcher's nervous breathing.[16] Highlighting her neighbors' thoughtful deliberations in the context of Beaubourg's transformation reveals her inclination to comprehend their *genius* in its totality; the modernization process threatens a serious loss of urban foci as well as the physical buildings that serve as meaningful hubs of activity, where people may simultaneously experience individuality and belonging.[17]

Varda returned once again to Parisian history nearly a decade later in *Les Dites Cariatides*, using geographic history to reveal how spatial organization forms the city's character. Pointing to the nineteenth-century architectural style

of Paris's caryatids, the film shows these female and male figures as a "montage of sculptures in the streets of Paris" accompanied by the poetry of Baudelaire, the music of Offenbach, and Varda's own voice-over narration.[18] With slow camera movement, Varda interprets the city's history through these sculpted representations, with particular attention to how they display female bodies. After hearing the piano version of Jean-Philippe Rameau's 'Gavotte et 6 Doubles' (1727) with a credit sequence, Varda films a woman caryatid carrying a lamp above her head, with a vertical tilt up from her feet to her head.[19] A naked man walks out from the building and keeps on walking in the street, reappearing in the following scene. The camera follows him from behind, and Varda's voice-over says: "Le nu, dans la rue, est plus souvent en bronze qu'en peau humaine, plus souvent en pierre qu'en chair" (On the street, a nude is more often in bronze than human skin, more often in stone than in the flesh).[20] In these sequences, Varda shows a disconnect between the fixed sculptures of female bodies, whose nudity surprises nobody, and the male body represented with live, corporeal nudity roaming in the streets. This draws attention to the differences in how gender roles are reflected in city spaces and how their resonance can shift across time.

The architectural tradition of the caryatids comes from Greece. After the Peloponnesian War, the Greeks sought revenge on Karyatian collaborators, enslaving both men and women as punishment; in architecture, columns were then sculpted into human forms instead of classic columns in order to illustrate their punishment. The female bodies were represented partially or entirely naked, whereas the male figures are sculpted to signify power and strength. Varda injects her own skepticism about this history by referring to the caryatids as "so-called," which challenges the official history and emphasizes that their main purpose has been to expose women's bodies in public spaces. Thus, beyond their association with neoclassicism, the women caryatids represent the place of women in urban spaces. In the related sequence, after the male caryatids are represented with muscular and facial tension, shot from a low camera angle, Varda shows a woman walking over to the camera by her head-basket. This example is compared to several old photographs taken in Portugal, showing several women who bear bread, food, or child in a head-basket. These female bodies are thus exposed in the same way across time, place, and means of representation.

Repeating this same camera movement, the film assembles close-ups of caryatids, other facades, streets, and balconies, culminating in a set of enormous female caryatids. In the final sequences, after Varda, in voice-over, recites Baudelaire's poem "L'Amour du mensonge" (The Love of Lies), the giant statue is

cleaned with brushes by seven people on a different balcony on Rue Turbigo. The film ends with Varda's voice-over "Hail, mask or décor! Your beauty I adore!" The documentary underscores how these markedly feminine monuments define the Parisian spirit of place, conserving the past and carrying new nuance into the future.[21]

Foreign and Familial Connections

While Parisian locations emphasize Varda's personal familiarity with place, she also made a number of films far from home, including while living in California. Her status as a temporary, foreign-born resident of the American West Coast did not deter her from incorporating her personal perspective on these environments. In *Uncle Yanco,* Varda investigated her family connections to the area; and in *Mur Murs* she used the mural art of Los Angeles as a window on the *genius loci* of urban California.

In the winter of 1967, an acquaintance at the San Francisco Film Festival alerted Agnès Varda to another local artist named Varda, who turned out to be her father's cousin, Yanco. She arranged to visit him at his home in Sausalito Bay, a visit that produced the colorful, joyful short documentary *Uncle Yanco*.[22] Exploring their shared family history, she filmed Yanco's life on his houseboat as a working artist, noting how his Greek Orthodox roots emerge in his paintings of holy cities. The film invites the audience to take a joyful and conceptual journey from a pleasant, if distinctly patriarchal perspective.

At the beginning of the film, their reunion is depicted repeatedly, in various languages, through colorful, heart-shaped filters. The emphasis on love and the communal lives of these California artists resonates with the hippie movement, which refused materialism, competition, and militarism in favor of communal love, drug-fueled ecstasy, and the study and practice of non-Western philosophy and spirituality.[23] This sociopolitical background infuses Varda's examination of her uncle's houseboat settlement in Sausalito. Her ethnographic gaze addresses the countercultural community's history and living conditions: their relationships, their communal habits, their activism, and their traditions, like the weekly Sunday meal in Yanco's floating home.

During the Second World War, the Sausalito shoreline was used for shipbuilding by Don Arques, who was the son of a prominent waterfront property manager.[24] After the war, the Marinship shipyard closed down, leaving behind a wealth of unfinished boats, lumber, metal, machinery, floating barges,

ferries, and parts.[25] After a while, Arques invited the struggling artists, hippies, bohemians, and beatniks to settle there, giving them the physical space to build a community and pursue their alternative way of life. They spent the 1960s using these remaining materials to grow a largely unregulated houseboat community that, today, consists of more than 400 houseboats. This vernacular, recycled settlement represents the communities' respect for their natural environment and the variability and transience inherent in place-making above the water. In several close-ups of these Sausalito houseboats, Varda illustrates the effects that countercultural ideology, culture, and history have had on the constitution of place, connecting these man-made, itinerant places to their inhabitants' distinctive lifestyles. Although Varda was a mere acquaintance to this environment, her family connection catalyzed her identification with the place and signaled a sense of belonging. In *Uncle Yanco*, her inclination to explore her roots and uncover shared memories enabled new encounters and confirmed the dynamism of spatial relationships in human activity.[26]

In her life and work, Varda valued feeling a sense of establishment in geographic, economic, and social terms.[27] Her temporary move abroad created a sense of urgency to retrench this groundedness in new territory, and in true Varda form she set about doing this by forming connections to other people. Connection and collaboration form the backbone of *Mur Murs*, which explores the history of mural art and artists in Los Angeles. In the Mexican neighborhoods of Venice and elsewhere around Los Angeles, Varda uses the ephemeral form of the mural to draw attention to multiple aspects of the city, using its very walls to reveal its urban identity and collective memory. The film captures hundreds of murals that reflect a range of sociopolitical issues, and she filmed dozens of interviews with muralists and locals who expressed their sense of belonging through these spatial elements, which also identify boundaries within the city. As in *Les Dites Cariatides*, focusing on the character of place helps narrate the history of urban Los Angeles, this time through a focus on more temporary structures with eminently traceable points of origin.

Varda was especially impressed by the heterogeneity of Los Angeles, and this diverse group of residents unites in *Mur Murs* to form a collective identity marked by space. One of the strongest examples of socially minded collectivism in the film is a project spearheaded by Judy Baca, a painter, muralist, art educator, and feminist (as Varda proudly notes in her voice-over) who has formed an independent group of dozens of local youths, all of whom have had prior run-ins with law enforcement. In creating their mural—which Varda shows as a work-in-progress, already 1,500 feet long but barely covering a fraction of the

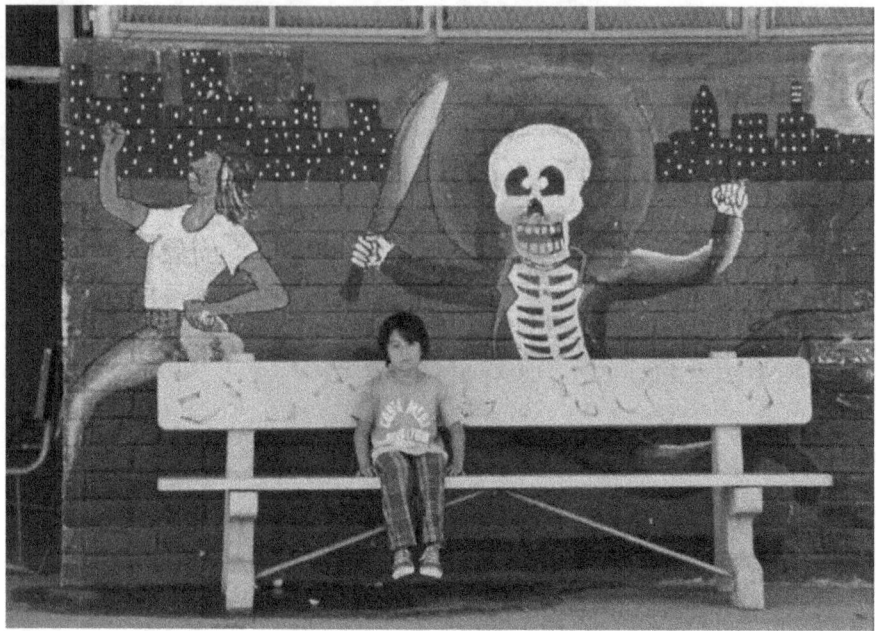

Figure 8.2 A mural by Manuel Cruz juxtaposes the image of active, violent death with a young life in repose in *Mur Murs* (1980), Varda's study of Los Angeles street art.

flood-control channel earmarked for the project—kids from different gangs and ethnic communities work together to depict the history of California, particularly its forgotten people.

Varda's experimental and collaborative documentary practice helped her integrate her own subjectivity to a new environment, but her gaze focuses most frequently on Los Angelenos whose ethnic background and migration history differ strongly from her own, particularly the Chicano and Black communities. The interconnections between these communities are also noted: how the tradition of mural paintings comes from Mexico, how social gatherings and creative endeavors like music give the two communities the chance to intermingle. For example, the muralist Manuel Cruz, who is a member of the Macy gang, sings the blues in front of a bar he painted with a mural whose design represents his Chicano ancestry. Cruz's mural also represents death: the indigenous ancestor holds the body of a teenager, as his mother and brother look on in sorrow. Like many other murals shown in the film, Cruz's work mourns the young people killed in gang violence (Figure 8.2). In the following sequences, Varda displays several other murals in close-up that feature skulls, men holding

guns, and crying mothers, while the soundtrack plays "Barrio Blues." But this darkness is juxtaposed with lighter moments, as Varda shows children playing with each other against the backdrop of the torpedoes and violent images in these paintings.

Not every conversation about death in *Mur Murs* centers on violence. In another segment, Betty Brandelli stands in front of her cocktail bar that features a mural made in 1973, which features Betty with her husband, a former boxer and community fixture who by the time of filming had passed away (Figure 8.3). Several close-ups from the painting memorialize him as the artist narrates old memories (or perhaps projects his own version of history). After this introduction to her husband, Betty stands again before the camera, more loosely now, with a questioning gaze as she asks people just out of frame, "You don't want me no more?"—a poignant question indeed. Multiple members of the crew assure her that she's done filming, and she starts listing out loud to herself her belongings to collect before leaving. However, it's not clear whether or not she completes her list; the image cuts to a re-representation of the mural as the artist

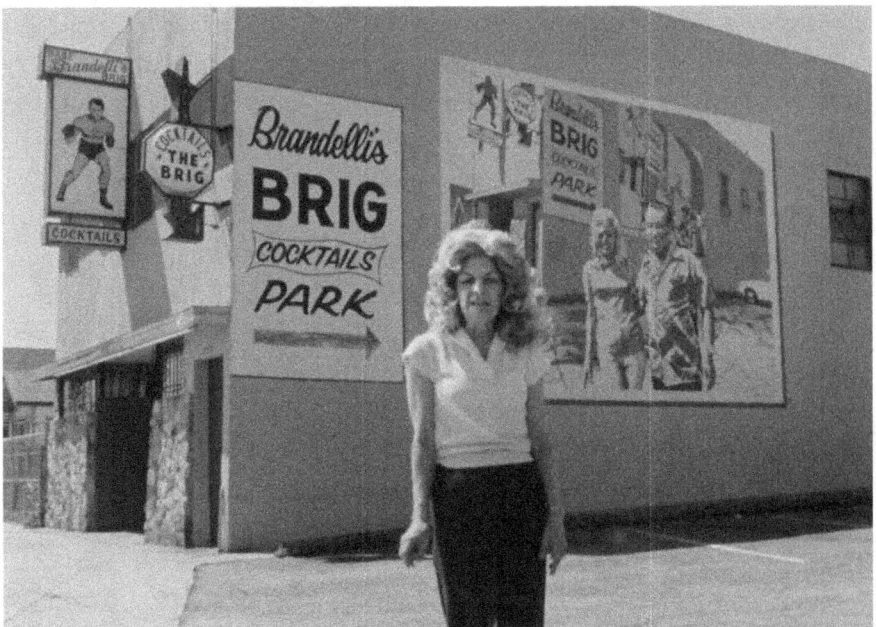

Figure 8.3 In *Mur Murs* (1980), Los Angeles resident Betty Brandelli stands in front of her cocktail bar whose exterior wall features a mural painted there in 1973 that features Betty with her late husband, a former boxer. Varda's framing in this shot recreates the framing of the mural itself as it also centers Betty telling her story.

continues his voice-over comment on the work. This sequence, in its reference to spousal mourning and the attention it pays to the widow left behind—who is preoccupied by her own exit from the frame—presages some of the same themes as Varda's moving image installation *Les Veuves de Noirmoutier* (2005).

In contrast with the embodied and often explicitly feminine experiences that define her Parisian films, her California documentaries adopt a more ethnographic distance vis-à-vis her filmic objects. The social and cultural fragmentations Varda observed in Los Angeles inspire her representation of the city's spatial actors. Much like her work in *Daguerreotypes*, rather than offering a conventional overview of a particular urban settlement, Varda used one particular, recurring feature of the city—in this case, the city's own walls—to craft a broader vision, refracted through built space and creative artwork. True to Norberg-Schulz's understanding of *genius loci*, Varda's cinematic journey through California was founded on how space shapes the experience of some of its most marginalized residents.

For Norberg-Schulz, *genius loci* is an energy field, a sense of authenticity, and a particular atmosphere that defines man-made places according to cultural, ecological, and historical values. Conceptually, it serves as a key between existence, space, and architecture that also underscores the relationship between natural spaces and places built by human ingenuity. In her urban documentary and essay films, from Paris to California, Varda concretizes her immediate environment and defines its *genius loci* through specific encounters and subjective representation. Phenomenologically speaking, the environment of these films is where the sensing subject and the thinking subject meet; naturally, the sensations and thoughts that come to us at home are different from those experienced abroad.[28] In each of these films, Varda concretized the history, identity, and meaning of place through a combination of her connections with others and her own subjective experience. Whether her own most intimate connection is defined by place, as in the Paris films, or by people, as in the California films, Varda uses this personal intimacy to reveal each city's *genius loci* by entering her films as both subject-maker and subject-matter.

Notes

1 Christian Norberg-Schulz, *Genius loci: Towards a Phenomenology of Architecture* (New York: Rizzoli, 1996), 11.
2 Norberg-Schulz, *Genius loci*, 11.

3 Ibid., 14.
4 Ibid., 18.
5 Jeff Cody and Francesco Siravo. "Genius Loci: Towards a Phenomenology of Architecture." Essay. In *Historic Cities: Issues in Urban Conservation* (Los Angeles: The Getty Conservation Institute 2019), 31–45.
6 Norberg-Schulz, *Genius loci*, 19. Grammar and emphasis kept as in the original text.
7 Jenny Chamarette, "Embodied Worlds and Situated Bodies: Feminism, Phenomenology, Film Theory," in *Signs: Journal of Women in Culture and Society* ed. Mary Hawkesworth (Chicago, IL: University of Chicago Press, 2013), 289–94.
8 Chamarette, "Embodied Worlds," 293.
9 Ibid.
10 Cody and Siravo, "Towards a Phenomenology of Architecture," 31–45.
11 Mireille Amiel "Agnès Varda Talks about the Cinema," in *Agnès Varda: Interviews*, ed. T. Jefferson Kline (Jackson: University Press of Mississippi, 2014), 64–78.
12 Kate Ince, "Feminist Phenomenology and the Film World of Agnès Varda," *Hypatia* 28, no. 3 (Summer 2013): 602–17, https://doi:10.1111/j.1527-2001.2012.01303.x.
13 Rebecca J. DeRoo, "The Limits of Documentary: Identity and Urban Transformation in Daguerréotypes," in *Agnès Varda between Film, Photography, and Art*, ed. Rebecca J. DeRoo (Oakland, CA: University of California Press, 2018), 104
14 DeRoo, "The Limits of Documentary," 87.
15 Cody and Siravo, "Towards a Phenomenology of Architecture," 31–45.
16 DeRoo, "The Limits of Documentary," 91.
17 Cody and Siravo, "Towards a Phenomenology of Architecture," 31–45.
18 T. Jefferson Kline, "Introduction," in *Agnès Varda: Interviews* (Jackson: University Press of Mississippi, 2014) IX–XIX.
19 Jennifer Wallace, "Agnes Varda in Paris: The Urban Gaze of the Female Filmmaker in Three Short Films," in *Women and the City in French Literature and Culture: Reconfiguring the Feminine in the Urban Environment*, ed. Siobhán McIlvanney, Gillian Ni Cheallaigh (England: University of Wales Press, 2019), 72–92.
20 Wallace, "Agnes Varda in Paris," 81.
21 Ibid., 85.
22 Delphine Bénézet, "Cinecriture and Originality," in *The Cinema of Agnès Varda: Resistance and Eclecticism* (London: Wallflower Press, 2014), 111–39.
23 Bénézet, "Cinecriture and Originality," 116.
24 April Harper, "The Houseboat Wars: A Battle of the Haves and Have-Nots," 2015, https://www.foundsf.org/index.php?title=The_Houseboat_Wars:_A_Battle_of_the_Haves_and_Have-Nots.
25 Sharon McDonnell, "Living on the Dock of the Bay: The History Behind Sausalito's Quirky and Colorful Floating Homes," last modified November 13, 2019, https://roadtrippers.com/magazine/sausalito-floating-homes-california/.

26 Peter Wagstaff, "Traces of Places: Agnes Varda's Mobile Space in The Gleaners and I," in *Revisiting Space: Space and Place in European Cinema*, ed. Wendy Everett, Axel Goodbody (New York: Peter Lang, 2005), 273–91.

27 Philippe Carcasonne, and Jacques Fieschi (1981), "Agnès Varda," in *Agnès Varda: Interviews*, ed. T. Jefferson Kline (Jackson: University Press of Mississippi, 2014), 102–8.

28 Chamarette, "Embodied Worlds," 289–94.

9

Iran Under Varda's Eyes: Interview with Dr. Ali Rafie

Negar Taymoorzadeh

When I stumbled upon *Plaisir d'amour en Iran* a year ago, I was struck by how unrelated to Varda's oeuvre it seemed to be. This short film, which explores an episode in the life of one of the female protagonists ("Pomme") of Varda's *L'une chante, l'autre pas*, was labelled a "petit documentaire" but to me it seemed to have come straight out of a Western fantasy. Set in Masjed-e Shah (Shah Mosque) in Isfahan and in one of the surrounding villages, the film's six minutes revolve around Pomme and Dariush touring the mosque, exchanging poetry, and commenting on the architecture.

It was also impossible not to notice that the male lead Dariush was played by none other than Ali Rafie, who at the time was director of the Teatr-e Shahr (City Theater of Tehran), and remains today one of the major figures of contemporary Iranian theater. This casting captured my curiosity. Realizing that Ali Rafie's role was not limited to *Plaisir d'amour en Iran*, but entailed a major role as Pomme's Iranian lover in *L'une chante, l'autre pas*, I began wondering about Varda's inspiration. Why had she inserted an Iranian lover into the story of *L'une chante, l'autre pas*? What was Varda's relation to Iran? Why did she choose this setting of Masjed-e Shah in Isfahan? What did she know of Iran in 1976?

During a visit to Iran in 2019, I had seen Ali Rafie's production of Federico García Lorca's *The House of Bernarda Alba* as brought to the stage of Vahdat Hall,[1] a performing arts complex in Tehran, under the title "Khāne-ye Bernarda Alba." Rafie, who years ago had staged Lorca's *Blood Wedding* and *Yerma* and long awaited Ahmad Shamlou's[2] translation of *The House of Bernarda Alba* before staging it, had in the meantime taken the liberty to interfere with Shamlou's translation, adapting *The House of Bernarda Alba*, which had been completed during the Spanish Civil War, into a story that related to contemporary Iran. Emerging from the theater on a snowy day that January, I realized that during

the two and a half hours inside Vahdat Hall, I had forgotten that this piece had originally been written by a Spanish author. What I had seen on stage was Lorca's 'La Casa de Bernarda Alba' but it was also Shamlou's and Rafie's "Khāne-ye Bernarda Alba." What Shamlou's translation together with Rafie's staging had achieved was not a mere translation of literal language, but rather a cross-cultural translation that retained the poetry of the original while also interfering with it.

Translation and cross-cultural adaptation seem to be a theme of *Plaisir d'amour en Iran,* too. While Pomme "translates" the architecture of the mosque as a mirror of their erotic love, Dariush cites a poem in Persian, then cites the French translation of it before abruptly interrupting his translation. I began looking at *Plaisir d'amour en Iran* as a tale about translation and the lack and interruption thereof. To what extent was the encounter between Pomme and Dariush marked by interferences and interruptions in the process of translating their different worlds? What was Varda's translation of Iran as it was in 1976? What was the nature of translation in the encounter and collaboration of Agnès Varda and Ali Rafie at the time?

The following interview with Ali Rafie is my attempt to shed some light on this collaboration. I conducted the interview on July 12, 2020, via video call between Dr. Ali Rafie in Tehran and me in Berlin. It has been edited for clarity, and the translation into English—including any interference and the lack thereof—is mine.

* * * * *

N. T.: How did your collaboration with Agnès Varda begin? How did you meet?

A. R.: I was teaching at Tehran University when Dr. Nahavandi, the president of the University, called me in for a meeting. When I entered, I immediately recognized Mr. Jacques Demy, Agnès Varda's husband. I was not a great fan of his work, but his sympathetic, loveable, and extremely professional appearance was in my mind. Between Dr. Nahavandi and Jacques Demy who were sitting at both ends of the table, I saw a photo of me. Jacques started explaining to me, that when Agnès decided to make this film, she was looking for a certain cast and didn't believe she would find that person. So they consulted a few casting agencies, and he said: "We found your photo among the agency's photos, but they told us that Mr. Rafie has returned to Iran and is now teaching at the University of Tehran." I was the director of Teatr-e Shahr[3] as well, which was and still is the most well-known theater of Iran. So he said to me: "She [Varda] is planning this

kind of film, I've brought the script with me for you. We'll be delighted if you accept it. I have the authority to sign a contract with you here, I don't need to invite you to Paris to sign the contract with Agnès herself. But if you prefer, you'll have a return ticket and a stipend for Paris." I immediately interrupted him, and I said: "Jacques, I can't, because I love the work I am doing right now. And besides, I'm not an actor. And I don't like acting." I have acted in a number of films, but that was for other reasons than love and interest. They always wanted me for my looks. I myself know that I'm not a good actor, that I'm a bad actor. So when they insist on me it's solely because of my appearance. And this is not only unpleasant, it annoys me.

N. T.: Did you feel like that with regard to working in France?

A. R.: Yes, in France I played in a number of films and series, and mostly because the wages were very good and that made me work jobs that were unrelated to theatre. My aim was to become a director. From the beginning, my mind, my soul, my desire was directing. Especially with one of the films, Mr. Roger Vadim granted me entrance into the School of Boxing of the French National Theater. I definitely wanted to enter the National Theater. I would reject the lead role in a film for the part of an extra in a theater play. I said all of this and Jacques replied: "You've acted in seven or eight films, so add this one to them as well. Agnès comes from that same National Theatre that you have come from." Agnès started her work with theater photography in Paris, in that same National Theater. I responded: "I can't just leave my class at the university." Dr. Nahavandi said: "I'll take care of that." He really wanted me to go to Paris to play this part. To cut a long story short, I decided to go to Paris and sign the contract with Agnès. I signed for one film, *L'une chante, l'autre pas*. My contract said that I would have to stay in Paris and that my hotel costs were taken care of for the two or three months that the shooting would take, or, that if I wanted to return to my teaching, I would come to Tehran once a week and return to Paris for the shooting. And so I continued moving back and forth between Tehran and Paris until the shooting ended.

The period in which we shot in Iran, Agnès tricked me. She tried to trick me on several occasions, but I stopped her. I stopped her with rage and anger. On one of these occasions, we went together to Masjed-e Shah[4] in Meydan-e Naqhsh-e Jahan[5] and Agnès wanted to shoot a few sequences there. I said: "What's the story? These are not in the script of *L'une chante, l'autre pas*." She responded: "I want to shoot a 'petit documentaire.'" I said: "I don't care about petit or grand. I'm not under contract for this film. I'm angry because you didn't tell me about

it. If you had told me and asked my permission, I would have accepted. But you tried hiding it and you thought that I, like others, have this same enthusiasm for acting that you can take advantage of." She realized that she couldn't do this with me and so she had to add this film to my contract.

I want to tell you very sincerely that the material side of this was not relevant to me *at all*. It was Agnès' character, her secrecies, and her insidiousness that annoyed me. At the same time, I offered her help and provided support in Tehran, in Isfahan, and the surrounding villages in ways that, if it wasn't for me, she would have had to double or triple the budget to shoot in Iran. I took care of her residence permit, I provided meals for the team at my home or arranged for it at my friends' homes. I provided her with innumerable facilities. All for free, all for free, to make her understand that when I want to be hospitable, when I want to support, I am able to do so, and that she does not have the right to act insidiously. In the end, the film was finished, the sequences related to her documentary in Isfahan as well. In fact, my support for her was extraordinary, I myself was amazed. My friends too did everything in their power with a special affection and devotion for Agnès.

In Amsterdam, too, something happened that annoyed me a lot. It was night, when we entered Amsterdam. She took us to a hotel. But I think, it was a brothel in Amsterdam. A third-class hotel with a stinky smell. I said to her: "Look, I'm a professional person. The others might be young and inexperienced, but I know the rules of the syndicates. I know the rights of actors, especially the lead roles, but any actor. You don't have the right to take this group into this neighborhood and into this stinky hotel, just to save, save, save. It's all about saving money with you. Do you want to make this film for free?"

N. T.: What do you think was the reason for her behavior?

A. R.: She wanted to finish the film cheaply. As simple as that. I forced Agnès to book a hotel for the whole group, and not in the most underdeveloped neighborhood. These things happened, and the film was finished in the end, and I returned to Iran. I never wanted to be in touch with her again. She sent me many messages. Even two months before her passing, my niece Mina, who works there in Cinema and Theater, goes to Agnès' place in Rue Daguerre—I had been there several times in the beginning—and says to her: "Ms. Agnès Varda, I'm the niece of Mr. Rafie and just wanted to say hi." And Agnès hugs Mina and says: "Where is Ali? I'm always looking for him. Please tell him next time he comes to Paris to promise to come see me. I'm old now and on my way out, and I want to see Ali. And I could not have made this film the way I wanted without Ali." But, in the end, I did not have the opportunity to see Agnès.

N. T.: Otherwise, you would have liked to?

A. R.: Yes, yes. I did want to see her. Because she was an artist. Agnès Varda was an extremely competent woman. She was a master of her work, unique, unprecedented. However, these bitter memories are there too. This is my story with her.

N. T.: Did Agnès Varda's position in French cinema at the time play any role in your decision to participate in the film?

A. R.: No, not at all. Her social persona [her social activism] was more important to me. At that time, defending women's rights in the world was not an issue yet, and Ms. Gisèle Halimi, a lawyer, had caused a stir in France, that was in reality the first stir of feminism. Agnès collaborated with her a lot, and Gisèle Halimi plays in a short sequence in the film. So her social persona was attractive to me, her background in the French National Theater, photographer of Jean Vilar's work, the founder of the French National Theater, the founder of Festival d'Avignon, with whom Agnès Varda worked shoulder to shoulder and photographed his work—all of this was valuable to me.

N. T.: Did you accept the role after reading the script?

A. R.: Yes, yes. The script was very simple, but at the same time, the topic of these two women, of which one sings and the other doesn't, the fate of these two humans was appealing to me. The diligence and struggle of these two women in that society, where one of them decides to enter political activities through music and singing. Because at the margins of my professional life in theatre, there were also political activities in France of that time, in the confederation of Iranian Students in France.[6] And I too had—as the saying goes—"that head that smells Ghormeh Sabzi."[7] So her sociopolitical persona was attractive to me and I saw that the only musical film of that time that attracted audiences was *Les Parapluies de Cherbourg*, a film made by Jacques Demy, Agnès Varda's husband. So again in France a film in which music plays a role, in which a woman sings and has her own voice, how one of them stands with her music to express herself and the other one doesn't and gives in to a very conventional life. The truth is, I think, that the film not only left French audiences of the time surprised and amazed with its success, but also left Agnès Varda herself surprised, who had been so worried about the financial burden of this film and did everything to not spend any money. When it was finished, she realized how successful it was.[8] The funny thing is, I went to the post office [in Paris] one day, and a woman came up to me and asked: "Are you Ali Rafie?" and I said "Yes," and she said: "I've seen you in that film" and she started praising the film.

N. T.: When you spoke about Agnès Varda trying to not spend money on the film, could it be that she actually had no or very little budget? French New Wave films did not operate on huge budgets, and it would have been even more difficult for a woman filmmaker to gather a big budget.

A. R.: Even if these films did not benefit from generous funding through the French government, certain things have to be respected. Whenever I, as an assistant in a theater production, would travel with a theater group to another country or to some smaller city in France to stage a production, I saw how we were accommodated, where we were accommodated, what meals they would provide, and how they respected us. Look, the main issue was not the hotel, nor the food. The main issue was respect. Agnès did not show that respect. I was her film's male lead. For the other two women, Valerie Mairesse and Thérèse Liotard … No, the point is that she did not respect us as artists, she did not respect our position as artists. That respect that you have to show under any circumstances … Give the actors a sandwich and explain to them: I have no money, I can't take you to a restaurant, I can't take you to a five-star hotel, I can't. I would have accepted that. I *would* have accepted it.

N. T.: There were a number of other French and European films in Iran made during that period with heavy support from the Shah. Do you know anything about that kind of support for Agnès Varda's film?

A. R.: No, no. I was far from anything to do with the monarchy. I have never accepted this idea that an artist should be appeasing in order to improve their own situation. Even if the artist is agreeing with that regime, one should not compromise oneself. [Being an] artist means critiquing the status quo, whether you agree with it or not. Consequently, I was never part of those films, and I have never seen any of those films.

N. T.: With regard to the character of Dariush, which you play in the film, was there anything in the script that made you think, I want to play this part?

A. R.: I didn't like the character of Dariush, because he was a young man who looked down on women. His idea of a woman was that she should sit at home and peel eggplants, cook food for her husband, and wash the children's clothes. I discussed this a lot with Agnès, but she said: "You teach theater at the university. You know drama, you know tragedy. We don't have the right to deny the realities. Dariush's character corresponds to a reality in today's Iran." That's what I accepted about the character, that it corresponds to a social reality, and strongly. I was just not fine with this character. And then I thought to myself that

either I should not have accepted this character, or now that I have accepted it, I have to do it right.

N. T.: I think you are right, that a character like that was a reality in Iran at that time, but it was a reality in France too, I think.

A. R.: Well, Agnès saw this issue in black and white. There was no shade of grey between this black and white, none at all. I can admit that at the time I was not very picky about this issue. I just accepted it, because by any means the social face/appearance of Dariush was this. His family, which he presents and whose images are in the film … I myself could see that this would not happen in my family and never happened. I grew up in a family where this looking down upon a woman did not exist. I could see my father's attitude. I saw that my father preferred that his daughters wear a *chador*[9] when leaving the house, but he never forced them. He would say: "This is my opinion. You do want you want." My father was an educated and cultured man, in the context of an Iranian father, an Iranian man at the time. When I say cultured and educated, I mean he had neither gone to university nor to school. He had gone through Islamic education as a *talabe*,[10] but when he graduated and was supposed to become a cleric, he escaped and went to earn money instead. The result of this was that he made me read books from childhood on. He was open-minded and read books all the time. I don't think she [Agnès Varda] exaggerated the character [of Dariush], but she did give it more color, she did intensify the shade.

N. T.: You yourself are from Isfahan, and *Plaisir d'amour en Iran* is set in Isfahan. Is this your influence on the film, or was Isfahan already set as the setting for the film? Is it a coincidence?

A. R.: No. Without exaggeration, without overstatement, I had a lot of influence on Agnès' gaze and frame of mind. I spoke to her a lot about the aesthetics of the Safavid era,[11] about what is left from that time and era, and I thought that *Plaisir d'amour* is in reality our historical memory that is being recorded. And this is what helped me to take things easy. Although this film was added to my contract, I never followed up on receiving that extra wage. I didn't want to receive it, because I knew that this would be a beautiful film. You know, there is a very short sequence in *Plaisir d'amour* in the courtyard of a house. Dariush is reciting a poem for Pomme. This attention to poetics was of great importance to me. The image she presented of a village at a distance of some seventy kilometers from Isfahan called Shahreza, where she shot on the roof of one of the neighborhoods of Shahreza, in which the all roofs stand out like female breasts and the minaret

that is visible …. She was interested in eroticism in Iran, and these images that were put in montage with some images of Iranian miniature …. There were these things too, that for me represented values of Iran.

N. T.: It seems interesting that *Plaisir d'amour en Iran* is separated from *L'une chante, l'autre pas* but it's part of the story of that film. And *L'une chante, l'autre pas* is framed as a fiction film, while she calls *Plaisir d'amour en Iran* a documentary. So while Pomme and Dariush walk through the mosque, they keep connecting the architecture surrounding them to their love and desire and to eroticism, and it forms this snippet that belongs to the film but has fallen out of it, like these postcards she writes to Suzanne.

A. R.: Yes, yes. I think, that the images themselves were reflections of these thoughts, to say it bluntly. But Agnès was basically a poet. And consequently, her poetic gaze on Iran—but Iran of *that* time—the timing is extremely important here, because if Agnès had come to Iran to make a film after the Islamic revolution, she could not have made this film. I think, that even in *L'une chante, l'autre pas* this poetics continues, whether you consider it as preceding *Plaisir d'amour* or in continuation of it. Agnès was deeply impressed by Iran, Iran's culture, the arts of Iran, and historic figures related to poetry and architecture. Her gaze was very incisive. She did this to the point that the film allowed her. The potential of the film has to be measured in relation to its length. Because, in a short film, what else could Agnès have said that would have reflected this love between two beings, would have been rooted in the poetry and architecture of Iran? These two parallels made this documentary film extremely valuable. I don't cherish *Plaisir d'amour* less than *L'une chante* at all, maybe even more. I extremely admire *Plaisir d'amour*. This was very important, especially the team behind the camera, the camera operator, the assistants—I could see it in their eyes, in their behavior, in their reactions toward me when Agnès would say "cut"—and they even expressed it explicitly—"we have never taken images that would move us so much." You know, the dialogues I had with Agnès off-camera, where I would say: It's a pity we don't have this and that," and she would respond: "I don't have much time for this film. I have these minutes only."

N. T.: Thinking about the timing of these two films, 1976 and 1977, and what followed in 1978 when Edward Said published *Orientalism*, a critique of the Western gaze toward the east. A gaze that conserves the East in a frozen image, and he links all this to colonialism, to certain Western fantasies, even sexual

fantasies around the image of the harem. Do you think, Agnès Varda to a certain degree might have had an orientalist gaze on Iran, especially when you think about how she conceptualizes the character of Dariush?

A. R.: I'll immediately say yes. It's been sixty years now that I live with France, forty years of which I've actually lived *in* France. Now that I don't live there anymore, my mind is there, and I'm there very often. I love France. I am grateful to France. Everything I have, I got from France. My profession, my views, everything. However, I am very aware of what you are pointing to, and I agree with you. There is definitely a frozen gaze. [...] I have done many historical readings, many of which were travelogues of foreigners who came to Iran or foreigners who now come to Iran, who came here within the last ten, twenty years, fifty years, hundred years, six hundred years

N. T.: And Pomme writes postcards from Iran to Suzanne, which one could read as a form of travelogue ...

A. R.: Yes, they all have that same frozen frame. It's completely weird. You know, when Agnès made this film, they either knew this country for the Shah and Soraya,[12] or the Shah and Farah Diba,[13] oil, and carpets, and for a bunch of underdeveloped people that no one knows which part of the history of humankind they belong to.

I remember, I was sitting in a train from Switzerland to Paris. The Islamic Revolution had begun in Iran, so "Iranian" to them meant a person holding a knife with his/her teeth attacking someone. A man was sitting next to me, and I was reading Edward Said's *Orientalism*. He kept looking at my book and finally asked me: "Where are you from?," and I responded: "I'm Iranian." If the train's window had been open, he would have thrown himself out of the train immediately. After, a few moments he collected himself, apologized for his reaction and then went into a long monologue about poetry, and Khayyam, and astrology which is indebted to Khayyam and Hafez and I don't know what. This is what annoys me, has always annoyed me and keeps annoying me. I understand, that Agnès couldn't ... she just couldn't ... as someone who was born in France, trained in France, and has now come to point where she wants to make a film called *L'une chante, l'autre pas* with a few sequences in Iran.

N. T.: You mean, she could not have a different gaze than the orientalist gaze?

A. R.: Yes, exactly. It's not that she didn't want to [have a different gaze]. However, if she wrote this script in this way, even if she didn't want to [have an orientalist

gaze] and was aware of deeper realities, she would have made this same film. This is the part of humans in the Western world, that is extremely irritating.

N. T.: It's interesting that you're mentioning this. Said speaks exactly about the way in which Orientalism simultaneously combines a condescending looking down upon the East with an extreme respect and admiration for the ancient literature, poetry, arts of that part of the world.

A. R.: Yes, what it doesn't see is that that poetry and literature is flowing in the veins and nerves of the Iranian human of today as well. If she [Agnès Varda] could not understand this, it is because many other issues have come to cover it. The Iranian human has infinite concerns and his/her life is infinitely complex. She could not grasp that. She couldn't.

N. T.: You know, when I watch *L'une chante, l'autre pas*, it seems to me that there are certain contradictions. When I think about this film being made by a feminist woman in France and her gaze toward Iran, especially the complete absence of Iranian women … I mean she sets an important sequence in Iran, and she inserts an important Iranian character into the film, but the function of this character is reduced to representing the "backward," traditional man, while Iranian women actually have no presence at all, except for some scenes where we can see a few silent women wearing *chador* in the background, as opposed to Pomme wearing a light summer dress. And then you think about that historical moment: this is two or three years before the revolution, a historical moment in which women were massively present in the streets—irrespective of what one might think about the outcome. At that historical moment we are dealing with an extremely dynamic society, in which women play an active role as political subjects. So for me the question that arises is: Could a feminist French woman not extend that gaze of feminist solidarity with which she looked at women in France, could she not extend that gaze of feminist solidarity to women in Iran?

A. R.: I don't even fully believe in that solidarity with women in France, I'm sorry. The more time passed during the sixty years that I have been growing and educating and developing myself in Iran, I have more and more come to the conclusion that the frame of mind of the Western human has not been transformed at all, despite all these events and circumstances. For a while they adored Iranians and certain things of Iran, and then they forgot all that, because their adoration is superficial, just as now their criticism and opposition is superficial. I am a 100 percent in agreement with your view, your analysis, and I must say I like it very much. But I was not able to say to Agnès Varda: Where is

the Iranian woman in these films? Do you know the nature of the relationship between an Iranian woman and an Iranian man, how it was built, how it is built? You never asked me about my five sisters, about their relation to their husbands, about the relation between my mother and my father. You could have met them. A certain kind of egoism, selfishness makes them follow that fixed gaze. Agnès didn't even think about this. There is the possibility of thinking about something and then not wanting it. But she didn't even think about this. That gaze is simplistic and superficial.

N. T.: Every historical moment has its limitations, and the frame of mind of every human being is limited by that historical moment, and so sixty years later we can go back and point out those limitations but that doesn't necessarily mean that people failed at that moment.

A. R.: That's right, but I don't want to justify anything about myself, not at all. My whole life is proof of who and what I am, what kind of pieces I bring on stage. I haven't made any films but all the roles I performed are proof of what I think.

N. T.: Of course. When I was in Tehran two years ago, I saw your production of Federico García Lorca's *La Casa de Bernarda Alba*. And I obviously have read about your work, and so I thought that someone who does these kinds of productions with strong female figures, who centers women in his work on stage ... it would be interesting to talk to you about your collaboration with Agnès Varda. And so if I hadn't been sure that you are conscious of these kinds of questions, I would not even have asked to talk to you.

A. R.: In any case, our lives have ups and downs, with regard to our thinking and acting, but what matters is where one stands now, how one sees the worlds, how one lives. There is no point in regretting anything. What I'm hearing is that both these films have been circulating recently in Iran through WhatsApp or some other application. I get regular calls about these films. I haven't given any interviews about this, but a kind of wave of new interest has started.

Notes

1 Known formerly as Roudaki Hall (Tālār-e Rudaki), it was renamed Tālār e Vahdat ("Unity Hall") after the revolution.
2 Ahmad Shamlou (1925–2000) was an Iranian poet, writer, and journalist. Shamlou was arguably the most influential poet of modern Iran.

3 City Theater of Tehran.
4 Shah-Mosque, located on Naqhsh-e Jahan Square in Isfahan, was built during the Safavid era and is regarded as one of the masterpieces of Persian architecture in the Islamic era. It was built under Sahah Abbas and was renamed Imam Mosque after the Iranian Revolution.
5 Naqhsh-e Jahan Square (trans. "Image of the World Square") is situated at the center of Isfahan. Constructed between 1598 and 1629 under Shah Abbas, when the capital of the Persian Empire was moved from Qazvin to Isfahan, this project was part of the remaking of the entire city. Naqhsh-e Jahan Square was named Imam Square after the Iranian Revolution.
6 Confederation of Iranian Students was an international students' organization of Iranians studying abroad during the 1960s and 1970s. It was made up by activists and sympathizers of different Iranian groups opposed to the Shah regime and most active in Germany, France, England, and the United States.
7 Ghormeh Sabzi is an Iranian stew, based on herbs and meat. Here, it forms part of an expression in Persian meaning to harbor risky/radical (leftist) political ideas.
8 To contextualize Rafie's impression of the film's success: according to Simon Simsi, *L'Une chante, l'autre pas* accumulated 288,992 theater entries in France from the time of its initial release in 1977 through the end of 1999. Over the same time period—and considering only women directors—Diane Kurys' *Diabolo Menthe* was the sixth most successful national release of 1977, with more than 3 million entries across France; meanwhile, Marguerite Duras's two films that year, *Des Journées entières dans les arbres* and *Le Camion*, posted a combined spectatorship of 72,838 entries, with each title one of seven films from 1977 to mark fewer than 100,000 entries over the given time frame. Simsi, Simon, *Ciné-Passions: 7e art et industrie de 1945 à 2000* (Paris: Éditions Dixit, 2000).
9 A full-body-length semicircle of fabric, the *chador* is open down the front and is wrapped around the head and upper body leaving only the face exposed.
10 An originally Arabic word meaning "the one who requests," *talabe* in Persian is used to refer to students who undergo Islamic education to become a Shia cleric.
11 Safavid Persia, 1501–1722, ruled by the Safavid dynasty, often considered the beginning of Modern Persian history.
12 Shah Mohammad Reza Pahlavi and his second wife Soraya Esfandiary-Bakhtiyari.
13 Third wife of Shah Mohammad Reza Pahlavi.

Part Four

Teaching Varda

Section Introduction: Teaching Varda

Colleen Kennedy-Karpat

This volume's goal is to explore how creation, connection, and environment have shaped the artistic legacy of Agnès Varda. The fourth section of this book brings all three of these elements together in one specific context: the classroom.

Pedagogy is an inherently creative endeavor, and the classroom environment is an inherently creative and collective space. Scholars and activists focused on pedagogy have long sought to blur or break down the barriers that separate teachers from learners, insisting that the most effective pedagogies frame all participants as capable of sharing as well as receiving new knowledge. Engaged pedagogy, which bell hooks defines in *Teaching to Transgress* as "practices that emphasize mutual participation between teacher and student," is "really the only type of teaching that truly generates excitement in the classroom, that enables students and professors to feel the joy of learning" (204). Varda offered a model of education through mutual exchange in her work, particularly the five-part documentary series *Agnès de ci de là Varda* (Agnès Varda: From Here to There, 2011). In this audiovisual travelogue, her directorship behind the camera aligns with her teaching role, while on screen, her conversations with artists and experiential approach to art situate her as a student. Watching how Varda's exemplary curiosity unfurls in her artistic practice and in relation to others is central to the appeal of this and other late documentaries she directed.

This section's focus on pedagogy also anticipates an increased presence for Varda's work in curricula and syllabi, as more of her oeuvre has recently been made available to private and institutional collectors as high-quality digital transfers. The conditions that brought about these new releases reveal a silver lining in the self-production that Varda navigated throughout her career: a more seamless (though certainly not effortless) path to preservation and distribution once the film has been made. Varda's company Ciné-Tamaris—which has remained under daughter Rosalie Varda's direction after her death (and which also handles Jacques Demy's archive)—has worked to ensure the availability of

her complete filmography on DVD, of which most entries have been restored under the guidance of the director herself. The widely recognized, canon- and cinephile-friendly Criterion Collection label has also produced a box set of Varda's complete works, a culmination of individual releases that span her career, all accompanied by extra material that underscores her value to the medium and its history.

Besides the paratextual and filmic resources assembled in these collections, Varda's late documentaries also serve as a *de facto* archive of her non-filmic work: her video art, multimedia installations, and other space-specific experiences figure prominently in the biographical *Les Plages d'Agnès* (The Beaches of Agnès, 2008) and *Varda par Agnès* (Varda by Agnès, 2019). The crowd-funded, Oscar-nominated documentary *Visages villages* (Faces Places, 2017) is similarly structured as a series of vignettes that capture ephemeral installations displayed in various locations throughout France, portraying as well the process that Varda and her co-director JR undertook to create them. By documenting her own installation art and making it accessible through her films, Varda ensured that these works could reach audiences who would not have experienced them in person. These documentaries thus braid together the different strands of her work on film, in digital media, and in museums. They also bestow upon the whole the imprimatur of her own authorship, charting the breadth of her legacy as a visual artist while reaffirming the case for her own status as an auteur.

The pedagogical essays in this section confirm that a few of Varda's films are already on heavy rotation in the classroom: *Cléo de 5 à 7* (Cléo from 5 to 7, 1962), *Sans toit ni loi* (Vagabond, 1985), and *Les Glaneurs et la glaneuse* (The Gleaners and I, 2000). Her other work also holds lessons worth teaching and learning. As recent collectors' releases make the full scope of her career more publicly accessible, our hope is that these essays will inspire teachers at all kinds of institutions and across a range of disciplines to examine why and how they incorporate Varda's work in their courses, and to consider how, in the future, they might do so differently.

Writing about pedagogy from the perspective of an active classroom teacher invites an approach that diverges from rigid scholarship, particularly in its embrace of subjective experience. We invited contributors to write about what Varda has taught them personally as well as how they have taught her work, and, of course, what teachers do in the classroom already depends on who they are and how they have learned what they know. As a genre, the pedagogical essay necessarily combines the personal with the critical, able to serve both in equal measure, yet flexible enough to tip the scales as the topic or mood requires.

Its subjectivity stems in significant measure from teachers' positionality, which hooks and others have made a central tenet of feminist praxis in the classroom. Positionality underscores the intimate connection between teachers' past learning environments and the pedagogical approaches they have adopted (or avoided), and many authors in this section take careful account of their own geographic, linguistic, cultural, and generational perspectives on Varda. We hope that colleagues in and beyond the academy will extend a similarly (self-)critical spirit to future discussions of how they introduce Varda's work to others, and that sharing those experiences will continue to sustain her legacy.

10

Agnès Varda: The Queen of the Margins

Beth Tsai

Confession: Agnès Varda is a late discovery for me. I've only been fully exposed to Varda and her work since her death in March 2019. I can only imagine that this moment of honesty is somewhat shocking, and it's certainly embarrassing, coming from someone who has claimed to be a prolific film scholar, practitioner, and educator. Allow me to backtrack a little: I first became aware of Varda's films during the time I was pursuing my doctoral degree, when I noticed that one of my peers would always choose *Cléo de 5 à 7* (Cleo from 5 to 7, 1962) in her classroom as an example of the French New Wave, instead of screening the usual suspects *À bout de souffle* (Breathless, 1960) or *Les Quatre cents coups* (The 400 Blows, 1959), for example. At the time, I did not think there was anything unusual about her choice, but I also did not fully understand the significance of her action until years later. My excuse was that my working knowledge of the French New Wave at that point in time was placed within the scope of my research interest—connection between Taiwan New Cinema and the expansiveness of French influence, and during the process I unavoidably privileged male directors among the pioneer group.

But here is another confession: in all my years of graduate training in film studies, no one ever taught Varda *to me*, and it probably didn't help that most of my professors were men. In academic contexts, the name Agnès Varda may have been mentioned in passing, but rarely positioned at the center of debate on the development of the French New Wave movement. In most French film studies Varda's presence and her work are acknowledged but much of the discussions tend to surround her documentary films, particularly her playful approach of mixing fiction and actuality. But most importantly, in textbooks as well as in classrooms, Varda is identified as a unique being, a marginalized subject, the other. She is often recognized as the only woman in the French New Wave group and yet her contributions are often discussed in parallel to the movement, not on center stage.

David A. Cook, in *A History of Narrative Film*, devotes several subsections to his chapter on the French New Wave, covering topics ranging from the authors of *Cahiers du Cinéma* to stylistic conventions to individual profiles of major New Wave figures, yet left Varda out of the section. In fact, it almost appears as if Varda is mentioned as an afterthought: Varda is described and grouped together, inevitably, with her husband Jacques Demy, as part of the group that is "sophisticated but less spectacular"[1] than François Truffaut, Jean-Luc Godard, Alain Resnais, and Claude Chabrol. Even though Varda made her first film five years before Truffaut and Godard, *La Pointe Courte* (1955) was described in an ascertainable way as "something of a New Wave landmark" but nothing more.[2] To other historians, Varda represents the Left Bank group, a group of documentary directors known for their experimental and formal approach to cinema and who treated cinema like literature or photography. But most commonly, because of Varda's prolific filmmaking career, her name has been continually associated with various groups and movements spanning over six decades, including that of the 1960s and 1970s counterculture and cinematic left, as well as the wider recognition of global women directors who have finally come into the spotlight since the 1980s.

In Gerald Mast and Bruce Kawin's account, Varda received much more praise, although not without reservation. In their textbook *A Short History of the Movies*, Varda's *La Pointe Courte* was noted ambiguously as either the first New Wave film or a film that may have decisively anticipated the movement.[3] Varda was described as "a totally different kind of filmmaker: probing, thoughtful, intellectually sensitive"[4]—a step forward, but not as assertive as Georges Sadoul's claim that *La Pointe Courte* is "genuinely the first film of the French *Nouvelle Vague*."[5] In describing these viewpoints, my point is less about arguing whether *La Pointe Courte* should be considered the first French New Wave film or if it decisively figures Varda as a pioneer—not just for the fact that she was the only woman director among the movement—than it is about the arbitrary process of selecting and forming canons through narrative framing. In my more than ten years of teaching at the university level, the French New Wave has always been introduced first with Truffaut, followed by Godard, while Varda stands oddly in a category of her own, as if historians and scholars have been unable to define her and her work with confidence. It was only recently, when I began to include this conversation in my teaching, that I noticed how reframing the historical narrative brought significant changes in the way students respond to these filmmakers. Without disclosing their identifying personal details, it remains imperative to point out that the students who responded most strongly and

critically to this shift were primarily women, minorities, and the underserved—including many Black and Asian Americans.

Before I begin divulging what students shared with me in the classroom, I would like to provide the context here—something about myself, my background, and my teaching. Since receiving my doctoral degree, I have been teaching at a public flagship state university in the United States, having first arrived as a foreign student and then becoming a permanent resident in this country. I have offered courses ranging from film history, including international film movements, to hands-on production courses in experimental film and video. As a practitioner, my films have screened at international film festivals and at various venues in New York.

In a 2009 interview with *The New York Times*, Varda dubbed herself "the queen of the margins," referring to the nonconformity of her films, of herself, and of her outlier status in an industry that relies on commercial success.[6] Like Varda, I strongly identified with the feeling of being displaced and marginalized: growing up in Taiwan before moving to the United States, I know what it feels like to find oneself outside the dominant culture. In academia and in everyday life, these are the boxes I check off while navigating the workplace: minority, woman, person of color, foreign language speaker. I never hide my own status as an instructor with an international background and experience as a second language learner; many students, especially those from historically underserved groups, are inspired by my story. My bicultural experience also informs my ability to identify with the challenges of an increasingly diverse student population. As a woman, I make sure my teaching materials and conversations in the classroom emphasize the global struggle that sexual and gender minorities still face today. So perhaps it is not surprising that Varda triggered an abundance of emotions in me; it is not just her work and the women's issues it presents, but also the way she insinuated herself into an industry that has long been dominated by men.[7] My students must share this same experience, because the most positive, excited responses I have received about Varda have come from those who belong to multiple marginalized groups, including first-generation students, low-income students, and ethnic and racial minority students.

What follows may sound like a cliché, but it is true: there are many things I can learn from observing my students in the classroom. After landing my current teaching position, the first course I offered was a world cinema course that examined various film movements that operate either alongside or against Hollywood and other international film industries, from the French New Wave to Chinese and Southeast Asian independent cinema. I started the class

with Varda's *Visages villages* (Faces Places, 2017), and not long after the class commenced, from the reading discussion, a student wrote the following:

> While reading about the French New Wave for the second week of class, there was a particular part of a sentence that struck me: " … and by a small group of sophisticated but less spectacular talents such as Louie Malle, Eric Rohmer, Jaques Demy, Jaques Rivette, and Agnes Varda" (Cook, 2016, p. 357). The article then goes on to speaking on the "spectacular" talents—Francois Truffaut, Jean Luc Godard, and Alain Renais—without speaking on those "less spectacular talents" such as Agnes Varda whose name is even listed last. Of all the French New Wave films I have watched (*Hiroshima Mon Amour, Bande a Part, A Bout de Souffle,* and *Cleo from 5 to 7*), *Cleo from 5 to 7* affected me the most, so I fail to see how Varda is considered "less spectacular" and why, as mentioned in lecture, there is not much literature on Varda especially since, of all those names listed in the reading, Varda is the only woman.[8]

Surely the comment on the lack of literature on Varda is an overstatement (this was a lower-division general education course), but I was mostly struck by this female student's genuine response to her own reaction, that in comparison, she believed she was able to relate to *Cléo de 5 à 7* the most because it is a film by a female director about women's issues, and that this caliber is simply lacking in other male directors' work of the time. Many students in the same class recognized Godard's *Bande à Part* (Band of Outsiders, 1964), for example, as misogynistic in its rendering of female characters as passive and self-doubting, as opposed to Varda's magnifying and honoring of ordinary women. An example is the scene in *Visages villages* where Varda interviews the wives of dock workers and sets blown-up photographs of them on a massive stack of shipping crates to monumentalize these women and to thank them for their underappreciated labor.

Students also asked challenging questions about Varda's filmmaking practice and wondered how they could use this curiosity to reflect on their own practices. In particular, one asked:

> I would also like to learn about the filmmakers that influenced her [Varda], as well as how she actually came to the profession of filmmaking—what steps did she take? How did she begin as a filmmaker? How can I apply those things to my own personal and professional growth as an experimental filmmaker?[9]

This student, as an experienced filmmaker herself working at a local youth media center catering specifically to the Black community, was commenting in reference to her own line of inquiry about what she felt compelled to work on.

While she intended to dig deeper into the layers of feminism through the French New Wave movement, she was also interested in exploring Varda's advantages and disadvantages as a woman in a male-dominated industry. Mainly, she was interested in connecting what she learned through the research back to her own filmmaking experience. She has remarked over and over again, in conversations and in work presentations, about the ongoing struggle of being a Black female filmmaker. Put simply, she argued, there are not enough black-skin representations both on-screen and off-screen; there are not enough Black women working in the industry. The statements she made were not only astute but also timely. At the time of this writing, broader social solidarity for racial minorities is being put to the test, as Black Lives Matter protestors and allied groups and individuals stand up against police brutality across the United States. And yet as anti-racism protests continue to expand, they are still facing widespread pushback by white compatriots.

So how has Varda influenced me *personally*? The first Varda film I watched is one of her late-stage works, *Les Plages d'Agnès* (The Beaches of Agnès, 2008), a self-portrait documentary where Varda revisits places from her past and reminisces about her work. The documentary opens with Varda standing on the North Sea beaches of Belgium, claiming she's "playing the role of a little old lady" to tell her life story by revisiting the places that shaped her. We see a dozen mirrors on the beaches, some wood-framed, while the director recounts her childhood memories—her parents' bedroom, the kind of music they listened to. Occasionally, she holds up a mirror to show reflections of her crew in lieu of the traditional approach of having an opening credits sequence (Figure 10.1). I was immediately enthralled by Varda's charisma and her playful attitude— it was theatrical, performative, and yet cinematic at the same time. I was also immediately reminded of midcentury American experimental films, such as Maya Deren's *Meshes of the Afternoon* (1943), where in the last sequence we see broken mirror pieces fall onto the beach, followed by ocean waves washing ashore. The use of mirrors has been widely discussed in cinema history; mirrors, symbolically employed by so many filmmakers, provide reflections of reality that are akin to the indexicality of the cinematic image. The use of mirrors also brings a meta-indexicality between reality, cinema, and self/identification, adding extra psychological layers to cinema ever since Lacan's theory of the mirror stage. I see Varda's cinematic self-portrait as reflexive, a *mise en abîme* that documents the performance while at the same time revealing the filmmaking process.

Les Plages d'Agnès is the quintessential essay film: it has always been my go-to film when I introduce an assignment like video self-portrait in my

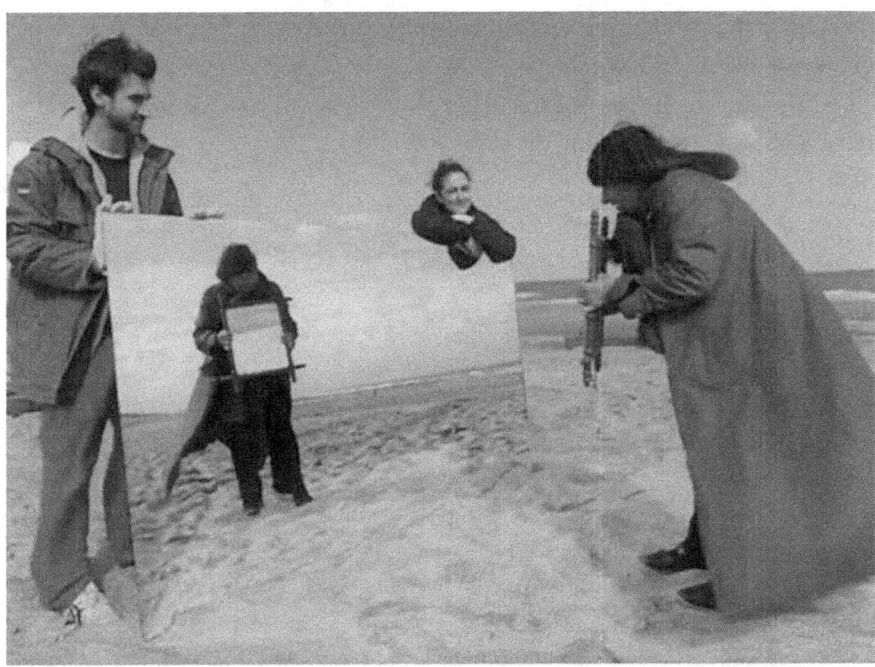

Figure 10.1 Frame capture from *Les Plages d'Agnès* (The Beaches of Agnès, 2008) that shows Agnès Varda (frame right and mirror image) adding live, spoken credits to thank the assistants, Céline Miquelis (center) and Jérôme (left, last name unknown), who carried the mirrors on set.

film production class. Aside from the mirrors, we also see Varda use a Sony camcorder to conduct her own recording, creating another reflexive moment when the audience is watching through another video camera—a second crew is operating the footage of Varda in action that we are just experiencing. Seeing the camera in the film recalls Robert Stam's definition of reflexivity[10] that denotes the revelation of making the invisible visible; in other words, Varda's work lends itself as prisms through which to ask questions about ourselves, identity, and marginality. *Les Plages d'Agnès* also acts as a brief recounting of the birth of the French New Wave: how it happened, whom she met, and where was her place at the start of the movement. I will never forget the long moment of feeling stunned after watching Varda's film—how did she revolutionize women's lives by exploring and amplifying the female cinematic voice? How was she able to provide a harsh criticism of patriarchy and yet remain sincere and personal at the same time? I don't know if I can ever sum up Varda's influence in one short essay, but if I have to, I would like to conclude that what Varda taught us, at its

essence, is that to be strong is to be vulnerable, and that the feminist voice comes in diverse forms. And to quote my student: "[Varda] brought individuality to the cinematic world. She told stories about women, about herself, and in doing so inspired people like me to do the same."[11]

Notes

1. David A. Cook, *A History of Narrative Film*, 5th ed. (New York: W. W. Norton & Company Inc., 2016), 357.
2. Cook, *A History*, 370.
3. Gerald Mast and Bruce Kawin, *A Short History of the Movies*, abridged 11th ed. (New York: Pearson, 2012), 245–47.
4. Mast and Kawin, *A Short History*, 246.
5. Georges Sadoul, *Dictionnaire des films* (Paris: Editions du Seuil, 1965), 196, quoted in Sandy Flitterman-Lewis, *To Desire Differently: Feminism and the French Cinema* (Urbana and Chicago: University of Illinois Press, 1990), 31.
6. A. O. Scott, "Living for Cinema, and through It," *New York Times*, June 25, 2009, https://archive.nytimes.com/www.nytimes.com/2009/06/28/movies/28scot.html.
7. For a more comprehensive exploration of Agnès Varda's marginalized experience in the French film production context of her time, see, for example, Sandy Flitterman-Lewis's chapter "Varda in Context: French Film Production in the Early Sixties—The New Wave," in *To Desire Differently: Feminism and the French Cinema* (Urbana and Chicago: University of Illinois Press, 1990), 248–67.
8. Student discussion board post, November 19, 2019, International Film Movements, University at Albany, SUNY.
9. Student paper, October 9, 2019, International Film Movements, University at Albany, SUNY.
10. Robert Stam, *Film Theory: An Introduction* (Malden, MA: Blackwell Publishers Inc., 2000), 151–3.
11. Student paper, December 1, 2019, International Film Movements, University at Albany, SUNY.

11

Teaching Varda Teaching

Sandy Flitterman-Lewis

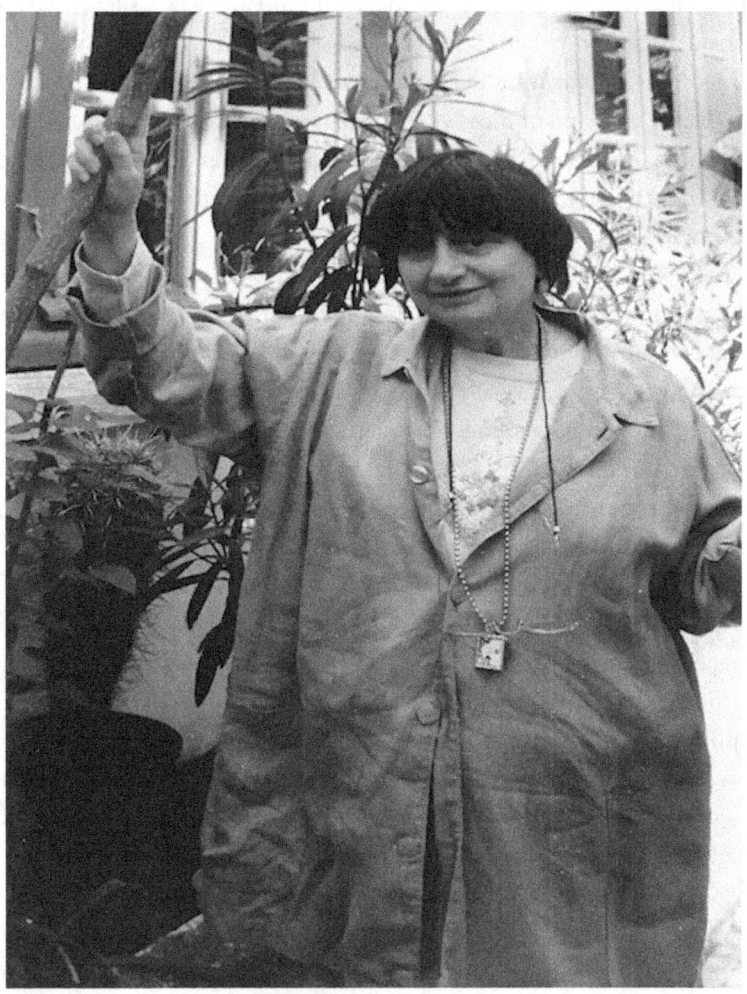

Figure 11.1 Agnès Varda in the courtyard of her rue Daguerre home/studio, Paris, c. 1996. Photo courtesy Sandy Flitterman-Lewis.

Among the several artistic personae that Agnès Varda adopted for herself (photographer, cineaste, installation artist), there was another: teacher. Her abiding interest in learning (about those she encountered and filmed) is enhanced by her continuing pleasure in teaching. As she introduced herself in *Les Plages d'Agnès* (The Beaches of Agnes, 2008) her autobiographical celebration of her eighty years, she is "pleasantly plump and talkative, telling her life story. And yet it's others I'm interested in; others I like to film." Through the years, each encounter I had with Agnès contained a small yet precious reference to teaching (Figure 11.1). She always appreciated the fact that my writing was geared toward education, that I would bring my students to meet her whenever she came to New York, and that her own atelier/household in Paris was a site of learning for the many artists, filmmakers, scholars, and students who came to visit. The last time I saw Agnès, at the MoMA screening of *Visages villages* (Faces Places, 2017) to an audience made up of mostly JR's Instagram followers (who seemed to have no idea who Varda was), she was wistful and a little overwhelmed at the size and energy of the crowd. I sat with her for a few moments, reminding her that I was an identical twin—having just seen *Les Demoiselles ont eu 25 ans* (The Young Girls Turn 25, 1993), where twins figure prominently—and chatting about *Visages villages* and its reception. And then she posed her usual question, "Are you still teaching?" My affirmative response was met with a hearty "Good. Keep it up!"

Over the years my approach to teaching Varda has changed, along with the class composition and awareness or relative unawareness of her work by those I was teaching. It's perhaps typical of the Varda oeuvre that it is both timely and timeless, some films capturing the essence of the historical moment, such as *Black Panthers* (1968); *Lions, Love … and Lies* (1969); or *L'Une chante, l'autre pas* (One Sings the Other Doesn't, 1977), while others transcend generations, such as *Cléo de 5 à 7* (Cleo from 5 to 7, 1962), *Sans toit ni loi* (Vagabond, 1985), or *Les Glaneurs et la glaneuse* (The Gleaners and I, 2000), whose impact is always fresh in spite of the dates of the actual films. When I teach Varda, I try and maintain that equilibrium, as supporting materials and a plethora of texts have emerged in the wake of her new-found celebrity and her own retrospective accounts in *Les Plages d'Agnès* and *Varda par Agnès* (Varda by Agnès, 2019). I take Varda's statement (as it appears on the wonderful Lincoln Center retrospective lobby display of 2020) as a core principle of my teaching of her films: "In my films I always wanted to make people see deeply. I don't want to show things, but to give people the desire to see." So, how to convey this desire to students as we look at specific films and learn about cinematic strategies? What does this mean in the

classroom setting? How to engage in a dialogue with Varda—so essential to her project—through her films?

My first task is to contextualize Varda's work from the dual standpoint of film theory and film history, and her six decades of cinematic production allow for just such an overview. I usually set the tone with a close reading of Alexandre Astruc's seminal 1948 article, "The Birth of a New Avant-Garde: La Caméra-Stylo," an essay that inspired much of the New Wave's exuberant renewal of cinematic language. With *Cléo de 5 à 7* Varda established a totally new method of cinematic storytelling, one that corresponds to Astruc's vision of cinema as a true act of writing, where a filmmaker writes with the camera as an author does with a pen. It is also the perfect way to establish Varda's exemplary fidelity to those aspirations, because while many of her New Wave cohort lapsed into either commercialism or maddening hermeticism, she continued to explore the parameters of cinematic expression as she experimented with forms: documentary, fiction, surrealist fantasy, realism, ciné-tract, personal meditation, sociological investigation, and so forth. The most vital example of Varda's enduring commitment to Astruc's assertion of cinema's unique expressive capability is her formulation of the neologism, "*Cinécrit* par Agnès Varda" that opens *Sans toit ni loi* nearly 25 years after *Cléo*. She is very explicit about the invention of this concept for her work, whether it is in terms of the personal conception of the author ("*Cinécriture* is a word that refers to the recognizable universe of a filmmaker") or in terms of the total process encompassing all aspects of a film's creation ("To write a film is not a screenplay, but the creation of the film itself. What I do in the editing room is writing. Deciding [on the] music … is part of the writing"). Varda thus conceptualizes the film as a visual texture developed in the process of shooting and editing. And she sees filmmaking as the creation of a state of availability, allowing her to freely improvise while viewers have the freedom to engage with whatever intrigues them (or to return to key moments of their choice).

In order to use Astruc's essay as a teaching text that will illustrate Varda's consistent appreciation of his ideas, the class first starts with a close reading of his article. Obviously, we are guided by Chapter 9 of *To Desire Differently* (Varda in Context: French Film Production in the Early Sixties—The New Wave), which details the Astruc essay and Varda's adherence to it throughout her career. Several sentences sum up his approach, which was written just after the Second World War with a visionary appreciation of a new kind of cinema and taken up twenty years later by some of the New Wave filmmakers:

> The cinema is quite simply becoming a means of expression ... it is gradually becoming a language. By language, I mean a form in which and by which an artist can express his thoughts, however abstract they may be, or translate his obsessions exactly as he does in the contemporary essay or novel. ... [The] cinema will gradually break free from the tyranny of the visual [as in silent film], from the image for its own sake, from the immediate and concrete demands of the narrative, to become a means of writing just as flexible and subtle as written language. ... All thought, like all feeling, is a relationship between one human being and another human being or certain objects which form part of his universe. It is by clarifying these relationships, by making a tangible allusion, that the cinema can really make itself the vehicle of thought.[1]

After this reading, the class engages in a discussion of what it means to convey abstract thought in film. Students are asked to come up with examples, either from films or from their imaginations. Then, once they have a better sense of what an abstract idea in film might look like, they are encouraged to envision their own *cinécrite* creation. This can be done as a short assignment or as a group project.

Keeping in mind the concept of *cinécriture* when we turn to film analysis, I like to consider a pair of films that mirror each other in productive ways. I contrast *Cléo from 5 to 7* with *Sans toit ni loi*, as Varda herself did when she premiered the restored version of the former film. Cleo Victoire, a commercially successful pop singer, is a woman who learns about herself in the course of a few hours, going from a woman "who sees herself only through other people's eyes" (Varda), and who thinks physical beauty will prevent her from the catastrophe of illness, to a woman who embraces the world around her, fascinated by all manner of ordinary things and people, and open to a caring relation of friendship. She ceases to be an object, constructed by the looks of men, and assumes the power of vision, a subjective vision of her own, directed outward toward others from a newly constituted self. On the other hand, Mona, the protagonist of *Vagabond*, enjoys no such self-awareness. Her journey through the frozen late-autumn villages and vineyards of Languedoc produces no self-knowledge, no epiphany about the importance of embracing others, no calm satisfaction in the recognition that a woman can define herself apart from patriarchal conventions. The film opens and closes on Mona's frozen corpse, as our quest for who she was (initiated by Varda's single interrogative voice-over) reveals only the truths of the people she encountered. Along the way the viewers discover (though Mona does not) the value of community, work, and friendship: in short, the necessity to think of self in relation to others. Mona stands as an active sign of resistance, but her assumed independence leads to nothing but isolation and negation.

Our discussion of these two films revolves around several questions. How does Varda convey these meanings textually, keeping in mind Astruc's conception of cinematic writing? How do these films illustrate the "tangible illusion," the materialization of abstraction that Astruc proclaims? How do these exquisite narrative films provide the "vehicle of thought" that he asserts? And how can we discern Varda's feminism when it's not explicit in a form we are familiar with? I have the class look closely at a few key sequences to determine both Varda's singular voice and her cinematic inventiveness.

For *Cleo from 5 to 7* we look at the central transformative sequence that heralds Cleo's new awareness. In the exact middle of the film, Cleo sings a mournful song about lack, absence, and death, and this transports her into a selfless recognition of the world around her. The centrality of this sequence allows us to contrast the two halves of the film, the first of narcissistic self-absorption and then of the social recognition of intersubjectivity. As Cleo sings the haunting lines of "Cri d'Amour," the camera slowly swings around and tracks in on her until it isolates her out of all diegetic context; a frontal medium close-up of her face is framed by a black curtain, which now fills the entire background. Varda calls this sequence "the hinge of the story," in which "the circular movement which isolates Cleo is like a huge wave carrying her off. Her voyage begins after the black curtain of the intermission. She strips herself and changes her appearance." The class discusses the technical aspects of the sequence, then Varda's words, and then the relevant passages from Astruc, to reveal through analysis, the feminist power of this transformation.

Varda uses another discursive strategy for *Vagabond*, because her character Mona is much more a reflection of those who encounter her: "*Vagabond* is really constructed about different people looking at Mona—like building together an impossible portrait of Mona." Our focus, therefore, is a little different. Instead of deriving a feminist lesson from a singular character's experience, we must look to the vast, multi-faceted social vision portrayed by those whose lives this hapless vagrant has touched. There is much that is enigmatic about this film and this character, and discussion can revolve around the feminist question, again evoking Astruc's proclamation of abstraction. And yet, there is a structure to this parable of impossible freedom, and it has to do with the necessity of connection. Mona has the option of two relationships with men, with David the hippie and with Assoun the vineyard laborer. In each case these dissolve, first by Mona's choice, and then by Assoun's rejection. Then there is Madame Landier, the professor who tries to encourage Mona to make use of her academic training. And Sylvain the philosophy dropout goatherd, who pronounces the

most stinging critique of Mona's inability to connect. But at the heart of the film is a sublime moment of sharing, where Tante Lydie and Mona collapse in giggles while imbibing forbidden cognac. It's just a moment, but it is a treasure, impossible because these two are of such different backgrounds, social classes, and ages, yet indicative of the utopian idea of a human connection through laughter. This is a much more difficult film to discuss in terms of feminism, yet it is more illustrative of Astruc's principle of the camera-pen. Varda dedicates the film to novelist Nathalie Sarraute, thereby providing a significant clue linking writing with filming, for the invocation of this literary pioneer resonates with Varda's own cinematic adventurousness.

It should come as no surprise that each analysis is aided by reference to chapters in *To Desire Differently*—Chapter 10 (From *Déesse* to *Idée*: *Cléo from 5 to 7*) and Chapter 11 (The "Impossible Portrait" of Femininity: *Vagabond*), some of the earliest close readings in English of Varda's work. From a pedagogical standpoint, students will be able to engage with textual analysis, feminism, and film theory, through the exemplary and dazzling work of this cinematic pioneer. And they will be encouraged to pursue further investigations into Varda's oeuvre, aided, perhaps, by the complete box set of her life's work in film.

Note

1 Alexandre Astruc, "The Birth of a New Avant-Garde: La caméra-stylo," in *The New Wave: Critical Landmarks*, ed. Peter Graham (Garden City: Doubleday, 1968), 18–20.

12

Varda's *Sans toit ni loi*/*Vagabond* (1985): The Center of My Feminist Film Teaching, 1998–2020

Kate Ince

Innumerable tributes have been paid to Agnès Varda since her death on March 29, 2019, not long after the release of her final two-part film *Varda par Agnès* (Varda by Agnes, 2019), a retrospective of her career and life that resembles her acclaimed autobiographical film *Les Plages d'Agnès* (The Beaches of Agnes, 2008). We now know a great deal about Varda's personal life, much of it learned from the autobiographically inclined or unhesitatingly autobiographical films of her last two decades, *Les Glaneurs et la glaneuse* (The Gleaners and I, 2000), *Les Plages d'Agnès*, and *Visages villages* (Faces Places, 2017), as well as numerous video documentary shorts and the TV mini-series *Agnès de ci de là Varda* (Agnès Varda: From Here to There, 2011). It was particularly in her old age that Varda spoke and wrote regularly about the feminism she had espoused—as practice or praxis more than as ideology or a politics—since her twenties, when it memorably shaped the surrealistic body imagery of *L'Opéra-Mouffe* (Diary of a Pregnant Woman, 1958). But the film of hers that took feminist cinematography to a level that arguably remains unsurpassed since it was made in 1985, several years after the end of the "founding" decade of feminist cinema, is, as hundreds if not thousands of film teachers worldwide know, *Sans toit ni loi* (Vagabond, 1985) the "story" of Mona, a *routarde* or vagabond hitchhiking her way round France's Languedoc-Roussillon region. Varda thoroughly researched the subject of the lives of drifters like Mona, the 1980s being a decade when homelessness of the kind opted for by Mona was as extensive an issue in capitalist European societies as it remains four decades later. *Sans toit ni loi* is thus a thoroughgoing blend of documentary and fiction, the person of Mona Bergeron being Varda's invention, even if she based Mona to some extent on a *routarde* called Settina whom she befriended and featured alongside Sandrine Bonnaire as Mona in a

late scene of the film. In this essay, I shall first explain how *Sans toit ni loi* has been central to my teaching of women's cinema and French cinema over the last twenty-two years, and then detail why it is such an excellent pedagogical film, which continues to attract and interest students born in the twenty-first century, more than fifteen years after it was made and released.

Having myself completed a DPhil thesis in 1992 that was mainly about French philosophy and literature (its subjects were Jacques Derrida, Emmanuel Levinas, "French Freud" minus Lacan himself, and Marguerite Duras), I keenly wished to add French film to the teaching portfolio of literature and literary/critical theory (including feminist critical theory) that I had begun to build. The first film I undertook to lecture on, in 1996, was Claire Denis's *Chocolat* (Chocolate, 1988), to first year students of French, and later in the 1990s I exchanged the final year option on the theatre and fiction of Samuel Beckett and Marguerite Duras I had then taught for four years for a new module titled "French Theatre and Film," in which the theatre of Beckett, Jean Genet, Duras, and Marie Redonnet figured alongside a small number of films including *Sans toit ni loi*. Since my doctoral work had pursued feminist readings of several of Duras's films including *India Song* (1974) and I was actively following the young but burgeoning career of Claire Denis, I quite naturally—keen to expand my acquaintance with films directed by French women—started to view work of Varda's made before *Sans toit ni loi*. By the time my "French Theatre and Film" module was replaced by its successor "French Auteur Cinema" in the mid-2000s, Varda had released *Les Glaneurs et la glaneuse* and *Les Glaneurs et la glaneuse ... deux ans après* (The Gleaners and I: Two Years Later, 2002) to great acclaim, and had begun her self-described transition from "old filmmaker" (*vieille cinéaste*) to "young installation artist" (*jeune plasticienne*). French women's cinema had also been thoroughly shaken up by the release of Catherine Breillat's *Romance* (1999), *A ma soeur!* (Fat Girl, 2001), *Sex Is Comedy* (2002), and *Anatomie de l'enfer* (Anatomy of Hell, 2004), and since I had designed my "French Auteur Cinema" module to focus on four directors of which two would be male (Jean-Luc Godard and Michael Haneke) and two female, pairing three of Varda's films with three of Breillat's was an obvious form for the module's second half to take. The three Breillat films offered to students had all been released between 1999 and 2004, but the three Varda films—*Cléo de 5 à 7* (Cleo from 5 to 7, 1962), *Daguerréotypes* (1975), and *Sans toit ni loi*—spanned over twenty years of Varda's career without even touching upon her contemporary successes, an implicit tribute to the impressive length of her career. I taught "French Auteur Cinema" until 2012, and *Sans toit ni loi* had therefore already featured continuously in my final year teaching for

fourteen years before I came to offer a course devoted entirely to films directed by women—to second year, "intermediate" students rather than final years, as chance would have it. (The final year module that replaced "French Auteur Cinema" was titled "Artists' Film and Video," and was delivered to students of art history as well as of French Studies/Modern Languages, so Varda's transition to installation art and autobiographical film made her just as suited to this course as to my previous ones.) The intermediate module on women's cinema I taught for the first time in 2013–14 and am still teaching is called "Behind the Camera: women's cinema from the 1960s to the present": in its first, two-semester form this included *Glaneurs* as well as *Sans toit ni loi*, but in its 2020 form Varda is represented just by *Sans toit ni loi*, which will in the coming term be featuring on one of my modules for a record twenty-third year!

Why, then, is *Sans toit ni loi* such an enduringly rewarding film to teach to undergraduate students? It is not only Sandrine Bonnaire's remarkable performance and the utter persuasiveness of Mona as a character that draws students to the film: over thirty-five years, *Sans toit ni loi* has generated an astonishing quantity of high-quality criticism, from the essay by Susan Hayward[1] and a groundbreaking chapter in Sandy Flitterman-Lewis's *To Desire Differently: Feminism and the French Cinema*[2] to its treatment by Alison Smith in her early monograph for Manchester University Press's "French Film Directors" series, whose first three volumes were all devoted to women: Varda, Coline Serreau, and Diane Kurys.[3] Critics of French cinema such as Guy Austin and Jill Forbes include Varda's 1970s and 1980s films (and therefore *Sans toit ni loi*) in their profiles of French women filmmakers in the books *Contemporary French Cinema: An Introduction* and *The Cinema in France, After the New Wave*, and *Sans toit ni loi* joins *La Pointe Courte*, *L'Opéra-Mouffe*, *Les Glaneurs et la glaneuse*, and *Les Plages d'Agnès* to form the corpus of the 2012 article "Feminist Phenomenology and the Film-World of Agnès Varda" subsequently incorporated into my book *The Body and the Screen: female subjectivities in women's cinema*.[4] For the first seminar of my intermediate "Behind the Camera" module, I ask students to read Laura Mulvey's seminal article on the male gaze "Visual Pleasure and Narrative Cinema,"[5] which pairs perfectly with both Chantal Akerman's *Jeanne Dielmann, 23 quai du Commerce, 1080 Bruxelles* (1975) and with *Sans toit ni loi*, the first two of the five films that make up the module's syllabus. The fact that Varda's film can meaningfully be taught alongside the highly Lacanian feminist framework developed by Mulvey in "Visual Pleasure and Narrative Cinema" and just as meaningfully contribute to the feminist phenomenological approach to Varda I developed in "Feminist Phenomenology and the Film-World of Agnès Varda"

thirty-five years later is a testament to the semantic and hermeneutic riches of the film as well as to the "impossible portrait" of womanhood offered by Mona and the film to which Varda herself referred. The particular point I want to draw out of this catalog of some of the criticism generated by *Sans toit ni loi* is that students have an extensive and rich bibliography to consult when preparing class presentations or writing assessed essays on the film, which perhaps explains why the work they produce is often astonishingly good.

It is however not only the excellent criticism on *Sans toit ni loi* that makes it such a valuable pedagogical resource: the film lends itself unusually well to the kind of close analysis students need to learn on introductory or intermediate film studies modules, to enable them to include "shot by shot" analysis in their presentations and essays or to produce similar work in a formative or summative assessment. A sequence analysis of a three- to five-minute extract from one of the five prescribed films makes up 25 percent of the mark of my "Behind the Camera" module, and although students often find it difficult to understand and put into practice terms such as *mise en scene* (perhaps particularly *mise en scene*, often more challenging than editing, sound, or cinematography!), they also tend particularly to appreciate having learned how to undertake and write up the analysis of a sequence of film. As with *Jeanne Dielmann ...*, *Chocolat*, *A ma soeur!*, and *Bande de filles* (Girlhood, 2014), I have used extracts from *Sans toit ni loi* for sequence analysis purposes: the music Varda commissioned for the film from Joanna Bruzdowicz and its set of right-to-left tracking shots (usually accompanied by Bruzdowicz's "Mona's theme") make excellent material through which students learn how the tracking shot can be used conventionally and unconventionally, as well as in a plethora of ways distinct to particular film narratives.

Additionally, Bruzdowicz's harsh, grating string sounds often puzzle and alienate student listeners until they have worked out how expressive they are both of the film's winter landscape and of the exposure to it through which Mona eventually meets her death. The combination of Bruzdowicz's music and the tracking shots—in which Mona is the most important figure but often not the only one, and is no more the camera's focus than the road signs, piles of old pallets, and farm machinery on which it typically comes to rest—perfectly demonstrates Varda's cinematographic inspiration regarding Mona, who is never objectified in the intensely curious, voyeuristic manner implied in Mulvey's "male gaze." And it is not only the tracking shot sequences of *Sans toit ni loi* that make highly suitable material for practicing the analysis of camera movement and editing; the film's landscape shots, color palette, and use of a wide variety of contrasting interior locations, from farmhouses to cafés, from a garage to the homes of Mme

Landier (Macha Méril) and Tante Lydie (Marthe Jarnias), all offer rich pickings to the analyzer of *mise en scene*.

To add to the above account of the pedagogical uses of *Sans toit ni loi*, an anecdote from last year's iteration of "Behind the Camera" illustrates how the film may demonstrate gendered authorship in action. A student writing on the title "Detail how female authorship makes itself evident in any two of the films you have studied on the module" was, in the planning stage, starting to take far too biographical an approach, by dwelling on a source she had found about Varda's personal interest in the phenomenon of homelessness and memories of having seen *routard(e)s* in French villages. But once I had pointed out that it was through her *mise en scene*, cinematography, and fiction-making capacities that Varda had transposed her memories and ethico-political concern into filmic form, then directed the student to Angela Martin's article on how Varda's *cinécriture* can found a "theory" of female authorship,[6] the student wrote persuasively and strongly about how Varda's femaleness seems to be inscribed in the textuality of the film, and gained a good mark for her assignment. It may not be an exaggeration to claim—as I now do to conclude my reflections on teaching one of Varda's best-known films—that *Sans toit ni loi* is the perfect pedagogical film. It is cinematographically experimental without being avant-gardishly "difficult"; built around a narrative (conveyed entirely in flashback) that is absorbing without overlapping with mainstream "entertainment" cinema; it features memorably polished performances from Bonnaire, Méril, Jarnias, and Stéphane Freiss that are mixed with performances by evidently untrained "actors" and combines the fiction of Mona's life and death with an expertly researched documentary *mise en scene* of rural southern France in the mid-1980s. It may indeed be the perfect "teaching" film!

Notes

1 Susan Hayward, "Beyond the gaze and into *femme-filmécriture*," in *French Film: Texts and Contexts*, ed. Susan Hayward and Ginette Vincendeau (London and New York: Routledge, 1990), 285–95.

2 Sandy Flitterman-Lewis, *To Desire Differently: Feminism and the French Cinema* (New York: Columbia University Press, 1996).

3 Alison Smith, *Agnès Varda* (Manchester: Manchester University Press, 1998); Brigitte Rollet, *Coline Serreau* (Manchester: Manchester University Press, 1998); Carrie Tarr, *Diane Kurys* (Manchester: Manchester University Press, 1999).

4 Kate Ince, "Feminist Phenomenology and the Film-World of Agnès Varda," *Hypatia: A Journal of Feminist Philosophy* 28, no. 3 (2012): 602–17; Kate Ince, *The Body and the Screen: Female Subjectivities in Contemporary Women's Cinema* (London and New York: Bloomsbury, 2017).
5 Laura Mulvey, "Visual Pleasure and Narrative Cinema," in *Narrative, Apparatus, Ideology: A Film Theory Reader*, ed. Philip Rosen (New York: Columbia University Press, 1986), 198–209.
6 Angela Martin, "Refocusing Authorship in Women's Filmmaking," in *Women Filmmakers: Refocusing*, ed. Jacqueline Levitin, Judith Plessis and Valerie Raoul (New York: Routledge, 2003), 29–37.

13

Teaching *Vagabond* (1985)

Homay King

When I teach Agnès Varda's *Sans toit ni loi* (Vagabond, 1987; hereafter *Vagabond*) in my post-war global film history survey course, I begin by asking the students a series of five questions. First: In terms of its formal and narrative style, which films from the previous decades of cinema does *Vagabond* remind you of? And is it more realist or more formalist? On a first glance, the film often strikes students as realist. Having studied Italian Neorealism, they know that such films often highlight marginal, every day, destitute characters like Mona in place of extraordinary heroes or villains, and employ non-professional actors. The witness testimonies and episodic narrative structure in turn strongly recall the conventions of documentary. The lack of a happy ending, and the sea of unanswered questions that remain at the film's conclusion, furthermore strike students as "realistic," that is, frustrating in a way that a Hollywood film would never be.

Then, however, we turn to the film's lateral tracking shots. One cannot deny their careful construction, and their beauty. The sequence of the film that introduces us to the living Mona invokes painting, a reflexive gesture associated with formalism. Mona emerges from the sea as in the Birth of Venus, and Varda, who studied the history of art, emphasizes the quotation by juxtaposing that image with postcards of nude women in a shop. At this juncture, we also remember the audio track of this sequence, in which Varda speaks in voice-over, prefacing a series of temporally complex flashback vignettes, each prompted by a different witness, that will come to tell the story of the weeks leading up to Mona's death. Here, as Sandy Flitterman-Lewis notes, is a supremely formalist narrative device: the voice-over/flashback structure, similar to the one employed by Orson Welles in *Citizen Kane*.[1] Both films begin with the death of a character whose life the remaining sequences will attempt to reconstruct. But as Flitterman-Lewis notes, this is an inverted *Citizen Kane*: we don't discover or understand much in

the end, there is no Rosebud sled to provide a clear solution to the film's riddles. Mona remains opaque—accessible only as a fragmented, "impossible" portrait, in Flitterman-Lewis's words. The pieces do not fit neatly together. In this way, *Vagabond* is a portrait similar to those Varda made later in her career out of shattered mirrors and plaster (Figure 13.1).

The second question I ask my students has two parts: What do you think Mona wants? And why doesn't she stay with the people who offer her work, shelter, stability, companionship, and love? This is when the group typically becomes more divided. Some students simply cannot fathom Mona's choices; they find her impossible to identify and empathize with. She wants freedom, they speculate, but a kind of freedom that is ultimately irresponsible, as it endangers her life and leads to nothing constructive. I bring up examples of male vagabond characters from the history of cinema: Charlie Chaplin's Little Tramp, Boudu in *Boudu Saved from Drowning* (1932), and Christopher McCandless in *Into the Wild* (2007), who died alone in the Alaskan woods after eating poisoned berries. The film nonetheless portraitizes McCandless as an extraordinary man, a bold seeker who rejected the constraints of civilization. Were these characters also irresponsible? A feminist teaching moment arises when we realize that Mona is being held to a double standard. We may or may not "like" or respect her more for it, but we now understand that women are typically denied access to the category of the Quixotic dreamer, the rebellious

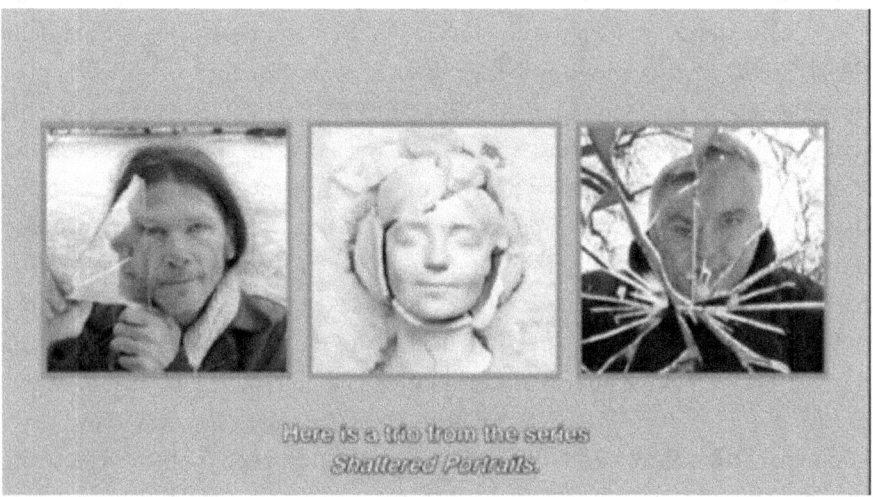

Figure 13.1 Agnès Varda's *Shattered Portraits*, as they appear in *Agnès de ci de là Varda* (Agnès Varda From Here to There, 2011).

rambler, the solitary wanderer. *Vagabond*, along with Barbara Loden's *Wanda* (1970) and Kelly Reichardt's *Wendy and Lucy* (2008), is one of the rare cinematic examples of such a story.

Next, I ask my students who or what, in their opinion, is responsible for Mona's death. The answers are multiple: a society that failed to provide a place for her, the frighteningly costumed participants in the wine harvest ritual, those who neglected or abused Mona during her life, or, as they say most frequently, Mona herself. Once again there is a feminist lesson to be learned here. Unlike in a typical Hollywood narrative film, causality and responsibility are often not as simple as a linear equation in which action A gives rise to situation B. Individual characters are not always assignable as clear agents or perpetrators of a given action; causality can be more complex. This way of understanding *Vagabond*'s story cannot easily be slotted into a typical three-act narrative with a clear actors, conflicts, and resolutions.

Furthermore, our own opinions of Mona are inevitably shaped by those in the partial accounts offered by the witnesses, who are our only "direct" point of access to her: the goatherd, who presents himself as a kind of moral compass for radical living off the grid, and who accuses Mona of "withering"; the academic who studies tree fungus, who seems to represent a kind of liberal conscientious subject; Assoun, who views Mona through the lens of love; the anonymous motorcyclists and truckers who harass her. The characters' attempts to judge Mona quickly turn, like a mirror, to commentary on their own beliefs and assumptions: smart women never travel alone; women should choose family and community over the self. As a result, the viewer's own ways of framing Mona are also foregrounded: as Varda puts it, "the audience is just continuing the list of witnesses who have seen Mona pass by"—and thus, not getting closer to her truth, but rather adding to the series of projections that have been layered onto her, which are now our sole point of access (Figure 13.2).[2]

If we say that someone else was responsible for Mona's death, we paint her as a victim—of other people, of capitalist modernity, of patriarchy or society or circumstance. Even knowing as little as we do about Mona, the victim label does not seem to fit the image of the fierce character portrayed by Sandrine Bonnaire. However, if we say that Mona is responsible for her own death, there is once again a judgment implied, as if her life was not hers to be so careless with. The film shows Mona exercising free will, in that she has opportunities to settle down, people who are willing to care for her, that she often inexplicably rejects—to the great frustration of the audience. Again, though, we need only bring to mind the figure of the male merry wanderer, so familiar in literature

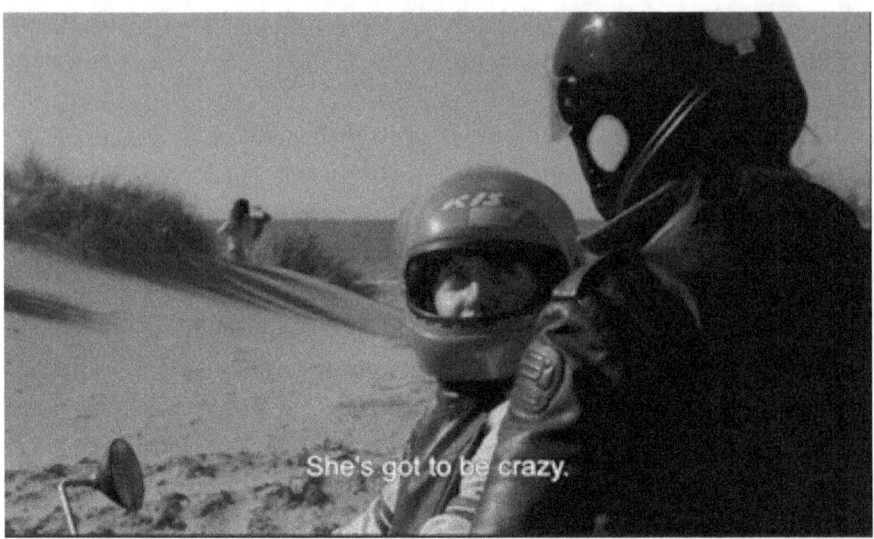

Figure 13.2 "She's got to be crazy": Mona seen by others in *Vagabond* (1989).

and art, who is celebrated as a free spirit and rebel rather than derided as careless or mourned as a victim, even when they, too, die ignominious deaths.

The witnesses in *Vagabond*, for the most part, have opinions about Mona that are reflected in their interviews, sometimes explicitly, sometimes only hinted at. But what about the film's enunciation, its discursive narrator—Varda the *auteur*, if we want to use that shorthand? Is the film itself "for" or "against" Mona, does it ever support or criticize her choices, and if so, how? This is the next question I ask my students. *Vagabond* is a masterpiece of restraint in this respect. It is difficult to find examples of editorializing or heavy-handed camera work or editing. But there are a few places where the camera does make its presence felt, showing that it has a consciousness, as well as compassion and curiosity towards Mona—independently of whether it "approves" of her or not. The clearest example occurs when Varda's camera quickly and deliberately pans away from the film's rape scene, so that it takes place off screen; we see only a cluster of pine needles. Here, an authorial point of view makes itself felt in the form of a sensitivity to Mona, and a refusal to spectacularize a scene of sexual violence. The discursive narrator's role is not to eliminate sexual violence from the story or pretend it does not regularly occur. It is simply to note what happens and do what it can to allow Mona to retain her dignity.

This scene is often a divisive one with regard to the final question I ask my students: Do you consider *Vagabond* a feminist film? For some, the film's lack of

a strong, positive female role model character is simply a deal-breaker according to their definitions of feminism. For others, the fact that the film includes a rape scene, even an off-camera one, likewise marks the film as unfeminist. But I feel that Varda and I have done our job if we can get these students to understand at least two things, even if not to change their minds. First, one cannot help but note the double-standards in the representation of solitary, itinerant women versus men—the pathologization of women who reject a roof and convention, the romanticization of men who do the same. Second, I try to convey the idea that narrative opacity is occasionally a virtue, not a flaw, nor attributable to an error in story-telling execution. Why do we want so badly to know why Mona does the things she does? Why do we search for an explanation in her childhood, her past, that is never provided to us? Why do we experience frustration at the partialness, the fragmentary quality of these broken snapshots of her life—why are we so ill-content to allow parts of her to remain a mystery? As Freud's infamous question about what women want suggests, these are feminist questions, and ones that have also been ingrained in the history of cinema, which, especially in its classical Hollywood form, has taught us that woman is an enigma in need of a good unraveling. Varda does not unravel Mona. She creates a mosaic of her, leaving the grout visible. Her feminist gesture is not to make Mona good, nor to redeem or rehabilitate her, nor finally to martyr her—it is simply to leave her alone (Figure 13.3).

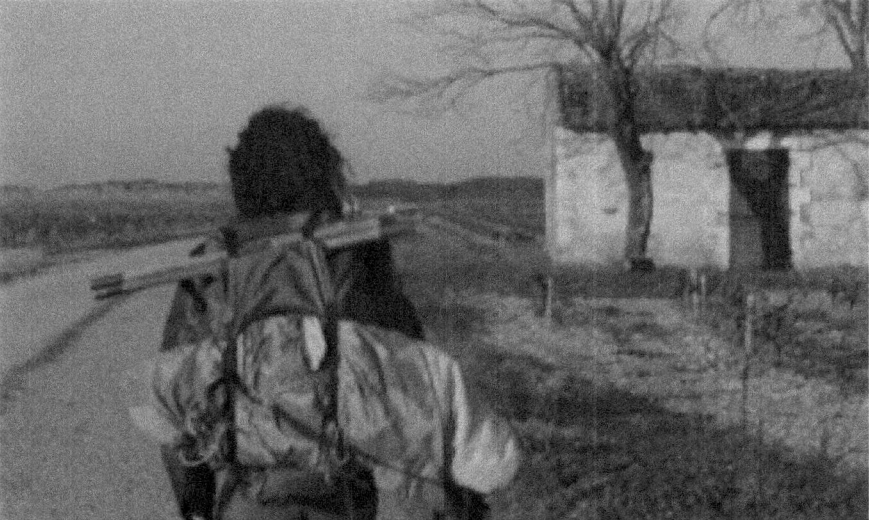

Figure 13.3 Mona with her back to the camera in *Vagabond* (1989).

Notes

1 Sandy Flitterman-Lewis, *To Desire Differently: Feminism and the French Cinema* (New York: Columbia University Press, 1996), 286.
2 Flitterman-Lewis, *To Desire Differently*, 306.

14

Cléo from Abu Dhabi to Seoul

Seung-hoon Jeong

It may not be a common opportunity to see how today's university students outside Europe respond to Agnès Varda's early masterpiece *Cléo de 5 à 7* (Cléo from 5 to 7, 1962). Luckily, I have had a unique experience of teaching this French classic in the United Arab Emirates and South Korea three times over half a century after its release. Though that was fully my choice, I was not initially sure if young, non-European viewers unfamiliar with the "mother of the New Wave" would find the film worth watching and discussing. However, they were intrigued to accompany Cléo's urban odyssey full of relatable existential anxieties and chance encounters. Their overall reception of the film confirmed that its local modernity still resonates with global contemporaneity.

My first Varda session took place in my 2017 undergraduate course "Frames of World Cinema: 1960 to Present" in the Film and New Media program at New York University Abu Dhabi. Since most students in the program belonged to the "practice" track, film "studies" courses—especially elective ones—had a small number of students. This world cinema class was also tiny but international enough, with three students from the United States, Mexico, and Jordan. The American student was a senior, a young man majoring in film and new media studies, whereas the other two were women, including a freshman deeply interested in the program.

Let me first note how the session was designed and where Varda was located. The course aimed to explore modern cinema in the national, transnational, and global frames that I have elsewhere formulated (Jeong 2019). These frames were then applied to a diverse set of national cinemas, significant directors, notable genres, and crucial debates on cinematic issues including art cinema, feminism, Third Cinema, and auteurism. Simultaneously, the theoretical investigation continued around the universal themes of love, desire, power, and the psyche on individual, familial, and mythical levels. In this way, the course did not

resemble a historical world tour of national cinemas, but rather illuminated timeless themes of human life that have been repeatedly reflected in various cinematic modes across areas and time periods. Throughout the semester, the students learned about concepts including sovereignty, Oedipalization, the flâneur, and the uncanny; these were framed through different methodologies: mythology, psychoanalysis, feminism, postcolonialism, politics, and ethics. Each week consisted of three parts: my contextual lecture in the first seventy-five-minute class, an on-campus screening followed by the students' viewing responses (posted online), and an in-depth discussion plus a final lecture in the second seventy-five-minute meeting.

Cléo from 5 to 7 was the main film for Week 5 on modern cinema, the third of four weeks under the rubric "The National Frame." The two previous weeks had examined national cinema through film art and festival, centering on *Ju Dou* (Zhang Yimou & Yang Fengliang, 1990) and *Nobody Knows* (Hirokazu Koreeda, 2004) respectively. Thus, Week 5 marked the turn from Asia to Europe, not least because the following week directly addressed European cinema through *The Double Life of Veronique* (Krzysztof Kieslowski, 1991). In the first class, I lectured on the historical and theoretical context of the French New Wave and cinematic feminism, drawing on Aristides Gazetas's *An Introduction to World Cinema* (2008) and Scott MacKenzie's edited volume *Film Manifestos and Global Cinema Cultures* (2014). The second class involved intensive discussion of the film while referring to the students' short reviews and channeling their ideas into the week's agenda. I also showed excerpts from *My Life to Live* (Jean-Luc Godard, 1962), *L'Eclisse* (Michelangelo Antonioni, 1962), *Daisies* (Vera Chytilová, 1966), *Jeanne Dielman, 23 Commerce Quay, 1080 Brussels* (Chantal Akerman, 1975), and *Riddles of the Sphinx* (Laura Mulvey & Peter Wollen, 1979).

With this framework, I positioned *Cléo from 5 to 7* at the crossroad of the so-called modern "women's films" (about women) and "women's cinema" (by women). The film pioneered a New Wave portrait of a contemporary woman from a contemporary woman's perspective, influencing a series of increasingly experimental feminist films in the 1960s and 1970s. That said, Varda's version of feminism was not yet radical, nor was she actively involved in the feminist movement. Her intuitive yet insightful camera nonetheless captured some of the most fundamental issues regarding Cléo's identity formation and crisis while opening to universal concerns over mortality and fate, love and faith on the one hand and the postwar cultural trend of existentialism and modernism on the other. In this regard, Janice Mouton's article "From Feminine Masquerade to Flâneuse: Agnès Varda's Cléo in the City" (2001) served as a rich main text

for the session. And Laura Mulvey's canonical "Visual Pleasure and Narrative Cinema" (1986) also helped introduce cine-feminism's theoretical context.

Building on Mouton's work, I started my lecture with the feminine masquerade that characterizes Cléo's identity in the first half of the film. A young popular singer, she embodies the epitome of clichéd femininity, defined and measured by her being-looked-at-ness, a fantasized object of the male gaze. She internalizes this gaze when looking in the mirror and concealing her anxiety over a pending cancer diagnosis with her auto-suggestive belief: "As long as I'm beautiful, I'm alive more than others." I explained this as an example of bad faith (*mauvaise foi*) as formulated by existentialists Jean-Paul Sartre and, more aptly, Simone de Beauvoir, who developed its feminist critique. Cléo's femininity indeed culminates in a sort of non-identity which is driven by commodity fetishism and exploited by men. Her songwriter even gives her a new song about her being "void" without a man, which determines her identity as deplorably subordinate to men and even makes it a selling point. Of course, at this moment, she feels something is wrong, expresses her anger, and leaves to take an aimless walk in the streets of Paris.

Cléo, strolling with no destination in the second half of the film, reflects the *flâneur*, a symbolic figure of urban modernity that Walter Benjamin highlighted in the poetry of Charles Baudelaire. Compared with Cléo's earlier shopping, her later wandering has no goal of capitalist consumption, but instead embodies artistic curiosity and unbound digression. It relieves a free-floating participant-observer of a modern metropolis filled with attractive distractions, sensorial stimuli, and contingent shocks. As a *flâneur*—or, rather, a feminine *flâneuse*, part of a lineage that also includes George Sand and Virginia Woolf—Cléo experiences Paris as an endless flow of such fragments of modernity while drifting over a café, an art studio, a projection booth, and a park by car and foot. No wonder *Cléo from 5 to 7* loosely recalls a cinematic version of James Joyce's *Ulysses*: it offers a nonlinear narrative of a nonteleological journey that Gilles Deleuze sees as pervasive in modern cinema. Stream of consciousness is palpably visualized in the café and street scenes where Cléo passes anonymous masses, whose perception mingles with her memory of people she knows, creating thought images in mind.

My students were especially interested in such *cinécriture*. They discussed how the camera tracks Cléo from the third-person director's perspective (we see her moving around) while, often without cutting, it also takes her own point of view in three contiguous yet divergent ways: (1) the free-indirect discourse shot (we see her and what she sees), (2) the supposed subjective shot (we see

what she seems to see), which is often confused with the objective shot (we see what is seen only from the camera's position), and (3) the precise, first-person shot (we see people looking at us), which is also doubled (we alternate between the present—people on the street—and the past, those she left behind in the apartment). The shift between these viewpoints is so subtle and flexible that even a single shot brings different filmic enunciations while forming a continuum of pure optical and sound situations, including diegetic noise and non-diegetic music. The effect, I argued, is Joycean absentmindedness: a state of mind led by metonymic distractions that take on metaphoric attractions. But it is also a cinematic experience of modern space-time that, while unfolding without limit or order, still pushes itself forward irreversibly from 5 to 7. Like Cléo, we face the arrival of an end.

What does this vociferous, unusual film about modern life tell in the end? Is it a New Wave road movie, its journey measured in psychological and emotional distance rather than the (notably limited) physical spaces Cléo moves through? I agreed with my students that Cléo's leaving home in black (after going home in white) marks a break with her self-absorbed solipsism and her narcissism, both of which are reinforced and exploited by men. She liberates herself from this caged femininity and moves toward an external new world of unknown others and things, enjoying the fullness of the ephemeral present despite an uncertain future. Thus, what matters in this journey is not any terminus but the process of opening herself to the road—not desiring immortality, but living the utmost of being-in-the-world. I connected this idea with another existentialist, Albert Camus, especially his question about the meaning of "absurd" life and his imagination of a "happy Sisyphus" (1991). Cléo's smile at the end, though brought after the doctor's assurance of her recovery, evokes the Nietzschean sense of *amor fati*: love your fate, and you'll be freed from it. Cléo might finally have become the subject of her own life by embracing its precariousness rather than avoiding it.

The students actively discussed the character of Cléo and Varda's art, showing interest in Varda's historical position in the French New Wave and the film's cultural background of cinematic feminism, literary modernism, and philosophical existentialism. Remarkably, both the female students saw the film as a coming-of-age story, empathizing with Cléo's struggle to find her true self or evolve beyond the feminine masquerade. It seemed as though they felt and said: "I am Cléo!"

My two sessions on *Cléo from 5 to 7* in Korea(n) were not radically different. In both, I chose the film to commemorate Varda's legacy after her death in 2019.

The first was a guest lecture titled "Femininity in French New Wave: Agnès Varda's Cléo" in a liberal arts course on Francophone culture at Seoul National University in 2019. The class had about 30 Korean students with diverse majors, but without any film students, as the university had no film program. Since I was invited only for that session, I led a free discussion without pre-assigning texts or requesting any follow-up work. Though some students found the film difficult due to its disorienting style and narrative, others—especially those in the humanities—commented on exciting points that they intuitively caught, such as the camera movement in the café scene and Cléo's existential crisis. I thus did some textual analysis while focusing on the universal question of life and death addressed in the film's specific literary and philosophical contexts.

The second Korean session on *Cléo* was at the beginning of my cinema studies major course on film criticism at Korea National University of Arts in 2020 under the subheading "New Wave Femininity and Cinephilia." Since more than half of the 17 Korean students were majoring in cinema studies, and the rest in filmmaking and broadcasting, their responses were very rich and scintillating. A few were brilliant in their critical insight and writing style, so I had two students read what they had written as sample reviews for collective feedback. It was also notable that many students drew attention to formal aspects: the relationship between the running time and the diegetic time, the timeline of 5 to 7 signaling the coming of sunset (death), the modernist trope of a couple's walk in the city (a New Wave motif as in *Breathless*), the possible difficulty of shooting such scenes while controlling the streets, the visual style experimenting with jump cuts, zoom-ins, rhythmic editing, frontal shots, the inclusion of a silent short film within the film that pays homage to the Lumière brothers' *The Sprinkler Sprinkled* as well as silent French and American comedies, and the auteuristic link of the film to *Vagabond* in Varda's filmography.

The students also remarked on the shift from the opening tarot card scene in color to the following depiction of Cléo's reality in black and white; the contrast between Paris's vivid flow of energy and Cléo's fixation with superstition; deterministic tarot card readings based on absurd contingency in shuffling cards; Cléo's change from escaping her fate to embracing a contingent and invasive world of floating signs and present-minded women such as a taxi driver and a nude model. Many students saw all these semantic elements leading to Cléo's rebirth as a new subject, as suggested the sequence where she takes off her glasses and smiles after meeting a doctor in an open garden (not within a rigid hospital). A student criticized the narrative for being didactic and artificially constructed but noted that the soldier figure Antoine represents intriguing

otherness and that we could imagine a companion film: "Antoine from 5 to 7." Another student wrongly associated Antoine's otherness with Algeria, and Algeria's struggle for independence with Cléo's, although Antoine is a French soldier deployed to keep Algeria under French control. So, I compared the historical context of the Algerian War against French colonialism to Korea's fight for independence from the Japanese empire, inviting students to consider how Antoine and Cléo's romantic mood hides their country's bloody history and how Cléo's existential awakening is limited to her own life.

In sum, *Cléo from 5 to 7* holds appeal for students across nationalities and regardless of gender. It may serve as a charming platform for discussing universally resonant issues of existential malaise and gendered experience, or as a historically specific product of the French New Wave, of modern cinema, or the broader contexts of modernity and colonialism. While elements of these contexts may be new to some students, the film remains accessible and hardly dull thanks to many scenes that stimulate their curiosities and sharpen their critical eyes. They may breathe in some fresh early New Wave sensibility brought to the screen by a unique female artist, who may be less known—yet no less crucial—than her male colleagues. Go global, Cléo!

15

Digital Time, Teaching Temporalities, and Feminist Pedagogies: Teaching Varda's *Gleaners* (2000) Twenty Years on

Jenny Chamarette

Les Glaneurs et la Glaneuse (The Gleaners and I, 2000; hereafter *Gleaners*) has been a key text on courses I have taught since the mid-2000s, for its political prescience; its intermedial relationships to art and visual culture; and its essayistic, auto-ethnographic approach. Digital filmmaking is of course one of the film's key subjects. More than any other, *Gleaners* has inspired me as a teacher to experiment with digital and feminist pedagogies: first in conversation with young aspiring university applicants; then via an interactive website I designed for undergraduates in the early 2010s; and from 2012 onward, to a new generation of students developing their critical expression through filmmaking and online interventions. In this short account, I discuss some feminist and digital pedagogies that have emerged out of twenty years of studying and teaching Varda. This approach is partly auto-ethnographic, placing my own development as a feminist educator, writer, and scholar alongside the ways that teaching Varda has moved and supported my students. Pedagogical strategies are, as bell hooks puts it, "not just for our students but for ourselves."[1] I need no further incentive to write myself into the picture of my teaching practices with Varda, and to write Varda into a personal history of feminist digital pedagogy.

Gleaners arrived on the curriculum while I was a final-year undergraduate in 2003: my first engagements with the film were also therefore as a learner. My burgeoning interest in Varda and French cinema in the latter two years of my degree continued during my master's and PhD on French cinema and continental philosophy. Varda entered my PhD through *The Gleaners*, which then expanded into an interest in *La Pointe Courte* (1955), *Cléo de 5 à 7* (Cléo from 5 to 7, 1962), *Le Bonheur* (Happiness, 1964), *Daguerreotypes* (1975), *Sans Toit ni loi* (Vagabond, 1985). I gradually gained access, through research trips to

Paris, and as Ciné-Tamaris digitized and made them available for redistribution or sale, to less well-known work: *Salut les Cubains* (Hello Cubans, 1964), *Ulysse* (Ulysses, 1983), *Ydessa, Les Ours et cetera* (Ydessa, the Bears, etc., 2004), *L'Une chante, l'autre pas* (One Sings, the Other Doesn't, 1977), and *Documenteur* (1981). The foundation of my thesis and postdoctoral work was Varda's turn toward installation art from the mid-2000s.

Seeking out additional income during my PhD, I taught taster sessions on French cinema for school pupils aged fourteen and upward, using sequences in *Gleaners* where Varda explores the technical and aesthetic capacities of her then-new digital camera, and where she films people collecting leftover fruit and vegetables at outside markets in Paris, accompanied by a hip-hop soundtrack. Over two to three years, I lead sessions for hundreds of pupils, largely comprising small group brainstorming sessions on how they would describe the images they saw, what it made them think of, and how it made them feel. The responses were as varied as one might imagine, but one set of comments remains with me. By which I mean to say that it raised my heartbeat, left me perplexed, bemused and wanting to learn more. In the shared reporting exercise that ended the session, one student group expressed the view that this film was not made with them in mind; that it was not to their taste, not *for* them.

I doubt that Varda had British adolescents in mind while she was making a film about subsistence living and her relationships to aging, to her own marginalization as a female filmmaker, and to marginalized groups in France. It is also true that I did not consider the students' cultural interpellation into *Gleaners* when I chose to teach it. The material deeply interested me, and I selected these short, pithy sequences because they focused on a wide range of aesthetic audio-visual techniques. Audience address was not something I had considered in my pedagogical choices, or at least, not as a means of assuring positive evaluations of taste. At the outset, I wasn't interested in whether students *liked* the film or not. I have also never been interested in researching or teaching material that fits comfortably into standard expectations of what a film is or should be; I am aware that expectations shape taste, and vice versa. Part of the point of the exercise was to expose students to unfamiliar material that might challenge their ideas of what cinema is or could be. I remember feeling surprised, and a little annoyed that the students' *expectation* was that the work should provide a direct address to them, or that they should like it; this seemed to my mid-twenties self like an adolescent form of narcissism. But this also betrays a degree of defensiveness of my own part, the fear of not being taken seriously that is a common feminist complaint.

Fifteen years later, my reflections are less concerned with the collective desires of young people to engage with film work that directly addresses them, or my obligations to provide material that falls within their expectations, and more toward the dynamic relationships between teachers and teaching institutions that this comment underlined. What space facilitated this evaluation of taste, preference, and interest? It takes a great deal of courage, when working with a teacher you have only just encountered, to cross the unstated power lines of a classroom, and state unequivocally that you do not like what has been offered. But then, had I been an older man, wearing a suit and tie, would the students have delivered this comment at all? How did that response sit, in a one-session class, compared to the sustained learning practices that they had acquired in primary and secondary education? I notice how meaningful excitement and pleasure were to this group of school pupils, and how, trained in a traditional university educational environment, I had already absorbed the sense that, in bell hooks' terms, "*Excitement* in higher education was viewed as potentially disruptive of the atmosphere of seriousness assumed to be essential to the learning process."[2] And yet perhaps what the students had also absorbed is the traditional formation of a classroom, where (hooks again) "only the professor is responsible for classroom dynamics" and, by consequence, pleasure.[3]

Since 2005, I have taught *Gleaners* at three UK Higher Education institutions, to learners of French and to students with no French language training, on courses about European cinema, contemporary French cinema, auteurs, and essay films. That teaching occasion remains with me as a pivot point, where I learned about my teaching style, about student expectations and gendered assumptions, about classroom dynamics, and, most significantly, about pleasure (and displeasure) as a feminist pedagogical tool. The purpose of teaching *Gleaners* often aligned with other feminist desires, too: to introduce film as a serious subject of study to a curriculum more broadly concerned with literature, to introduce women filmmakers to a male-oriented curriculum, to introduce non-English language films to a predominantly Anglo-American canon, to talk about personal essay films made with non-professional digital cameras, rather than consider high production values as a *de facto* marker of aesthetic distinction. Talking about *Gleaners* made it possible to discuss how digital camera technologies enacted a shift in the feasibility and budgetary demands of filmmaking in the 1990s and early 2000s, and more specifically how Varda made use of this discursively in *Gleaners* as a moment of pleasurable critical self-reflection.

Pleasure, engagement and digital cultures come together in more than one of my pedagogical journeys with Varda. The point at which I started teaching

Gleaners took place a year or two after the arrival of Web 2.0 or social media, a term that Sam Han describes as "a 'new' regime of media, identifying a new tendency in the development of software and applications on the world Wide Web but also technological devices."[4] The interactive and participatory functions of Web 2.0 were also at the beginnings of the insurgent empire now known as EdTech,[5] and emerged alongside new critical digital pedagogies,[6] which were taken with increasing seriousness over this period. In 2011, aware of the critical need to develop my own digital literacy, I undertook a Certificate of Humanities Computing for Languages at the University of Cambridge during my time there as a temporary teacher and postdoctoral researcher.

One advantage to have taken this course at an early stage of Web 2.0's development is that I learned how to use basic code, such as HTML, XHTML, and CSS. This served me well when I went on to teach students how to use the rudimentary code that is the basis of Wikipedia,[7] and has left me unafraid of acquiring new digital languages as time has passed. I was taught to understand code principally as a language, which made sense to me as a modern languages graduate. The rules of HTML, the ability to read and parse it into comprehensible units of function, and the thrill of then producing a digital object that reflected the material I had written, were all part of my process first of acquiring coding language, and then using it to create rudimentary digital artefacts. I pieced together an interactive teaching tool designed to support undergraduate student learning about *Cléo de 5 à 7*, at a point where film was being introduced into the core first-year undergraduate curriculum in French for the Modern Languages degree. Without a content management system to fall back on, I used ready-made (and now obsolete) Flash JavaScript-led add-ins to provide video containers for moving image content, transcribed and illustrated a short section of a lecture I gave regularly on *Cléo* and structures of time, and provided podcasts, videos,

Figure 15.1 (See p.165) Sample screengrabs from the *Cléo de 5 à 7* teaching resource developed in 2011, showing details of the website's design, including font, colors, margin arrangements, menu options at the top from left to right, and a smaller range of useful links along a right-aligned column that corresponded to relevant text in the main left-aligned column. While the Internet Wayback Machine did not preserve audio-visual content (presented by the white rectangles), the original website deployed readymade containers using Flash and JavaScript code for films, recordings and other material by and about Varda. At the time, integrating digital and textual interfaces in this way was considered highly innovative, especially as a precursor to the Virtual Learning Environments that were being introduced into UK universities in the early 2010s. Source: http://web.archive.org/web/20141125171710/ http://www.mml.cam.ac.uk/call/french/cleo/Project_2_New%20Wave.html.

links, and embedded texts on key topics (Cinematic Time, The French New Wave, Varda's life and filmmaking), together with a short linked bibliography for students who wanted to learn more.

In 2011, the Modern and Medieval Languages and Linguistics Faculty at Cambridge had not yet widely adopted a virtual learning environment: the website was therefore considered a highly adaptive digital pedagogical tool. For several years after my departure in 2012 for a permanent academic post, and until the university and faculty Content Management System (CMS) was overhauled in 2017, the website was widely adopted as a teaching resource for the French undergraduate programs in Cambridge. Sadly, after this point, the website was not migrated on to the new CMS, but material evidence of the site remains via the Internet Archive's Wayback Machine. Figure 15.1 gives an indication of the look and feel of the site (though without the video and image content). A decade is long enough for most detailed aspects of digital activity to become obsolete—this is a subject of critical enquiry in digital pedagogies, where digital artefacts have short lifespans because of the lack of durability of the code on which they are based (one key example is the ongoing deprecation of resources created in Adobe Flash, which affected my site too).[8]

Digital time and digital materiality became ongoing concerns in the next decade of teaching Varda. While I struggled with technologically unwieldy early versions of Virtual Learning Environments (VLEs) in my employing institutions from 2012, I also saw a rapid transition in my students' digital awareness. By 2019 most students had used VLEs since their early time in secondary school—they were, to use Marc Prensky's controversial term, "digital natives."[9] But regardless of students' digital literacy, digital obsolescence remained a continuing concern. At the start of the 2010s, the DVD copy of *Gleaners* or Varda's other collected editions in university libraries were the go-to resource for film students. Now, past the end of this same decade, most students do not have access to a DVD player, leaving a gap in provision between the VLEs and the legal streaming services available to university institutions. By 2015, students were in many instances shooting their own films on digital SLR cameras with resolutions so high that they could quite easily imitate the production values of commercial filmmaking. More recently, the typical student smart phone (which my students used in practice-based modules on the essay film) now significantly outstrips Varda's early 2000s digital camera in performance terms. Thus, what appeared in students' essays on *Gleaners* were unwitting reminders of the digital *age* of born-digital technologies; phrases denoting the distant past, or "old technologies" occurred

with increasing frequency. *Gleaners* has developed qualitatively different temporalities for university students born at the time of its release; their lives have been immersed in web-based social media from an early age, and their technological assumptions are at present reliant on high quality broadband, streaming services, and phone-based filmmaking.

Twenty years on from *Gleaners*, the digital temporalities of teaching Varda have shifted significantly. In the last few years of her life, Varda embraced social media, notably in her collaboration with artist JR in *Visages villages* (Faces Places, 2017), where selfies and reposting to social media are crucial for the communities they visit in transmitting, receiving and discussing the images they wheat-pasted in villages and other rural locations around France.[10] It is fitting that my teaching of Varda has coincided with the emergence of a critical digital consciousness, in particular an awareness of the rapidity of technological obsolescence and the precarity of information literacy. As Cecilia Rodríguez Milanés and Aimee DeNoyelles write, "a foundational element of feminist pedagogy is to conceive knowledge as evolving and social."[11] It has been to my delight that teaching Varda, even teaching the same film, has never remained static, always shifting in emotional resonances, pedagogical pleasures and digital technological aptitudes, together with the students it has been my honor to teach.

Notes

1 bell hooks, *Teaching to Transgress: Education as the Practice of Freedom* (New York: Routledge, 1994), 134.
2 hooks, *Teaching to Transgress*, 7.
3 Ibid., 8.
4 Sam Han, *Web 2.0* (Abingdon, OX; New York: Routledge, 2011), 5, http://site.ebrary.com/id/10551357.
5 Martin Weller, *25 Years of Ed Tech, Issues in Distance Education Series* (Edmonton, AB: AU Press, 2020).
6 Sean Michael Morris and Jesse Stommel, *An Urgency of Teachers: The Work of Critical Digital Pedagogy* (United States: Hybrid Pedagogy, 2018).
7 My pedagogical work in this area was recently recognized as a national case study for Wikimedia in the UK: see Ewan McAndrew and Sara Thomas, eds., "Wikimedia in Education": (Wikimedia UK and University of Edinburgh, January 1, 2020), https://commons.wikimedia.org/wiki/File:Wikimedia_in_Education_-_Wikimedia_UK_in_partnership_with_the_University_of_Edinburgh.pdf.

8 Email correspondence, Jacob Baldwin and Jenny Chamarette, "[School of Arts and Humanities] Re: Seeking Information on Archived Website Formerly Hosted by CALL Centre (2011 Onward)," January 7, 2021.
9 Marc Prensky, "Digital Natives, Digital Immigrants," *On the Horizon* 9, no. 5 (2001).
10 See Delphine Bénézet, "'Varda En Vadrouille/Agnès on the Road Again,' an Extended Review of *Visages Villages* by Agnès Varda & JR (2017)," *Contemporary French and Francophone Studies* 22, no. 4 (August 8, 2018): 406–17, https://doi.org/10.1080/17409292.2018.1537603.
11 Cecilia Rodríguez Milanés and Aimee DeNoyelles, "Designing Critically: Feminist Pedagogy for Digital / Real Life," *Hybrid Pedagogy*, November 5, 2014, https://hybridpedagogy.org/designing-critically-feminist-pedagogy-digital-real-life/.

16

Gleaning with Visible Machines: Teaching Digital Cinema and Embodiment with Agnès Varda

Michael Cramer

My teaching of Varda's *Les Glaneurs et la glaneuse* (The Gleaners and I, 2000; hereafter *Gleaners*) occurs in a perhaps-unexpected context, namely, a course titled "Cinema in the Digital Age." While the films studied in the course range from art cinema experiments (Peter Greenaway's *Tulse Luper Suitcases*) to mainstream explorations of digital video's photographic potential (Michael Mann's *Miami Vice*), the emphasis is, as one might expect, on the near-ubiquitous use of computer generated images in contemporary cinema and the challenge they pose to classical film theory that insists on cinema's specific capacity to engage with physical reality. Early course readings include selections from Siegfried Kracauer and André Bazin, as well as Dudley Andrew's *What Cinema Is!*, so students have ample exposure to these theories. What is essential to my approach to *Gleaners*, then, is its particular context within the syllabus (in juxtaposition with numerous CGI-driven blockbusters from *Terminator 2* to *Avatar*) and its very different use of the digital in respect to most of the films studied. Yet this seeming opposition can also be used to discuss how radically different uses of digital technology bring up the same theoretical and philosophical questions.

Varda's film, unlike the average CGI blockbuster, insists on the continuing relationship between cinema and our actually existing, historical world, as well as the important tension between its objective, contingent existence, and the filmmaker's subjectivity. She continues to adhere to "the *Cahiers* [*du cinéma*] axiom," namely, that "the cinema has a fundamental rapport with the real and that the real is not what is represented,"[1] providing evidence of its continued relevance in the digital age, not as something that is now lost or has been drowned out through the digital animation and sets that have replaced

the real in most recent cinema, but rather gains new strength through digital technology.

Varda's reliance on the world she discovers around her (as opposed to one that is completely created by the director) and her simultaneous insistence on using it as raw material for a highly subjective aesthetic creation (the two key components of the *Cahiers* axiom), of course far predates her turn to the digital, and indeed has characterized her entire career, from her juxtaposition of highly controlled and scripted scenes with documentary realism in *La Pointe Courte* (1955) to her essay film on her neighborhood in Paris, *Daguerréotypes* (1975). Yet with *Gleaners*, something essential changes: the camera becomes freer and smaller, now more easily transportable and fully detachable from the power source that limited (albeit in a productive way) her movements while filming *Daguerréotypes*. Furthermore, the camera gains a new kind of relationship with the human body, graspable in the hand, more fully realizing its status as a kind of prosthetic, not only in McLuhan's terms as an extension of human perception, but as something that quite literally achieves a physical intimacy and material continuity with the human body; indeed, at times the camera becomes a metonym for the body, as when Varda speaks of "one hand filming the other hand."

Varda of course stresses these capacities in her film, highlighting her new digital camera within the first ten minutes. While she does note the aesthetic possibilities of digital video, the film ultimately directs most of its attention to the possibility of "gleaning" with the camera, penetrating into the real and gathering together its scattered fragments, finding new value and potential in them, just as the film's subjects collect and repurpose the discarded items they glean. Again, this is not a unique capacity of digital cinema, but as Markos Hadjioannou notes in one of the readings I assign for the class on Varda (Chapter 5 from his book *From Light to Byte*), the film represents it specifically as such, depicting "The act of capturing images with a digital camera as an activity through which the world is continually archived, through the immediate ability to glean images and to subsequently encounter the subject-world relation as a creative activity."[2] While it is essential that what is "gleaned" and archived is not the creation of the filmmaker herself, but is found as-is, the act of creation is at the same time emphasized throughout the film, as when Varda constructs a tableau vivant of herself as a gleaner, or simply in the way in which various discourses (legal, aesthetic, economic) about gleaning are juxtaposed with one another; here the concept of the archive, often associated with digital media, takes on a leading role, insofar as she gleans not only film images but other texts and images that

she juxtaposes with her own. The line between the objective and subjective, however, is often also blurred, as aesthetic creation seems to be found ready-made in what is gleaned, such as the famous heart-shaped potato or the water spots Varda sees on the ceiling. Here too though, the presence of the subject is of course required to change the significance of these phenomena, to recognize them as aesthetic and therefore as perceivable and indeed "usable" in a way that is not inherent to them.

This discussion of contingency versus control, or the objective real vs. the creative work of the artist, is then placed within the context of an earlier course reading, namely, Lev Manovich's *The Language of New Media*. For Manovich, digital imaging technology gives the filmmaker unprecedented control over the image, one that he exalts as bringing cinema closer to painting.[3] In this context, painting is situated as a process of autonomous creation, which leads to a productive contrast with Varda's use of painting in *Gleaners*. For Varda, there is indeed painting in cinema, yet it is always characterized as an act that maintains a tension between the objective and the subjective: whether in Millet's realist painting of gleaners or in the filmmaker's aforementioned tableaux vivants (which, rather than assuming a clear opposition between painting and cinema, invite us to expand our conception of what a painting is), painting becomes another term for mediation between subject and world, in some ways very similar to cinema, rather than an act of human mastery that could be opposed to the contingency of cinema, as Manovich characterizes it.

This concludes the first section of the class, which is primarily focused on Varda's difference from and challenge to frequent usages of and discourses about the digital. At the same time, her film can be used to undermine this dichotomy, insofar as the question of the object/subject relationship is at play in Manovich's argument just as much as it is in the *Cahiers* axiom, albeit with a shifting of emphasis to the subjective pole. Both conceptions of cinema ultimately grapple with the same question, namely, how the human body itself relates to the image, whether photographic or computer-generated. In both cases, the body remains essential, as in Manovich's emphasis on artisanal techniques and the use of the hands in particular, or in Varda's stress of the connection between camera and not only the eyes, but also the hands, as in the line mentioned above about one hand filming the other, and in the many images of the director's aging hands.

Digital cinema has the potential to remain tied to the body (or indeed strengthen the ties between camera and body) in a way that belies its supposedly immaterial or disembodied quality. The class approaches the question of embodiment and cinema (digital and otherwise) through the work of Vivian

Sobchack (with portions of *The Address of the Eye* and the essay "The Scene of the Screen: Envisioning Photographic, Cinematic, and Electronic 'Presence'" from *Carnal Thoughts*),[4] focusing on her arguments concerning the camera's status as an embodied perceiver that functions analogously to the human body in such a way that allows for a specific bond between the two, a blending or mixing of two embodied perceptions.

The class thus turns to the question of how digital technology might change this relationship, and here again I refer to material encountered earlier in the course, this time Léos Carax's *Holy Motors*. Carax's film grapples with questions of medium and the current state of cinema, but often approaches them in terms of the human body. Perhaps most relevant to the discussion of Varda's film is a line uttered by one of Carax's talking cars in the final scene of the film: "People don't want visible machines anymore." For Varda, both camera and body are visible machines, possessing embodied existence, hence allowing the parallel between the two that Sobchack insists is essential to cinema. Both then—and I will return to this point in just a moment in more detail—are subject to the kind of mortality or decay that preoccupies Varda in *Gleaners*. It is also this capacity for decay that links both camera and filmmaker to the objects that are gleaned in the film, particularly the food that is in the process of going bad. What links the perceiving camera and filmmaker to the world is not only a visible body, but a susceptibility to the ravages of time.

I ask the students to consider this idea in respect to another scene in Carax's film, namely, the one in which Denis Lavant performs with a motion capture apparatus, his acrobatics "translated" into the computer-generated image of a dragon. In both Varda and Carax's films, the body remains central to cinematic production, yet in the latter it is transfigured, changed into something that is ultimately disembodied, without physical volume. But might this not lead us to question whether the human body can still be conceived of as limited to physical embodiment, instead extending itself to the domain of the image, which becomes a kind of second body that is not necessary any less "real" or "mine" than the fleshy one?

This second body, though, is no longer subject to the kind of decay that constitutes one of the main concerns of *Gleaners*: it exists outside of time, and is no longer subject to death. I conclude the class by considering how the question of mortality informs our conception of cinema as a medium, a question, of course that has been present since its inception (and which inevitably refers us back to Bazin). Once the tools of filmmaking cease to be "visible machines" and instead take the shape of algorithms and binary code, do they lose their capacity to connect us with *our* world, and thus with history itself? On the one hand, Varda

insists on the digital camera's capacity to continue to do so: at this point in the class, I show a scene from Varda and JR's *Visages villages* (Faces Places, 2017) in which the artists place an enlarged paper print of a photograph taken by Varda in the 1950s on a fragment of a bunker lying on a beach in Normandy. Like the body of the man in the picture (now deceased), the print washes away, demonstrating its subjection to decay and disappearance. Unlike a still photograph (and indeed, unlike a CGI image or a painting), the movie camera (digital or not) can capture this decay as process; both camera and its subject remain not simply embodied, but embodied in time. Yet there is also a profound melancholy and sense of loss expressed in the scene, due not only to the mediation on death and decay, but also a suggestion that cinema's unique capacity to represent these processes may be dying out: "the image had vanished. We'll vanish too! The film won't be finished," Varda laments, perhaps implying that with her death (and that of others of her generation who still embrace the *Cahiers* axiom), this sort of film will never be made again.

Again, this is of course not a capacity unique to the digital camera, but its attributes, particularly the ones highlighted by Varda—its size and ability to closely connect to the human body—seem to *increase* its mortal character, as though at the moment at which it might transcend its reliance on the physical world, and indeed its own physical support on the film strip, cinema somehow becomes even more embodied, more human. The question remains, though, as to whether digital cinema can retain the capacities of its forerunner in the longer term.

I suspect that for Varda, the answer to this question ultimately had little to do with the capacities of the camera alone (whose continued capacity to fulfill the *Cahiers* axiom she amply demonstrates), but instead was a question of the status of the world itself: if the motors behind our reality are no longer physical, no longer "visible machines" but disembodied information, is a cinema that conceives of the real as physically embodied still relevant or still in possession of the same capacities it held during the twentieth century? *Visages villages* suggests that the question of physical decay and the passage of time are closely linked to forms of labor and production, insofar as the film spends considerable time attending to the material processes that underlie our reality. The old world of industrial labor (represented in the film by the now almost-empty lodgings of coal miners) seems to have vanished, much like Varda's photograph. Yet her attention to the port of Le Havre and its dock workers, who unload the shipping containers that flow through the veins of global trade, reveals the insistent physical reality that still underlies an information-age economy; the link between the containers and the

body is rendered explicit as Varda and JR post a photomural of the dockworkers' wives onto the containers, inside which the women themselves sit. The laboring body and the intransigent weight of material objects do not disappear in the digital age, but instead have become further occulted and deprivileged, fully replaced by a spectacle that largely denies their existence, a spectacle of which a weightless and infinitely manipulable CGI cinema constitutes a major part. Perhaps only the camera that is aware of its resolute physicality, its status as "visible machine," and its subjection to time and decay, is adequate to fully capture the material processes that have become largely irrelevant to CGI-driven contemporary cinema. This camera, however, can certainly be a digital one, as Varda shows, and indeed, a digital camera may be more up to the task than yesterday's far more weighty machines.

I wonder, as I write this, where the camera that Varda depicts in *The Gleaners and I* might be; I certainly do not know, but I do know that it is more than a string of numbers stored on a computer, and that its dusty, likely moribund plastic body waits somewhere to be gleaned, made to see again by those who still recognize the necessity of visible machines.

Notes

1 Serge Daney, quoted in Dudley Andrew, *What Cinema Is!* (Oxford: Wiley Blackwell, 2010), 5; also see Andrew 4–11.
2 Markos Hadjioannou, *From Light to Byte: Toward an Ethics of Digital Cinema* (Minneapolis: University of Minnesota Press, 2012), 203.
3 Lev Manovich, *The Language of New Media* (Cambridge, MA: MIT Press, 2002), 304–8.
4 Vivian Sobchack, *The Address of the Eye: A Phenomenology of Film Experience* (Princeton: Princeton University Press, 1992); Sobchack, *Carnal Thoughts* (Berkeley: University of California Press, 2004), 135–64.

17

Teaching *Le Bonheur* (1964)

Jeremi Szaniawski

How many films are truly shocking the way Le Bonheur *is?*
I don't think there are any others.

– A. S. Hamrah[1]

While teaching some films by Agnès Varda is pure pleasure (not least the pleasure of having some students discover this singular and most powerful cinematic voice for the first time, be it through the gripping song of *Cléo*, or the moving account of "gleaning" by an aging Varda herself), it acquires a perverse quality—but perverse in the most pedagogically productive way—when it comes to teaching what may perhaps be her greatest fiction film (contentious though this claim may be!): *Le Bonheur* (Happiness, 1964).

Students pick up something ominous starting from the film's striking opening, with its iridescent sunflowers set to the music of Mozart (played by the clarinet quintet K591), in the quasi-blinding gorgeousness of the colors, in the aggressive editing that cuts from a close-up of a lone sunflower to a shot of more sunflowers with the family arriving, out of focus, in the background. *Le Bonheur* immediately suggests a tone that will be anything but sentimental despite the bucolic, pastoral surrounding. The family, all dressed in red, advances toward the camera almost in the manner of George Romero's living dead that would come out a few years later (though in stark black and white)—a film whose lasting reputation owes as much to its political resonance vis-à-vis late 1960s America as it does to its zombies. Varda's own ruminations about Vietnam and civil rights were not far around the corner, and with *Le Bonheur* she levels a perceptive and bitter charge against late capitalism by using and subverting the system's own idioms, elsewhere robustly engaged by Jean-Luc Godard: the imagery of commercials, of billboards featuring smiling workers drinking Coca-Cola and their beaming housewives cooking at home next to the latest washing machine.[2]

But unlike Godard, whose irony is palpable and whose political positions have consistently been marked over time, Varda refuses to procure a direct moral position, something we/students are so used to in mainstream cinema. There is, in *Le Bonheur*, this very destabilizing denial of a clear perspective in which the viewer can feel safe. Working-class life is depicted just as joyfully and colorfully as it is in the ads Godard denounced, and nowhere is there a clue that this consumerist hedonism is being criticized.

Decades before Kubrick cast a real-life couple in *Eyes Wide Shut*, Varda casts Jean-Claude Drouot (of *Thierry La Fronde* TV series fame), his real-life wife Claire, and their children as a happy, working-class family. That the opening credits lay this fact out immediately reminds us of Varda's talent for flaunting the borders between "fiction" and "documentary," between real life and cinema. Thérèse and François are not wealthy, but they seem to be lacking nothing: this is the France of the *trente glorieuses*, the France of full employment and paid holidays. The family loves to go for trips in their little car into nature outside of town. Although he finds nothing but happiness in his family and personal life, François meets a postal worker, Emilie, and soon the two are in love and seeing each other frequently. François has found his *bonheur*, and multiplied it with his affair. But as the French idiom has it, "le bonheur des uns fait le malheur des autres" (happiness for some creates misery for others)—or, perhaps more exactly, "le malheur des uns fait le bonheur des autres." During a picnic on a beautiful summer day, Thérèse asks François why he has been so happy of late. François, smug to the point of beatitude and evidently unaware of the consequences his revelation will have on his wife, explains that he loves her no less since he found happiness with Emilie. Shocked, but still full of love for François, Thérèse puts the children to sleep and asks her husband to make love to her, after which he falls asleep. Upon waking up, François realizes that Thérèse has gone, and after a frantic search, he finds that she has drowned in the lake—most likely (though not inarguably) a suicide. Soon thereafter, Emilie moves into the house, all but seamlessly replacing Thérèse to the apparent satisfaction of all, including the children. The film ends with the newly recomposed family walking in the woods, surrounded by equally gorgeous colors, but this time in the fall.

What distinguishes *Le Bonheur* from *Cléo de 5 à 7* or even Varda's first film *La Pointe Courte* is that these earlier films are committed to some form of straightforward emotionality, or mediate their dramatic irony through a score of devices such as the voice-over; yet, although *Le Bonheur* is unmediated in its scalding irony, the film still takes seriously its characters and their fate. For students, this matter-of-factness, amplified by the eye-gouging, exaggerated

colors and visuals, is what makes it so unsettling and often hard to grapple with. It is also a deeply chilling film in the apparently detached acting, particularly Marie-France Boyer who plays Emilie. In addition, the film's refusal to indict adultery, or to have the characters ever discuss it as problematic, tends to disturb students to this day—and it famously earned the film a ban for under-18 audiences at the time of its release, though it went on to reap prestigious awards.

While *Le Bonheur* is superficially and most obviously a social drama, with a strong Marxist critique embedded in its fabric, what I also explain to my students is that it is a fascinating revisiting of the fairy tale, and most significantly a reappropriation of the idiom by a woman. The majority of fairy tales have been codified in writing by men, much as cinema has been a male-dominated industry for over a century, and explained by male theorists and analysts. But the oral transmission of fairy tales to children was traditionally entrusted to women, though the genre was co-opted by patriarchy. Women's films have thus constituted a site of resistance to the hegemonic male gaze, and in this sense, the act of textualizing and inscribing on film what was first a matrilinear narrative domain must be understood as a potent, if understated, act of reclaiming and resistance. Varda has been keen to tackle story-telling and narration in so many ways, and the fairy tale in its many possible guises (a depressed and gravely ill *femme entretenue* who fancies herself a princess in *Cléo de 5 à 7*; the quasi-mythical vagrant in *Sans toit ni loi*) is never far away from her purview, emphasizing its political and critical dimension as a feminine genre. In many ways *Le Bonheur* is as grim a fable as can be, essentially a gothic tale of female abjuration and sacrifice, drained of melodramatic pathos yet bathed in the vibrant colors of magazine covers and consumerist advertising, the dark side of which it ironically and non-dogmatically unveils. Once upon a time, a married man with children met a woman and took her as a lover. He wanted to share his happiness with his modest and loving wife, but she preferred to remove herself from the situation. Although initially saddened by the death of the wife he loved dearly, the husband accepted her gesture, and remained a happy representative of the working class. As for his lover, she learned of the tragedy and replaced the dead wife, and they lived happily ever after.

No doubt with its charged and ironic title, the film constitutes a case in point to this discussion of the fairy tale and *merveilleux* affect lurking under the pretense of realism. But in the quasi-angelic hedonism of François, the sacrificial saintliness of his wife Thérèse, and Emilie's affectless manner as a cross between the fairy tale stepmother and the magical godmother—all of which result in the seemingly idyllic, recomposed family that closes the film—we discern an

ironic fairy tale for the late capitalist age. This contemporary fable retains the cruelty and matter-of-factness of the traditional tales, combining them with a realistic depiction bathed in oversaturated color, "more than merely gorgeous or lush, purposefully exaggerated almost as if Varda had re-painted reality to over-signify its falsehoods," as Ivone Margulies points out.[3] Tonally, we sense the film's grim and very tough worldview, extolling and denouncing female sacrifice as part of "happiness" in patriarchal culture, as the core of Varda's feminist charge and critique, as unambiguous as it is non-pontificating. The director decries the sacrifice of Thérèse while also seeing it as darkly inevitable within the constrictions proposed by this "idyllic" realm. Thérèse, of course, drowns herself at the ostensible peak of working-class family happiness: a beautiful summer day spent in the countryside, the children asleep under a sheltering net, the chance to make love to François. The image of characters peacefully reclining in nature, just minutes before Thérèse's death by drowning, recalls many a fairy tale wherein a walk in the forest (a stand-in for coming-of-age and awareness) may lead to a monstrous or fateful encounter. The moments of peaceful, loving repose suggest a wondrous, dreamlike state, just as they announce departure, separation, and indeed death (Figure 17.1).

Varda fascinates students in her approach to morality. The opposite of moralistic or prescriptive, the form and tone of *Le Bonheur* may nonetheless

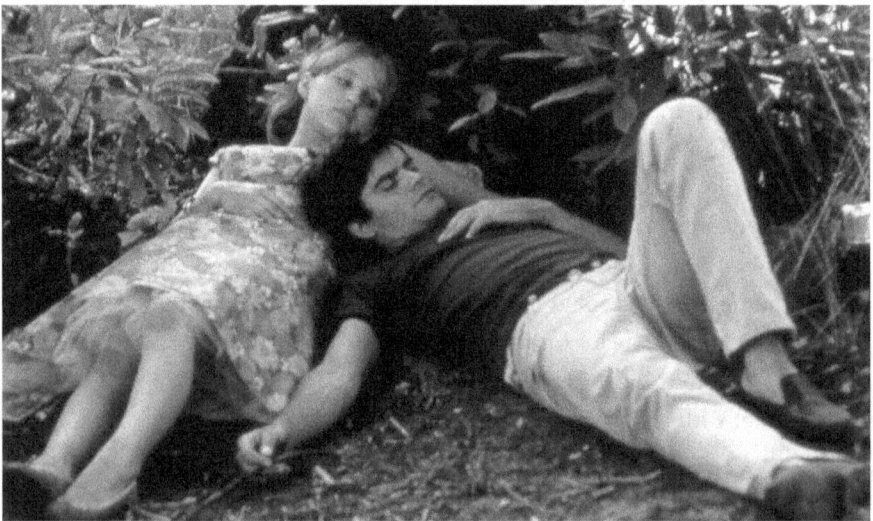

Figure 17.1 Thérèse and François (Claire and Jean-Claude Drouot, married in real life as well as in the film) reclining in nature, an idyllic image before the tragic event in *Le Bonheur* (1965; Ciné-Tamaris).

be compared to an Enlightenment thinker's tale; indeed, her symmetric, ultra-classical, almost sinister use of Mozart to the image of sunflowers, in the opening credits, hints at this. In its critique, *Le Bonheur* stands on par with Voltaire's ironic stories and the stark *moralités* of La Fontaine's Fables. Varda subverts patriarchal morality by a demonstration *à l'absurde*, overlaying it with commentary that better reveals her non-prescriptive feminist view. The purportedly edifying content remains central, which remains a staple of the male imposition on the genre: the need to sanction, prescribe, or prohibit. Varda spikes this patriarchal frame from within, in her pursuit of a genuine voice and gaze liberated from the constriction of the male/patriarchal model, pitting herself against and in distinction from it. All the while, she illustrates the predicament of the mother/wife/female subject, mortified to the point of self-destruction when she finds herself unable to conceive of a future reconciling the traditional patriarchal family structure, her duties and role therein, with the "free" love model François proposes.

While some critics and students see the film as horrifying[4]—and indeed, the diegetic proceedings constitute a feminist nightmare, in line with Ira Levin's *The Stepford Wives*—it doesn't do the film justice to reduce it to mere horror. *Le Bonheur* is also a masterful and ironic feminist critique and demonstration: Varda is in equal parts sincere, earnest, and ironic; she simultaneously delivers drama and scathing rebuke of its narrative model, while also honoring the richness and complexity of existence. This richness comes through in the celebration of nature (a nature that is both indifferent and non-indifferent), with which she bookends the film, and in her choice of Mozart for the soundtrack, which she intended to capture "a certain conception of happiness, like this seductive music, which yet is ever so slightly heart-wrenching."[5] Varda's *Le Bonheur* reaches the same heights of emotional and intellectual complexity as Mozart's music. It is a teacher's supreme pleasure to see students not only just intellectualizing, but feeling this complex work of art. They may be shocked, upset, or simply uncomfortable at first, but somehow they end up being grateful for the experience.

Notes

1 AS Hamrah in Hamrah, AS; Barber-Plentie, Grace; Chamarette, Jenny; Reardon, Kiva; Elkin, Lauren; Labidi, Samia; Flitterman-Lewis, Sandy; Heti, Sheila (8/4/2019). "After Agnès Varda: A Discussion." AnotherGaze.com. *Another Gaze*. Accessed 12/19/2020.

2. See Emilie's (Marie-France Boyer) de-eroticized, aseptic beauty, akin to models used to extol the virtues of modern home appliances and consumer durables in commercials decried by Debord, Barthes, Lefèbvre, and Godard.
3. Margulies, in Szaniawski, "Once Upon Her Time?" in *Women Filmmakers across Worlds and Generations* (London: Bloomsbury, 2019), 381.
4. "a horror movie wrapped up in sunflowers, an excoriating feminist diatribe strummed to the tune of a love ballad. It's one of the most terrifying films I've ever seen" (Jenny Chamarette in Hamrah, AS; Barber-Plentie, Grace; Chamarette, Jenny; Reardon, Kiva; Elkin, Lauren; Labidi, Samia; Flitterman-Lewis, Sandy; Heti, Sheila (2019-04-08). "After Agnès Varda: A Discussion." *AnotherGaze.com. Another Gaze.* Accessed 2020-12-19.
5. "Une certaine idée du bonheur, comme la musique séduisante de Mozart qui pourtant pince le cœur." Booklet of the 24 DVD "Agnès Varda. L'intégrale" box set, ARTE video, p. 16.

18

Vardian Lessons:
From Sea to Screen and Beyond

Nadine Boljkovac

On June 29, 2014, I was in Paris. Just before 6pm, I took the nearest available seat, and second last, in the basement screening room of the famed cinema, Le Champo. My spot was one of two seats near the back door, behind the regular rows. As I had learned of the screening immediately prior to its start in the *Cinéscope* of the now-defunct Wednesday weekly *Pariscope*, I rushed across the city and entered just as Agnès Varda was concluding her introduction. When she finished, Varda walked from the screen to the back of the room while the audience anticipated the start of her *Sans toit ni loi* (Vagabond, 1985; hereafter *Vagabond*). In the dark, a few short feet from where I sat, Varda paused at the door with her entourage. They left while Varda remained, approached, and then took the seat next to mine as the lights dimmed. And so, at the legendary Le Champo, as « un film de [sic] agnès varda » flashed, I was seated next to La Varda.

Varda did not remain for the duration, but she was there for the first minutes. Joanna Bruzdowicz's score began with the extended first shot. Against the strings' dissonance, the camera's slow zoom and slight pan right counters the leftward sway of the trees and smoke blowing across the vineyards in foreground and further afield. In a film of thirteen leftward tracking shots, a deliberately jarring direction for Western viewers, this early, isolated rightward trajectory of the camera momentarily resists the leftward movement as it scans the landscape in extreme long shot.

This stark shot evokes the opening image of Chantal Akerman's final film *No Home Movie* (2015). As cinéportraits that surpass conventional dictates of

My warmest thanks to Feride Çiçekoğlu and Colleen Kennedy-Karpat for their uncommon kindness and friendship, and to Sandy Flitterman-Lewis, our wondrous link.

(auto)biography, Varda and Akerman's elegiac films offer formally inventive glimpses of women in various cultural, economic, and societal circumstances. Further to Raymond Bellour's delineation of cinematic self-portraits vis-à-vis subjective cinema and (auto)biography, notions of the latter give way, in Varda and Akerman,[1] to incomplete portraits, to nonlinear, more authentic and accumulative palimpsests. A tripartite formulation, parallel to Varda's passion for triptychs,[2] comprised of an artist's humility, respect for subject and trust in spectator, aids in the creation of an open-ended portrait rather than the presupposition of an ostensibly authoritative account. The endurance and survival of these women—Mona (Sandrine Bonnaire), Varda's fictive vagabond, and Natalia, Akerman's mother, and Varda and Akerman themselves—onscreen and beyond, testify to the artists' ethical commitments in realizing a thorough osmosis between illusion and reality throughout their careers and lives.

With its first cut, *Vagabond* begins its leftward track in a medium long shot. The movement accompanies a man seen in the first shot. As he works the vineyard, he stoops, stops, and glares offscreen, low screen left. Shot three reveals the object of his gaze and shock with a cut to Mona's dirty corpse in a ditch, as deserted in death as in life. Sandy Flitterman-Lewis observes, following Varda's explanation of her film, that

> Varda gives us the total inversion of Welles' masterpiece [*Citizen Kane*, 1941] in *Vagabond*: a young, poor vagrant woman is dead. She died in a way we don't understand. We don't discover so much, just some pieces of her life and finally it is just a pagan ritual of the vine.[3]

Mona, said vagrant, seems to have come from the sea. The same might be said for Varda herself. As a multimedia artist uniquely attuned to people, places, and things from the minute to the cosmic, Varda embraced her encounters with an openness that provides a template for empathetic survival. As a lifelong "student," her practices transitioned with technological inventions and developed ever-new forms. All the while, Varda demonstrated how a lifetime spent innovating can also inform life itself.

I quickly learned that one does not "teach" Varda. When I share her images and words, my students and I attempt to adopt Vardian qualities of openness and grace. We listen with Varda, and consider how learning, teaching and life are codependent realities and experiences. Art, Varda's own seems to suggest, cannot hope for impact or profundity without intimately connecting with the lives she depicted.

From the earliest days of her career as a photographer, Varda was an intuitive portraitist who questioned and listened closely to her subjects. Mona's portrait is, as Varda insisted, inevitably incomplete and fragmented, and therein lies its strength. Through its depiction of a strong, resistant woman, *Vagabond* performs a rare act of celebratory acceptance. The embrace of silence and ambiguity affords Mona a dignity and respect most often denied defiance, especially as borne by an unknown, dejected and rejected woman. In a story about her, constructed entirely by others, Mona emerges, even as she becomes submerged in metaphoric and literal dregs, as a transient without possession. She has neither shelter nor law, and seemingly exists without need of another. Without anyone, Mona has self-exiled. Vitally, Varda ensures that Mona retains the mysteries of her narrative to her end.

It was perhaps the transience of Mona's illusory reality, those juxtapositions inherent to her fictive biography, that struck me most in the basement screening room of Le Champo, as I sat next to Mona's creator/alter ego. Varda and I shared Mona's coming into becoming again that day, and I continue to wonder: how can one self-define and maintain ownership over their narrative, life, body, mind, and its outputs? If *Vagabond* proffers a perfectly fabricated and at once authentic portrait of a journey, it also thwarts a world obsessed with knowing and undoing a woman who dares anonymity and self-possession.

I write to you then, as a "teacher" ever in-training. As Varda proved, encounters with various human and nonhuman worlds can productively exceed conventional notions of a classroom. My concurrent status as a lifetime "student" aids me in explaining Varda's influence on my life, personally and professionally.

<div style="text-align:center">☙❧</div>

> We know now that a text is not a line of words releasing a single 'theological' meaning (the 'message' of the Author-God) but a multi-dimensional space in which a variety of writings, none of them original, blend and clash.
> (Roland Barthes, "The Death of the Author")[4]

> Mona's only funereal tribute comes from these men, farmworkers and police [who behold her corpse]. They are like characters in the Nativity or in a painting. The hillock [in the frame's distance] is like a burial mound. The two cypress trees guard Mona's temporary tomb before she goes from the ditch to potter's field.
> (Varda)[5]

Cinécriture

A brutal honesty links Varda's oeuvre to works of other feminist artists, including Elena Ferrante, who writes:

> To tolerate existence, we lie, and we lie above all to ourselves. [...] Falsehoods protect us, mitigate suffering, allow us to avoid the terrifying moment of serious reflection, they dilute the horrors of our time, they even save us from ourselves. Instead, when one writes one must never lie. In literary fiction [and via Varda's famed *cinécriture*] you have to be sincere to the point where it's unbearable, where you suffer.[6]

Harangued as a female pseudonymous author, factions of Ferrante's readership remain unrelenting in their quest to furnish and paradoxically fabricate some actually lived reality, to forcibly reveal and define an unknown woman artist. This frenzy to unmask Ferrante conjoins with the same possessive, obsessive compulsion that erupted following the discovery and marketization of Vivian Maier's photographs after her death. *Vagabond* documents the same dangerous drive through Mona's journey and its depictions of those she encounters—the workers, shop owners, shepherds, other runaways, hitchhikers, and more—who attempt to construct Mona's tale, and by so doing, project their own narratives onto hers, save Assoun (Yahiaoui Assouna), the Tunisian worker who was cast for his eyes.[7] His gestures, as he smells and kisses the scarf that he lent Mona, reveal their mutual affection. The sole person to call Mona by her name, Assoun's final direct and silent gaze at the camera manifests quiet respect.

Varda's ethics of listening fully resides in Assoun and the leftward tracks across *Vagabond*'s barren landscapes, transversal movements through time and space that differently repeat Alain Resnais's. In the silence that lingered briefly between Varda and me on June 29, 2014, I felt humble respect for the uncommon woman of compassion seated to my left.

What I have come to increasingly sense is that artifice and truth coexist. Varda, Ferrante, and Maier chronicle real female experiences through novel strategies and masterful techniques. Their cinematic, literary, and photographic works supersede elements of autobiography as they invent new auto-fictive worlds. Their auto-portraits of women—whose forms and means are dictated by their subjects—demand acceptance without judgement, speculation or ownership. That summer of 2014 I also attended a Paris screening of *Finding Vivian Maier*, a 2013 documentary directed by John Maloof and Charlie Siskel, that introduced Maier's images to greater numbers while propagating the tired pursuit of an unknowable woman whose narrative must be conjectured. Again,

this societal impulse evident in finding and silencing Mona, Maier, and others, is akin to tactics of birtherism, xenophobia, sexism, and homophobia, which *Vagabond* likewise showcases, only differently.

"Get a photo of her face. Her face," one officer instructs another as they approach Mona's corpse. Suggestive of the officer's perspective behind his lens, Varda's camera complies with a cut from a long to still medium shot. Mona's arms appear outspread, angelic. Her position newly repeats the dying moments of another young life, Ettore (Ettore Garofolo) in Pier Paolo Pasolini's *Mamma Roma* (1962), filmic images that re-enact Andrea Mantegna's tempera painting, *Lamentation of Christ* (c. 1480). The dying and dead bodies of Mona and Ettore conjure many thoughts and, among these, Varda and Pasolini's shared impassioned and complex commitment to Christian art and realism. Certain realisms demand a non-naturalist approach to time and montage, as I have suggested with regard to Pasolini and André Bazin.[8] As Varda's works repeatedly evince, one cannot be realist without being formalist. The *tableaux vivants* of Mona and Ettore summon other images as well, such as a photograph by Robert Wiles of Evelyn McHale's corpse, which appeared as a full page in the May 1947 issue of *TIME* magazine and was later appropriated by other artists, including Andy Warhol with his print, *Suicide: Fallen Body* (1962). As Ben Cosgrove acknowledges, "[t]he woman in the photo was 23-year-old Evelyn McHale. Not much is known of her life, or of her final hours, although countless people have put enormous effort into uncovering as much about the troubled, attractive California native as they possibly could."[9]

~~

> Like Mona, I was wandering around, trying to capture images and sounds which would express what Mona wouldn't put into words and what others thought they saw.
> [...]
> I wanted to tell the story of a girl on the road.
> (Varda, *Remembrances*)

Other snapshots

In 2013, I experienced the series of self-portraits that line the Vasari Corridor in Florence. The histories and cities of art that significantly inform Varda's own also affected me, and resonate with Varda's remarks on *Vagabond*: "I often think

that some images are already loaded, already loaded with collective feelings. The very texture of emotions, not the story. [...] [T]he image shows it all at once."[10]

When in Sydney in 2015, I spoke more fully with students about Varda's effect on my approach to cinema and life. Having written on her close friends and collaborators, Chris Marker and Resnais, I longed to more directly explore her works.

Earlier in Paris, in 2006 at the start of my studies, I experienced Varda's installation *L'île et elle* at the Fondation Cartier. Especially moved by *Quelques veuves de Noirmoutier* (The Widows of Noirmoutier), I immediately called my mother. My father died in 2002, and Varda's listening to other widows, as a widow herself, struck me.

Later in Toronto, New Year's Eve 2017, I attended a screening of *Visages Villages* (Faces Places, 2017). By this point, Varda's works had become interwoven with my travels, writing and teaching. The 2014 afternoon at Le Champo seemed long ago. In the interim, waves of greater xenophobia have surged: migrants dying at sea, vagabonds freezing in ditches. Varda never shied from underscoring the darkness that lines our existence, even as she highlighted hope in global struggles for justice and dignity.

For Varda teaches us that it matters how one sensorily perceives and engages with our world. In *Vagabond*, the camera tracks from right to left each time Mona walks alone: "It was a way of saying that she keeps on walking. Her walk is interrupted by her encounters, but the basic truth is that Mona is walking toward her death to a music called 'La Vita'" (Varda, Criterion DVD). In a statement as true at the start of her career as at its end, Varda asserted that the "poor, the homeless, dirty and rebellious, drug addicts and drunks [...] deeply moved me" (Varda, Criterion DVD). Ever drawn to the people and places she encountered, she persisted in unconventional, true-to-Vardian form. Of course, Marker also sought to express the ineffable, "to follow the contours of what is not, or is no longer, or is not yet [, ...] to compose his own list of 'things that quicken the heart'" (*Sans Soleil*, 1983).

On July 29, 2014, the day of Marker's birth and death, I visited his tomb with a Vardian sunflower. Only a month earlier, on June 29th (Figure 18.1), I sat silently next to his dear friend, Varda, a moment high on my list of things that quicken the heart. Her silence yet touches me.

> "Who is she? Where's she from? We never find out."
> (Varda, *Remembrances*)

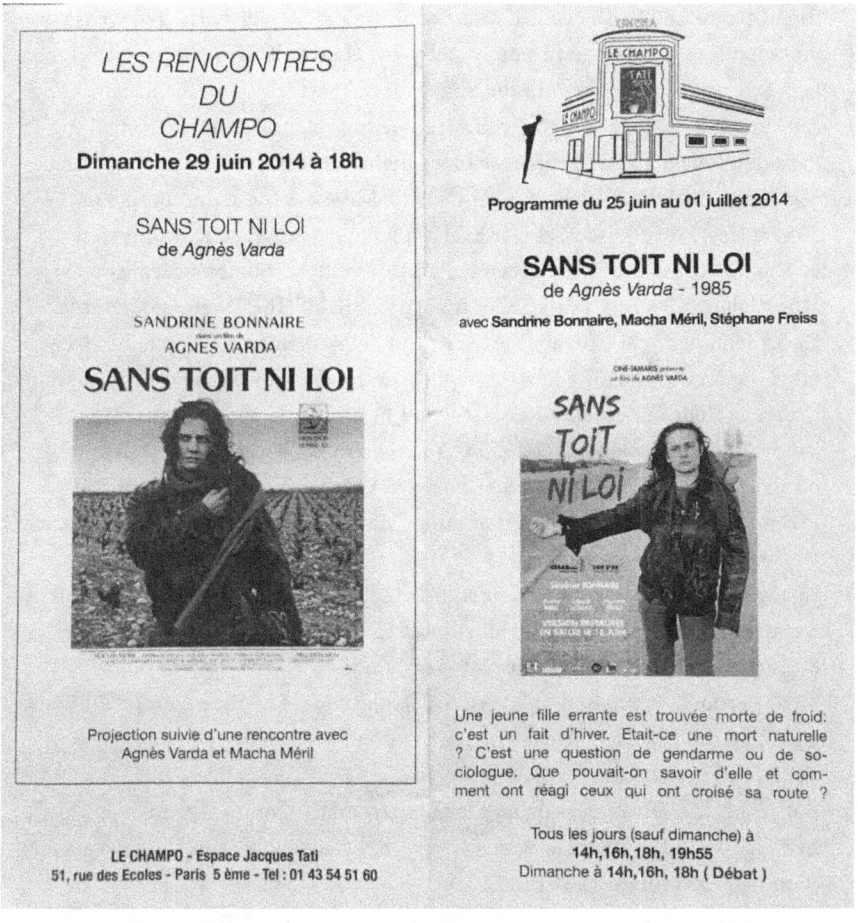

Figure 18.1 Le Champo flyer advertising the June 29, 2014 screening of *Sans toit ni loi* (Vagabond, 1985). Photograph courtesy of Nadine Boljkovac.

Notes

1 See Nadine Boljkovac, "In [No] Home Movie Style: Her Death and Rebirth," *Screening the Past: A Peer-Reviewed Journal of Screen History, Theory & Criticism*, eds. Saige Walton and Nadine Boljkovac, Issue 43 ("Materialising Absence in Film and Media," April 2018), http://www.screeningthepast.com/2018/02/in-no-home-movie-style-her-death-and-rebirth/.

2 In interview, Varda discussed the triptychs of her installation works, a form also evident in her films including *Visages Villages* (Faces Places, 2017): "When you make movies, one screen is offered. From a long time, I wanted to work on

three screens and I also decided to make portraits with side parts. Triptychs are presentation shapes of that I simply really love. I love all the older triptychs too. [...] I've just been in love with this shape for many years. I love the idea that you can close it. I love the idea that you see something central and then something on the sides. I make triptychs because I love them. As I say, I reconcile everything." See Sabine Mirlesse, "Agnès Varda by Sabine Mirlesse: The 'grandmother of the French New Wave' Discusses Her Ever-evolving Artistic Practice," interview by Sabine Mirlesse, *BOMB*, December 16, 2014, https://bombmagazine.org/articles/agn%C3%A8s-varda/. See also Miriam Bale, "The Three Agnès Varda Documentaries That Contain the Secret to Life," *W magazine*, March 29, 2019, https://www.wmagazine.com/story/agnes-varda-dead-documentary-films/. Many thanks to Colleen Kennedy-Karpat for this link.

3 Sandy Flitterman-Lewis, "*Vagabond*," The Criterion Collection, May 15, 2000, https://www.criterion.com/current/posts/78-vagabond.
4 Roland Barthes, "The Death of the Author," in *Image Music Text*, trans. Stephen Heath (London: Fontana Press, 1977), 146.
5 Agnès Varda, quoted from *Remembrances* (2003), a supplemental documentary on the making of *Vagabond* included with the Criterion Collection DVD release. See https://www.criterion.com/films/245-vagabond.
6 Elena Ferrante, *Frantumaglia*, trans. Ann Goldstein (New York: Europa Editions, 2016), 80.
7 Varda, *Remembrances*.
8 Boljkovac, "Screen Perception and Event: Beyond the Formalist/Realist Divide," in *The Anthem Handbook of Screen Theory*, ed. Tom Conley and Hunter Vaughan (London: Anthem Press, 2018), 317.
9 Ben Cosgrove, "'The Most Beautiful Suicide': A Violent Death, an Immortal Photo," *Time*, March 19, 2014, https://time.com/3456028/the-most-beautiful-suicide-a-violent-death-an-immortal-photo/.
10 Varda, *Remembrances*.

19

Farewell to Idols with Varda

Feride Çiçekoğlu

Varda had idols, and her farewell to each was painful. Her last farewell, to Godard, maybe the most painful of all, was probably an accumulation of all the previous ones: a secular redemption when she could vividly see her own farewell to life also. Chance helped her to make it cinematic and public, so she used it well, being as always the virtuoso of using chance as an assistant. The moment of coming to terms with loss—not only of Godard as a peer and an idol she wanted to revisit, but of all her past idols and demons—also brought a startling, fresh beginning if we carefully unpack the delicate moment of her tears in *Visages villages* (Faces Places, 2017).

I am grateful to Colleen Kennedy-Karpat, co-editor of this volume, for underscoring that moment and introducing Varda as a kindred soul during the conference on *Female Agency and Subjectivity in Film and Television* we organized at İstanbul Bilgi University in 2019.[1] Varda had passed away just two weeks before the conference, and Colleen's talk was much more than an academic presentation. It was an intimate narrative of Varda's missed rendezvous with Godard in *Faces Places* layered with details of her professional and personal lives going back more than six decades. Listening to Colleen during that conference was a revelation for me since I realized I could explore new ways of teaching Varda. Until then, I referred to her filmmaking mainly in my graduate courses about the city, cinema, and modernity, focusing on the protagonist of *Cléo de 5 à 7* (Cleo from 5 to 7, 1962) as a flâneuse, with reference to my earlier work.[2]

Let me insert a passing note here that the film itself was woven with new details for me once Varda's life became more accessible after her passing. It was only then that I learned Antoine Bourseiller—the actor playing the soldier leaving for Algiers in *Cléo de 5 à 7*—was the father of Varda's daughter Rosalie, who was born in 1958. That information added new layers to the narrative for me; I felt a vague sense of Varda's directorial irony, casting him in that humble

and transitory role opposite a taller and more attractive actress. It seemed to me as an act of neutralizing an earlier passion, humanizing a previous idol. But of course this blurs the line between the artist and her work in a totally speculative way. It may even be merely a projection from my own past experiences, but on the other hand, isn't that what we expect from films, to reflect our lived experience as experience of others and vice versa? This is the way I teach my scriptwriting classes—but I am running ahead of myself.

After Colleen's presentation I started watching Varda's films that I had not seen before, starting from the 1950s. These films' exploration of the spirit of a place (*genius loci*)[3] and their juxtaposition with lived experience (*erfahrung*)[4]— the dweller's understanding of her dwelling environment to put it in Vardian terms—struck me especially in *La Pointe Courte* (1955), *L'Opéra-Mouffe* (Diary of a Pregnant Woman, 1958), *Daguerréotypes* (1976), *Murs Murs* (1981), and *Les Dites Cariatides* (The So-called Caryatides, 1985). These films became the framework for assignments I gave in my graduate courses on the cinematic city.[5] I asked students to record their lived experiences of their immediate environment, and by the end of the semester we had a digital map of individual impressions of the city. It was particularly interesting to compare the records of the long time dwellers of the city and those who had just arrived for the semester as students. Another critical comparison arose due to the pandemic; maps before and after the restrictions showed totally different patterns. People standing apart from each other while sipping their drinks in parks or walking their dogs with masks were the post-pandemic inhabitants of the city as documented in these videos.

Let me now go back to describe the pedagogical method in my undergraduate courses, which is highly intuitive, mostly subjective, idiosyncratic, and almost forcefully interactive. "So, whom did we not hear yet?" is my favorite question, not only in the spaces of classroom but also during online teaching. Most of my effort goes into getting to know each student individually, rather than focusing on what I have to teach. I am more interested in hearing than in telling. For my graduate courses, I learn a lot about each student through interviews and through their previous work, so by the time they come to my class I don't need to ask many questions. Undergraduate students, on the other hand, are full of mystery. They come to the university having survived an education system designed to truncate and amputate most of them into a monotonous army of similarities. So, I have to work hard to bring out the uniqueness in each and every one of them, to cope with their silence and reluctance, distrust and shyness, and that is where Varda keeps me company.

I start with her artistic biography, not as chronological information but as a patchwork of images from her period as a student of art history, her photographs at Jean Vilar's National Popular Theatre, and her collaboration with Alain Resnais. Here I use the photo where she is taking a photo of Resnais while he is editing her first film *La Pointe Courte* (1955). This is where I also tell the story, from the late 1980s, of my own collaboration with the father of my daughter, as two architects, when he was making a model and I was watching him, with admiration. His hands were so beautiful, the hands of an artist that were good at making things. That scene was followed by an argument over who would go out to pick up glue, with him saying that since he was busy with the model, I was supposed to do the chore while I refused since it was late at night.

I sometimes flash forward from that point to the mid-1990s, when he set fire to our apartment after our divorce, but sometimes I save that story to follow Varda's painful period in Los Angeles, when she was separated from Jacques Demy, and which became a semi-autobiographical story in her film *Documenteur* (1981). What happens when a love affair ends, at least for one of the parties? How do we come to grips with our fading or continuing admiration? How do we express or translate that pain into words or images? And what if we aspire to make a film inspired by it all? And I ask my students: Any similar stories? Someone they admired and they fell apart?

I throw in anecdotes from my own life story to encourage them to share theirs. Mine are probably not as exciting as Varda's, but they are not exactly mundane, either. I had my share of the twentieth century, and that meant we were ready to pursue our idols to the end after refusing the roles cut out for us as wives and mothers. I spent four years as a political prisoner during the military junta of 1980 in Turkey.[6] I was arrested right after the military seized power and was held in detention for fifty-five days.[7] I remember thinking of Lenin frequently during those long weeks of physical and psychological torture as if he was a teacher and I had to prove myself a good student by keeping my silence and dignity. My first husband (also an architect) was probably right, it would occur to me, being jealous of Lenin when I insisted on painting Lenin's portrait on a poster we were preparing for a demonstration in the late 1970s. He probably had reason to say I touched Lenin's poster face with more emotion and admiration than I touched his. Had I needed an idol since I lacked in real life? Lacked what? Was it necessary for us to admire so that we could love? We, the women of the twentieth century, were ready to shed the old skin of a wife and a mother, but still felt we needed love with admiration to feel complete. Varda's famous documentary *Réponse de femmes: Notre corps, notre sexe*

(Women Reply: Our Bodies, Our Sex, 1975) portrays women in their nudity and individuality, and then at the end shows a group of men: masculinity accepting the female invitation to a new kind of love.

Yes, our idols were masculine, and they were charismatic, even when not exactly handsome, with names like Heidegger, Sartre, Camus, Lenin, Ché, Rodin, Kahn, or Godard. Our names could be Hannah, Simone, Camille, Ann, Harriet, or Agnès, with total entitlement to stand alone, but we still had to step forward into the twenty-first century to claim our spotlight. I search for signs of boredom on my students' young faces while I narrate these stories from the past century, to see what resonates and what has no meaning at all. When I see that they are distracted—and this I can do even when they appear in the tiny rectangles on screen—I ask them about their families.

I tell them that there was only one girl in the first grade of my elementary school whose parents were divorced, and we thought she was so lucky since her father and mother took turns attending meetings and events. Any parents who are still together in their case? More than half laugh and tell stories, which remind us of the TV sitcom "Modern Family." Some are quiet and to some of those I ask if they have any portraits at their homes, of secular or religious leaders. Any film stars or pop singers? How about Instagram influencers? Would they think of them as idols? Any stories they want to share? As soon I regain their attention I take them back to the twentieth century and to the stories of those extraordinary women who tried to tone themselves down for the sake of their idols.

I give snapshots of the story of Hannah Arendt and her infatuation with Heidegger, or of Simone de Beauvoir, and hers with Sartre. I sometimes show parts of Nathaniel Kahn's film *My Architect* (2003), the documentary where he reveals his father's secret lives with two children from two talented intelligent women beyond his wife—artist Ann Tyng and landscape architect Harriet Pattison—accepting to remain in shades so that Louis Kahn would continue to be the star architect. But these are snapshots only, just to contextualize. I don't delve into them. I am keen not to take the spotlight from Varda, who was unique in claiming it and writing herself back into the canon while at the same time documenting her personal story for all of us. So that we could practice it ourselves, and that we might teach our students viscerally.

A milestone in Varda's transformation was her film *Les Cent et une nuits de Simon Cinéma* (One Hundred and One Nights, 1995), made to mark the centennial of cinema. Despite its flashy cast, ranging from Michel Piccoli and Catherine Deneuve to Robert de Niro, it was a huge flop, like an earlier film she had made with Piccoli and Deneuve, *Les Créatures* (The Creatures, 1966). But

over three decades, Varda had matured enough to use this failure as a springboard to reinvent herself. This she explores with wit and humor as a retrospective of her own career in *Varda par Agnès* (Varda by Agnès, 2019). While Richard Brody, longtime film critic of *The New Yorker*, highlights that Varda took the failure of *One Hundred and One Nights* "as the hinge of the narrative self-portrait in *Varda by Agnès*," he also points out that "Varda wasn't alone in discerning and responding artistically to that long goodbye" by pointing to a new era of filmmaking.[8] Brody quickly inserts Godard and Rohmer, highlighting the male idols of the past century, and tries to project their glory onto yet another century. In a review of Varda's film, no less! He seems to hint that they belong to the same narrative, and that Varda's voice had no distinctive value on its own.

But no: Varda definitely does not belong to the same narrative any more. After the failure of *One Hundred and One Nights* it would take another two decades to embark on *Faces Places*, but that film's journey through the French countryside with JR would be her farewell to that narrative from which she was excluded and which she no longer wants to be part of anymore. Having mourned Jacques Demy with the films *Jacquot de Nantes* (1991) and *L'Univers de Jacques Demy* (The Universe of Jacques Demy, 1995), having seen a flashy project with the idols of cinema end (once again) in box office disaster, she could start anew with fresh eyes. This is how she ended up making *Les Glaneurs et la glaneuse* (The Gleaners and I, 2000) at the turn of the century with a digital camera, opening up two decades of a new career, a beginner's story with her new persona as an artist.

This is where her tears in *Faces Places* come into play. Her farewell to Godard is a closure not only for herself, but also for all women of the twentieth century. Now is the time for us to transfer that lived experience to the younger generation, so that they will learn it as mere history, so as not to repeat that experience themselves.

Notes

1 Kennedy-Karpat, Colleen, "Agnès Varda and the Singular Feminine," in *Female Agency and Subjectivity in Film and Television*, ed. Diğdem Sezen, Feride Çiçekoğlu, Aslı Tunç, Ebru Thwaites Diken (Cham, Switzerland: Palgrave Macmillan, 2020), 11–25.
2 The issue of gender in the filmic representations of the city throughout the twentieth century was the theme of the first book of my trilogy on İstanbul as a cinematic city: Çiçekoğlu, Feride (2007) *Vesikalı Şehir*, İstanbul: Metis. The title of

the book can be translated as "The whore of a city," in reference to a cult Turkish film, *Vesikalı Yarim* (Ömer Lütfü Akad, 1968). The word *vesika*—document— signifies the license given to prostitutes and bar girls, and extends to the social stigma that surrounded them. The film tells the impossible love story of such a woman (Sabiha) and a married man, ending with Sabiha roaming the streets of İstanbul. A comparison of Cléo and Sabiha was the theme of my chapter "Sabiha in Public İstanbul" in *Public İstanbul: Spaces and Spheres of the Urban* ed. Frank Eckardt, Kathrin Wildner Bielefeld: Transcript, 319–32.

3 Christian Norberg-Schulz, *Genius Loci: Towards a Phenomenology of Architecture* (New York: Rizzoli, 1980).

4 Benjamin, Walter (1999) Published as "*Die Wiederkehr des Flaneurs*" and translated as "The Return of the *Flâneur*" in *Selected Writings* Volume II, Cambridge: Harvard. 262–7.

5 One of my graduate students, Zeynep Demirhan, picked up those examples as an inspiration for her master's thesis and used them as a framework for contextualizing her own films. I would like to extend my thanks to my co-editor Colleen Kennedy-Karpat for her contribution and co-authorship with Zeynep Demirhan in this volume.

6 I was judged and convicted of article 141 of the Turkish Penal Code during the Military junta of September 12, 1980. This article, adopted in 1936 and based on the Italian Penal Code of 1930, banned socialist propaganda. It was annulled in 1991. An early case on the constitutionality of these articles from the 1960s and later articles chronicling the history of annulation can be accessed at: https://dergipark.org.tr/tr/download/article-file/6399 http://dergiler.ankara.edu.tr/dergiler/38/337/3425.pdf http://dergiler.ankara.edu.tr/dergiler/42/1927/20205.pdf.

7 The Turkish Constitution allowed for detention periods of up to fifteen days prior to the military coup of September 12, 1980. The junta extended this period to three months. https://www.hrw.org/legacy/reports/1997/turkey/Turkey-09.htm.

8 Richard Brody, "Agnès Varda's Extraordinary Cinematic Accomplishment," *The New Yorker*, November 22, 2019, https://www.newyorker.com/culture/the-front-row/agnes-vardas-extraordinary-cinematic-accomplishment.

Filmography: Agnès Varda

I. Feature Films (Reverse Chronology)

Varda par Agnès (Varda by Agnès), 2019
Visages villages (Faces Places), co-directed with JR, 2017
Agnès de ci de là Varda (Agnes Varda: From Here to There), 2011
Les Plages d'Agnès (The Beaches of Agnès), 2008
Les Glaneurs et la glaneuse: Deux ans après (The Gleaners and I: Two Years Later), 2002
Les Glaneurs et la glaneuse (The Gleaners and I), 2000
Les cent et une nuits de Simon Cinéma (One Hundred and One Nights), 1995
L'Univers de Jacques Demy (The World of Jacques Demy), 1995
Les Demoiselles ont eu 25 ans (The Young Girls Turn 25), 1993
Jacquot de Nantes (Jackie from Nantes), 1991
Kung-Fu Master! 1988
Jane B. par Agnès V. (Jane B. by Agnès V.), 1988
Sans toit ni loi (Vagabond), 1985
Documenteur, 1981
Mur Murs, 1981
L'Une chante, l'autre pas (One Sings, the Other Doesn't), 1977
Daguerréotypes, 1975
Nausicaa [unfinished], 1971
Lions Love ... and Lies, 1969
Les Créatures (The Creatures), 1966
Le Bonheur (Happiness), 1965
Cléo de 5 à 7 (Cleo from 5 to 7), 1962
La Pointe Courte, 1955

II. Short Films (Reverse Chronology)

Les 3 boutons (The Three Buttons), 2015
Un salut à Henri Langlois (A Salute to Henri Langlois), 2014
La petite histoire de Gwen la bretonne (The Short History of Gwen from Brittany), 2008
Cléo de 5 à 7: souvenirs et anecdotes (Cleo from 5 to 7: Remembrances and Anecdotes), 2005
Rue Daguerre en 2005 (Rue Daguerre in 2005), 2005

Les dites cariatides bis (The So-Called Caryatids 2), 2005
Ydessa, les ours et etc … (Ydessa, the Bears and etc. …), 2004
Le Lion volatil (The Vanishing Lion), 2003
T'as de beaux escaliers, tu sais … (You've Got Beautiful Stairs, You Know), 1986
7 P., cuis., s. de b … (7 Rooms, Kit, ba …), 1984
Les Dites Cariatides (The So-Called Caryatids), 1984
Ulysse (Ulysses), 1983
Plaisir d'amour en Iran (The Pleasure of Love in Iran), 1976
Réponse de femmes: Notre corps, notre sexe (Women Reply: Our Bodies, Our Sex), 1975
Black Panthers, 1968
Uncle Yanco, 1967
Elsa la rose, 1966
Salut les cubains ! (Hello, Cubans!) 1963
Les Fiancés du pont Macdonald (The Lovers of Macdonald Bridge), 1961
L'Opéra-Mouffe (Diary of a Pregnant Woman), 1958
Du côté de la côte (Along the Coast), 1958
Ô saisons, ô chateaux (O Seasons, O Castles), 1958

III. Selected Installations and Other Moving Image Work (Reverse Chronology)

Bord de mer (Seaside), 2009
Les Justes de France (The Righteous of France), 2007
La Cabane de l'échec/La Cabane de Cinéma (The Cabin of Failure/The Cabin of Cinema), 2006
Les veuves de Noirmoutier (The Widows of Noirmoutier), 2006
Le Tombeau de Zgougou (Homage to Zgougou the Cat), 2006
Le Triptyque de Noirmoutier (The Noirmoutier Triptych), 2005
Patatutopia (Venice Biennale), 2003
Histoire d'une vieille dame (The Story of an Old Lady), 1985
Une minute pour une image (One Minute for One Image), 1983

Additional Filmography
(Alphabetized by Title)

A ma sœur! (Fat Girl), dir. Catherine Breillat, 2001.
The Act of Killing, dir. Joshua Oppenheimer, 2012.
Anatomie de l'enfer (Anatomy of Hell), dir. Catherine Breillat, 2004.
Avatar, dir. James Cameron, 2009.
Bande de filles (Girlhood), dir. Céline Sciamma, 2014.
La Petite prairie aux bouleaux (The Birch-Tree Meadow), dir. Marceline Loridan-Ivens, 2003.
Boudu sauvé des eaux (Boudu Saved from Drowning), dir. Jean Renoir, 1932.
Chocolat (Chocolate), dir. Claire Denis, 1988.
Chronique d'un été (Paris 1960) (*Chronicle of a Summer*), dir. Edgar Morin and Jean Rouch, 1961.
Citizen Kane, dir. Orson Welles, 1941.
Finding Vivian Maier, dir. John Maloof and Charlie Siskel, 2013.
Greed, dir. Erich von Stroheim, 1924.
Holy Motors, dir. Léos Carax, 2012.
India Song, dir. Marguerite Duras, 1974.
Into the Wild, dir. Sean Penn, 2007.
Jeanne Dielmann, 23 quai du Commerce, 1080 Bruxelles, dir. Chantal Akerman, 1975.
Justice League, dir. Zack Snyder, 2021.
Mamma Roma, dir. Pier Paolo Pasolini, 1962.
Marceline, une femme, un siècle (Marceline. A Woman. A Century), dir. Cordelia Dvorak, 2017.
Miami Vice, dir. Michael Mann, 2006.
My Architect, dir. Nathaniel Kahn, 2003.
No Home Movie, dir. Chantal Akerman, 2015.
Romance, dir. Catherine Breillat, 1999.
Sans Soleil, dir. Chris Marker, 1983.
Sex Is Comedy, dir. Catherine Breillat, 2001.
Terminator 2: Judgment Day, dir. James Cameron, 1991.
Tulse Luper Suitcases, dir. Peter Greenaway, 2003.
Wanda, dir. Barbara Loden, 1970.
Wendy and Lucy, dir. Kelly Reichardt, 2008.

Bibliography

Acker, Ally. *Reel Women: Pioneers of the Cinema, 1896 to the Present*. New York, NY: Continuum, 1991.
Adovasio, J. M., Olga Soffer and Jake Page. *The Invisible Sex Uncovering: The Roles of Women in Prehistory*. New York: Routledge, 2016.
Andrew, Dudley. "On Certain Tendencies of the French Cinema." In *A New History of French Literature*, edited by Denise Hollier, 993–1000. Cambridge, MA: Harvard University Press, 1989.
Andrew, Dudley. *What Cinema Is!* Oxford: Wiley Blackwell, 2010.
Andrews, Noam. "Albrecht Dürer's Personal *Underweysung der Messung*." *Word & Image* 32, no. 4 (2016): 409–29.
Archibald, Sasha. "End of the End of the End: Agnès Varda in Los Angeles." *East of Borneo*, September 15, 2014. https://eastofborneo.org/articles/end-of-the-end-of-the-end-agnes-varda-in-los-angeles/.
Astruc, Alexandre, 'The Birth of a New Avant-Garde: La Caméra-Stylo." In *The New Wave: Critical Landmarks*, edited by Peter Graham, 17–23. Garden City: Doubleday, 1968.
Austin, Guy. *Contemporary French Cinema: An Introduction*. Manchester: Manchester University Press, 2008.
Bale, Miriam. "The Three Agnès Varda Documentaries That Contain the Secret to Life." *W magazine*, March 29, 2019. https://www.wmagazine.com/story/agnes-varda-dead-documentary-films/.
Barthes, Roland. "The Death of the Author." In *Image Music Text*, translated by Stephen Heath, 142–8. London: Fontana Press, 1977.
Bauman, Zygmunt. *In Search of Politics*. Cambridge: Polity Press, 1999.
Bénézet, Delphine, *The Cinema of Agnès Varda: Resistance and Eclecticism*. New York: Columbia University Press, 2014.
Bénézet, Delphine. "'Varda En Vadrouille/Agnès on the Road Again,' an Extended Review of *Visages Villages* by Agnès Varda & JR (2017)." *Contemporary French and Francophone Studies* 22, no. 4 (2018): 406–17. https://doi.org/10.1080/17409292.2018.1537603.
Benjamin, Walter. "The Return of the *Flâneur*." In *Selected Writings* vol. II, 262–7. Cambridge, MA: Harvard University Press, 1999.
Berger, John. *Ways of Seeing*. London: British Broadcasting Corporation, 1972.
Bernstein, Joanne G. "The Female Model and the Renaissance Nude: Dürer, Giorgione, and Raphael." *Artibus et Historiae* 13, no. 26 (1992): 49–63.
Bluher, Dominique. "The Other Portrait: Agnès Varda's Self-Portraiture." In *From Self-Portrait to Selfie: Representing the Self in the Moving Image*, edited by Muriel

Tinel-Temple, Laura Busetta, and Marlène Monteiro, 47–76. Oxford: Peter Lang, 2019.
Bodroghkozy, Aniko. "Reel Revolutionaries: An Examination of Hollywood's Cycle of 1960s Youth Rebellion Films." *Cinema Journal* 41, no. 3 (2002): 38–58.
Boljkovac, Nadine. "In [No] Home Movie Style: Her Death and Rebirth." *Screening the Past: A Peer-Reviewed Journal of Screen History, Theory & Criticism* Issue 43 ("Materialising Absence in Film and Media," April 2018), edited by Saige Walton and Nadine Boljkovac. http://www.screeningthepast.com/2018/02/in-no-home-movie-style-her-death-and-rebirth/.
Boljkovac, Nadine. "Screen Perception and Event: Beyond the Formalist/Realist Divide." In *The Anthem Handbook of Screen Theory*, edited by Tom Conley and Hunter Vaughan, 309–26. London: Anthem Press, 2018.
Brody, Richard. "Agnès Varda's Extraordinary Cinematic Accomplishment." *The New Yorker*, November 22, 2019. https://www.newyorker.com/culture/the-front-row/agnes-vardas-extraordinary-cinematic-accomplishment.
Callenbach, Ernest. "The Gleaners and I (Les Glaneurs et la glaneuse)." *Film Quarterly* 56, no. 2 (2002): 46–9.
Carroll, Noël. *Theorizing the Moving Image*. Cambridge: Cambridge University Press, 1996.
Chamarette, Jenny. "Embodied Worlds and Situated Bodies: Feminism, Phenomenology, Film Theory." *Signs* 40, no. 2 (2015): 289–95.
Clarke, Shirley, and Storm de Hirsch. "A Conversation." *Film Culture*, 1968.
Cody, Jeff, and Francesco Siravo. *Historic Cities: Issues in Urban Conservation*. Los Angeles: The Getty Conservation Institute, 2019.
Colvin, J. Brandon. "Explaining Varda's Lions Love: A European Director Responds to an American Cultural Marketplace." *Studies in French Cinema* 16, no. 1 (2016): 19–31. https://doi.org/10.1080/14715880.2015.1065570.
Conway, Kelley. "Responding to Globalization: The Evolution of Agnès Varda." *SubStance* 43, no. 1 (2014): 109–22. https://www.jstor.org/stable/24540742.
Conway, Kelley. *Agnès Varda*. Urbana: University of Illinois Press, 2015.
Conway, Kelley. "*Visages villages*: Documenting Creative Collaboration." *Studies in French Cinema* 19 no. 1 (2019): 22–39. DOI:10.1080/14715880.2018.1545199
Cook, David A. *A History of Narrative Film*. 5th ed. New York: W. W. Norton & Company, 2016.
Corrigan, Timothy. *The Essay Film: From Montaigne, After Marker*. New York: Oxford University Press, 2011.
Cosgrove, Ben. "'The Most Beautiful Suicide': A Violent Death, an Immortal Photo." *Time*, March 19, 2014. https://time.com/3456028/the-most-beautiful-suicide-a-violent-death-an-immortal-photo/.
Çiçekoğlu, Feride. *Vesikalı Şehir*. İstanbul: Metis, 2007.
Çiçekoğlu, Feride. "Sabiha in Public İstanbul." In *Public İstanbul: Spaces and Spheres of the Urban*, edited by Frank Eckardt and Kathrin Wildner, 319–32. Bielefeld: Transcript, 2008.

Dederer, Claire. "What Do We Do with the Art of Monstrous Men?." *The Paris Review*, November 20, 2017. https://www.theparisreview.org/blog/2017/11/20/art-monstrous-men/.

DeRoo, Rebecca J. *Agnès Varda between Film, Photography, and Art*. Oakland, CA: University of California Press, 2018.

Dunn, Allan. "The Pleasures of the Text: Volatile Visuality." *Soundings: An Interdisciplinary Journal* 85, no. 3/4 (2002): 221–33.

Ferrante, Elena. *Frantumaglia*. Translated by Ann Goldstein. New York: Europa Editions, 2016.

Fiat, Antony, Roxanne Hamery, and Éric Thouvenal. *Agnès Varda: Le cinema et au-déla*. Rennes: Presses Universitaires de Rennes, 2009.

Fisher, Elizabeth. *Woman's Creation: Sexual Evolution and the Shaping of Society*. New York: McGraw-Hill, 1980.

Flitterman-Lewis, Sandy. "Varda: The Gleaner and the Just." In *Situating the Feminist Gaze and Spectatorship in Postwar Cinema*, edited by Marcelline Block, 214–26. Newcastle: Cambridge Scholars Publishing, 2008.

Flitterman-Lewis, Sandy. "Magic and Wisdom in Two Portraits by Agnès Varda: *Kung-Fu Master* and *Jane B. by Agnès V*." *Screen* 34, no. 4 (1993): 302–20.

Flitterman-Lewis, Sandy. *To Desire Differently: Feminism and the French Cinema*. New York: Columbia University Press, 1996.

Flitterman-Lewis, Sandy. "*Vagabond*." *The Criterion Collection*, May 15, 2000. https://www.criterion.com/current/posts/78-vagabond.

Forbes, Jill. *The Cinema in France, after the New Wave*. Basingstoke: Macmillan Press, 1992.

Focillon, Henri. *The Life of Forms in Art*. Translated by Charles Beecher Hogan and George Kubler. New York: Zone Books, 1992.

Forceville, Charles. "The Journey Metaphor and the Source-Path-Goal Schema in Agnes Varda's Autobiographical 'gleaning' Documentaries." In *Beyond Cognitive Metaphor Theory: Perspectives on Literary Metaphor*, edited by Monika Fludernik, 281–97. London: Routledge, 2011.

Forceville, Charles. "Visual and Multimodal Metaphor in Film: Charting the Field." In *Embodied Metaphors in Film, Television, and Video Games: Cognitive Approaches*, edited by Kathrin Fahlenbrach, 17–32. New York: Routledge, 2016.

Gazetas, Aristides. *An Introduction to World Cinema*. 2nd ed. Jefferson, NC: McFarland & Company, 2008.

Giraud, François. "Intermediality and Gesture: Idealising the Craft of Filmmaking in Agnès Varda's *Lions Love (... and Lies)*." *Studies in French Cinema* 19, no. 2 (2019): 122–34. https://doi.org/10.1080/14715880.2018.1448957.

Glick, Joshua. *Los Angeles Documentary and the Production of Public History, 1958–1977*. Berkeley and Los Angeles: University of California Press, 2018.

Grant, Catherine. "Secret Agents: Feminist Theories of Women's Film Authorship." *Feminist Theory* 2, no. 1 (2001): 113–30.

Hadjioannou, Markos. *From Light to Byte: Toward an Ethics of Digital Cinema*. Minneapolis: University of Minnesota Press, 2012.

Hamrah, A. S., et. al. "After Agnès Varda: A Discussion." *Another Gaze*, April 8, 2019. http://www.anothergaze.com/after-agnes-varda-obituary-memorial-discussion-sandy-flitterman-lewis-kiva-reardon-lauren-elkin-as-hamrah-grace-barber-plentie-samia-labidi-jenny-chamarette-sheila-heti/.

Han, Sam. *Web 2.0*. New York: Routledge, 2011.

Harper, April. "The Houseboat Wars: A Battle of the Haves and Have-Nots." *FoundSF.org*, 2015, https://www.foundsf.org/index.php?title=The_Houseboat_Wars:_A_Battle_of_the_Haves_and_Have-Nots.

Hayward, Susan. "Beyond the gaze and into *femme-filmécriture*." In *French Film: Texts and Contexts*, edited by Susan Hayward and Ginette Vincendeau, 2nd edition, 269–80. London and New York: Routledge, 1994.

Hayward, Susan, and Ginette Vincendeau. *French Film: Texts and Contexts*. London and New York: Routledge, 1990.

Heck-Rabi, Louise. *Women Filmmakers: A Critical Reception*. Metuchen, NJ: Scarecrow Press, 1974.

Hill, Rodney F. "The Family Business: An Interview with Rosalie Varda about *Varda by Agnès*." *Cinéaste* 45, no. 2 (2019). https://www.cineaste.com/spring2020/family-business-rosalie-varda-about-varda-by-agnes.

Holmes, Diana. "Sex, Gender and Auteurism: The French New Wave and Hollywood." In *World Cinema's "Dialogues" with Hollywood*, edited by Paul Cooke, 154–71. London: Palgrave Macmillan, 2007. https://doi.org/10.1057/9780230223189_10.

hooks, bell. *Teaching to Transgress: Education as the Practice of Freedom*. New York: Routledge, 1994.

hooks, bell. "Moving beyond Pain." *bellhooksinstitute.com*, 2016. http://www.bellhooksinstitute.com/blog/2016/5/9/moving-beyond-pain.

Hoops, Jonathan. "Lions Love." *Film Quarterly* 23, no. 4 (1970): 60–1.

Ince, Kate. "Feminist Phenomenology and the Film World of Agnès Varda." *Hypatia* 28 no. 3 (2013): 602–17. https://doi:10.1111/j.1527-2001.2012.01303.x.

Ince, Kate. *The Body and the Screen: Female Subjectivities in Contemporary Women's Cinema*. London and New York: Bloomsbury, 2017.

Jaikumar, Priya. "Feminist and Non-Western Interrogations of Film Authorship." In *The Routledge Companion to Cinema and Gender*, edited by Kristin Hole, Dijana Jelača, E. Kaplan, and Patrice Petro, 205–14. London and New York: Routledge, 2017.

Jeong, Seung-hoon. "Introduction - Global East Asian Cinema: Abjection and Agency." *Studies in the Humanities* 44 & 45, nos. 1 & 2 (2017): ii–xxii.

Jones, Amelia. "Essentialism, Feminism, and Art: Spaces Where Woman 'Oozes Away.'" In *A Companion to Feminist Art*, edited by Hilary Robinson and Maria Elena Buszek, 157–80. Hoboken: Wiley, 2019.

Kay, Karyn, and Gerald Peary. *Women and the Cinema: A Critical Anthology*. New York, NY: E. P. Dutton, 1977.

Kennedy-Karpat, Colleen. "Agnès Varda and the Singular Feminine." In *Female Agencies and Subjectivities in Film and Television*, edited by Diğdem Sezen, Feride Çiçekoğlu, Aslı Tunç, and Ebru Thwaites Diken, 11–25. Cham: Palgrave Macmillan, 2020.

Keshavjee, Serena. "Natural History, Cultural History, and the Art History of Elie Faure." *Nineteenth-Century Art Worldwide* 8, no. 2 (2009). https://www.19thc-artworldwide.org/autumn09/natural-history-cultural-history-and-the-art-history-of-elie-faure.

King, Homay. "Matter, Time, and the Digital: Varda's *The Gleaners and I*." *Quarterly Review of Film and Television* 24, no. 5 (2007): 421–9.

Kirk, Gwyn. "Standing on Solid Ground: A Materialist Ecological Feminism." In *Materialist feminism: A Reader in Class, Difference, and Women's Lives*, edited by Rosemary Hennessy and Chrys Ingraham. New York: Routledge, 1997.

Kline, T. Jefferson. *Agnès Varda: Interviews*. Jackson: University of Mississippi Press, 2014.

Lakoff, George. "The Contemporary Theory of Metaphor." In *Metaphor and Thought*, edited by Andrew Ortony, 202–1. Cambridge: Cambridge University Press, 1993.

Lakoff, George, and Mark Johnson. *Metaphors We Live By*. Chicago: University of Chicago Press, 1980.

Layde, Caroline. "Jacques Demy: Personal Worlds." *Senses of Cinema*, 2003. http://sensesofcinema.com/2003/great-directors/demy/.

Le Guin, Ursula K. "The Carrier Bag Theory of Fiction." In *Dancing at The Edge of The World*, 165–71. New York: Grove Press, 1989.

Lefenfeld, Nancy. *The Fate of Others: Rescuing Jewish Children on the French-Swiss Border*. Clarksville, MD: Timbrel Press, 2013.

Littman, Lynne. "Portrait of a Vagabond: An Appreciation of Agnès Varda." *IDA*, 2002. https://www.documentary.org/feature/portrait-vagabond-appreciation-agnès-varda.

Loridan-Ivens, Marceline and Judith Perrignon. *L'amour après*. Paris: Grasset, 2018.

MacKenzie, Scott. *Film Manifestos and Global Cinema Cultures: A Critical Anthology*. Berkeley: University of California Press, 2014.

Manovich, Lev. *The Language of New Media*. Cambridge, MA: MIT Press, 2002.

Martin, Angela. "Refocusing Authorship in Women's Filmmaking." In *Women Filmmakers: Refocusing*, edited by Jacqueline Levitin, Judith Plessis and Valerie Raoul, 29–38. New York: Routledge, 2003.

Mast, Gerald, and Bruce Kawin. *A Short History of the Movies*. Abridged 11th ed. New York: Pearson, 2012.

McAndrew, Ewan, and Sara Thomas, eds. "Wikimedia in Education." Wikimedia UK and University of Edinburgh, January 1, 2020. https://commons.wikimedia.org/wiki/File:Wikimedia_in_Education_-_Wikimedia_UK_in_partnership_with_the_University_of_Edinburgh.pdf.

McFadden, Cybelle. H. *Gendered Frames, Embodied Cameras: Varda, Akerman, Cabrera, Calle, and Maïwenn*. Madison, NJ: Fairleigh Dickinson University Press, 2014.

Meagher, Michelle. "Against the Invisibility of Old Age: Cindy Sherman, Suzy Lake, and Martha Wilson." *Feminist Studies* 40, no. 1 (2014): 101–43.

Milanés, Cecilia Rodríguez, and Aimee DeNoyelles. "Designing Critically: Feminist Pedagogy for Digital/Real Life." *Hybrid Pedagogy*, November 5, 2014. https://hybridpedagogy.org/designing-critically-feminist-pedagogy-digital-real-life/.

Mirlesse, Sabine. "Agnès Varda by Sabine Mirlesse: The 'grandmother of the French New Wave' Discusses Her Ever-evolving Artistic Practice." Interview by Sabine Mirlesse. *BOMB*, December 16, 2014. https://bombmagazine.org/articles/agn%C3%A8s-varda/.

Morris, Charlotte. "Teaching to Transform: Reimagining Feminist Pedagogies in Contemporary Higher Education." *MAI* no. 5 (2020). https://maifeminism.com/teaching-to-transform-reimagining-feminist-pedagogies-in-contemporary-higher-education/.

Morris, Sean Michael, and Jesse Stommel. *An Urgency of Teachers: The Work of Critical Digital Pedagogy*. United States: Hybrid Pedagogy, 2018.

Morton, Timothy. *Ecology without Nature: Rethinking Environmental Aesthetics*. Cambridge, MA: Harvard University Press, 2009.

Mouton, Janice. "From Feminine Masquerade to Flâneuse: Agnès Varda's Cléo in the City." *Cinema Journal* 40, no. 2 (2001): 3–16.

Mulvey, Laura. "Visual Pleasure and Narrative Cinema." In *Narrative, Apparatus, Ideology: A Film Theory Reader*, edited by Philip Rosen, 198–209. New York: Columbia University Press, 1986.

Nelson, Roy Jay. "Reflections in a Broken Mirror: Varda's *Cléo de 5 à 7*." *The French Review* 56, no. 5 (1983): 735–43.

Neupert, Richard John. *A History of the French New Wave Cinema*. Madison, WI: University of Wisconsin Press, 2007.

Norberg-Schulz, Christian. *Genius Loci: Towards a Phenomenology of Architecture*. New York: Rizzoli, 1980.

Peucker, Brigitte. *The Material Image: Art and the Real in Film*. Stanford: Stanford University Press, 2007.

Pratt, Mary Louise. "Arts of the Contact Zone." *Profession* (1991): 33–40.

Prensky, Marc. "Digital Natives, Digital Immigrants." *On the Horizon* 9, no. 5 (2001): 1–6.

Rancière, Jacques. *The Politics of Aesthetics*. London: Bloomsbury Academic, 2013.

Rascaroli, Laura. *How the Essay Film Thinks*. New York: Oxford University Press, 2017.

Rabinovitz, Lauren. "Choreography of Cinema: An Interview with Shirley Clarke." *Afterimage*, December 1983, pp. 8–11.

Rabinovitz, Lauren. *Points of Resistance: Women, Power & Politics in the New York Avant-Garde Cinema, 1943–71*, 2nd ed. Champaign, IL: University of Illinois Press, 2003.

Rollet, Brigitte. *Coline Serreau*. Manchester: Manchester University Press, 1998.

Rollins, Brooke. "'Some Kind of a Man': Orson Welles as *Touch of Evil*'s Masculine Auteur." *The Velvet Light Trap* 57, no. 1 (2006): 32–41.

Rosello, Mireille. "Agnès Varda's *Les Glaneurs et la glaneuse*: Portrait of the Artist as an Old Lady." *Studies in French Cinema* 1, no.1 (2014): 29–36.

Sachs, Leon. *The Pedagogical Imagination: The Republican Legacy in Twenty-First Century French Literature and Film*. Lincoln: University of Nebraska Press, 2014.

Sadoul, Georges. *Dictionnaire des films*. Paris: Editions du Seuil, 1965.

Schmid, Marion. *Intermedia Dialogues: The French New Wave and the Other Arts*. Edinburgh, UK: Edinburgh University Press, 2019.

Scott, A. O. "Living for Cinema, and Through It." *New York Times*, June 25, 2009. https://archive.nytimes.com/www.nytimes.com/2009/06/28/movies/28scot.html.

Scott, Grant F. "The Muse in Chains: Keats, Dürer, and the Politics of Form." *Studies in English Literature, 1500–1900* 34, no. 4 (1994): 771–93.

Sellier, Geneviève. *Masculine Singular: French New Wave Cinema*. Translated by Kristin Ross. London: Duke University Press, 2008.

Shambu, Girish. "For a New Cinephilia." *Film Quarterly* 72, no. 3 (2019): 32–4. DOI:10.1525/fq.2019.72.3.32

Silverman, Kaja. "The Female Authorial Voice." In *Film and Authorship*, edited by Virginia W. Wexman, 50–75. New Brunswick: Rutgers University Press, 2003.

Simsi, Simon. *Ciné-Passions: 7e art et industrie de 1945 à 2000*. Paris: Éditions Dixit, 2000.

Slocum, Sally. "Woman the Gatherer: Male Bias in Anthropology." In *Toward an Anthropology of Women*, edited by Rayna R. Reiter, 36–50. New York: Monthly Review Press, 1975.

Smith, Alison. *Agnès Varda*. Manchester: Manchester University Press, 1998.

Smukler, Maya Montañez. *Liberating Hollywood: Women Directors & the Feminist Reform of 1970s American Cinema*. New Brunswick, NJ: Rutgers University Press, 2019.

Sobchack, Vivian. *The Address of the Eye: A Phenomenology of Film Experience*. Princeton: Princeton University Press, 1992.

Sobchack, Vivian. *Carnal Thoughts*. Berkeley: University of California Press, 2004.

Spivak, Gayatri Chakravorty. *Outside in the Teaching Machine*. New York: Routledge, 1993.

Staiger, Janet. "Authorship Approaches." In *Authorship and Film*, edited by D. A. Gerstner and Janet Staiger, 27–54. New York: Routledge, 2003.

Stam, Robert. *Film Theory: An Introduction*. Malden, MA: Blackwell, 2000.

Stob, Jennifer. "*Détournement*, Social Space and the *Cinétracts* in Paris." In *Architectures of Revolt: The Cinematic City circa 1968*, edited by Mark Shiel, 35–65. Philadelphia: Temple University Press, 2018.

Summers, David. "Form and Gender." *New Literary History* 24, no. 2 (1993): 243–71.

Tarr, Carrie. *Diane Kurys*. Manchester: Manchester University Press, 1998.

Torlasco, Domietta. *The Heretical Archive: Digital Memory at the End of Film.* Minnesota: University of Minnesota Press, 2013.

Turner, Fred. *From Counterculture to Cyberculture: Stewart Brand, the Whole Earth Network, and the Rise of Digital Utopianism.* Chicago: University of Chicago Press, 2008.

Varda, Agnès. *The Gleaners and I* press kit. Zeitgeist Film Release. 2001.

Varda, Agnès. *Les Plages d'Agnès: Texte illustré.* Montreuil: Les Editions de l'Oeil, 2010.

Varda, Agnès, and Melissa Anderson. "The Modest Gesture of The Filmmaker: An Interview with Agnes Varda." *Cineaste*, (Fall 2001): 173–82.

Vincendeau, Ginette. *The Companion to French Cinema.* London, UK: Cassell-BFI, 1996.

Wagstaff, Peter. "Traces of Places: Agnes Varda's Mobile Space in The Gleaners and I." In *Revisiting Space: Space and Place in European Cinema*, edited by Wendy Everett and Axel Goodbody, 273–89. New York: Peter Lang, 2005.

Wallace, Jennifer. "Agnes Varda in Paris: The Urban Gaze of the Female Film-maker in Three Short Films." In *Women and the City in French Literature and Culture: Reconfiguring the Feminine in the Urban Environment*, edited by Siobhán McIlvanney and Gillian Ni Cheallaigh, 72–96. England: University of Wales Press, 2019.

Weller, Martin. *25 Years of Ed Tech.* Issues in Distance Education Series. Edmonton: Alberta University Press, 2020.

White, Patricia. *Women's Cinema, World Cinema: Projecting Contemporary Feminisms.* Durham, NC: Duke University Press, 2015.

Wilson, Emma. *The Reclining Nude: Agnès Varda, Catherine Breillat, and Nan Goldin.* Liverpool: Liverpool University Press, 2019.

Wilson, Jake. "Trash and Treasure: *The Gleaners and I*." *Senses of Cinema*, December, 2002. https://www.sensesofcinema.com/2002/feature-articles/gleaners/.

Wolf, Bryan. "Confessions of a Closet Ekphrastic: Literature, Painting and Other Unnatural Relations." *The Yale Journal of Criticism* 3, no. 2 (1990): 181–200.

Index

1960s 55–61, 64–5, 131, 145, 155–6, *see also: Lions Love ... and Lies*, New American Cinema, French New Wave, Left Bank

Agnès de ci de là Varda (2011) 2, 8–9, 96n10, 127, 143, 150
Akerman, Chantal 145, 156, 181–2
Algeria 46, 160
anti-authoritarianism 5, 7, 50–1
architecture 8, 17, 23–4, 99–101, 104–7, 110, 113–14, 120, 191–2, *see also:* Paris
art history 16–8, 20–2, 107, 145, 149, 191
Astruc, Alexandre 33, 139, 141–2
Auteurism 2–6, 16, 20, 33, 41–2, 49–50, 55–6, 144–5, 155, 163
autobiographical film 9–10, 42, 45–6, 49–50, 56, 83, 85, 101, 138, 143, 145, 184, 191, *see also:* Agnès Varda, *Agnès de ci de là Varda, Documenteur, Les Glaneurs et la glaneuse, Les Plages d'Agnès, Visages villages*
Awards 177
 Palme d'Or 7, 11
 Academy Awards 7, 11

Bachelard, Gaston 17, *see also:* Agnès Varda, education of
Bazin, André 169, 172, 185
Birkin, Jane 21, 44
Black Panthers (1968) 60, 64, 88, 138
Le Bonheur (1964) 20, 161, 175–9
Bonnaire, Sandrine 22, 143, 145, 147, 151, 182

Cahiers du Cinéma 57, 131, 169–73, *see also:* André Bazin, French New Wave, Jean-Luc Godard, François Truffaut

California 55, 60–1, 106–10, 185, *see also: Black Panthers, Documenteur,* Hollywood, Los Angeles, *Lions Love ... and Lies, Model Shop, Mur Murs,* Sausalito, *Uncle Yanco*
canon of films 50, 95, 128, 131, 163, 192
 in classical art 19–20
 of film theory 157
capitalism 76–8, 143, 151, 157, 175, 178
 and Hollywood 58
 and consumerism 71, 157
Carax, Léos 172
cinécriture 25, 33, 42, 139–40, 147, 157, 184
Ciné-Tamaris 127, 162
Clarke, Shirley 7, 55–6, 58–65, *see also:* New American Cinema
Cléo de 5 à 7 (1962) 20, 31–2, 43–6, 128, 129, 133, 138–42, 155–60
community 1, 7–10, 69, 71, 140, 151, 167
 among filmmakers 7, 56, 59 (*see also: Lions Love ... and Lies*)
 in urban spaces 8, 104, 109–10 (*see also: L'Opéra Mouffe, Daguerréotypes, Mur Murs, Les Glaneurs et la glaneuse*)
 of a minority group 10–11, 107–10, 133–4
 in counterculture 106–7 (*see also: Uncle Yanco, Les Glaneurs et la glaneuse*)
counterculture 15, 55–8, 106–7, 131
Les Créatures (1966) 192

Daguerréotypes (1976) 32, 44, 49, 73, 99, 101–3, 144, 170, 190
Delerue, Georges 101
Demy, Jacques
 Death of 26, 48, 193
 Films of 55–7, 117, 127, 133, 138
 Varda's marriage to 10, 44, 25–6, 55, 94, 114, 131, 191
Demy, Mathieu 26, 32, 103

digital camera, *see also:* Agnès Varda, filmmaker 38, 47–9, 69, 162–3, 170, 173–4, 193
Les Dites Cariatides (1984) 23–4, 99, 101, 104, 107, 190
documentary 61, 93, 131, 184, 192, *see also:* essay film
 directed by Varda 1–2, 8, 29–39, 41–5, 47–50, 57, 60, 99, 101–10, 116, 120, 127, 130, 139, 143, 149, 170, 191–3
 and autobiography 10, 42, 44–45, 91, 103–4, 133–5, 193, *see also: Agnès de ci de là Varda, Deux ans après, Les Glaneurs et la glaneuse, Les Plages d'Agnès, Varda par Agnès, Visages villages*
 integrated with fiction 42–5, 65, 73, 91, 102, 130, 139, 147, 149, 170, 176
 short form 42–43, 45, 60, 101–3, 143, 191–2, *see also: Black Panthers, Les Dites caryatides, Du côté de la côte, L'Opéra Mouffe, O saisons ô chateaux, Réponse de femmes, Salut les cubains, Ulysse, Uncle Yanco*
Documenteur (1981) 1, 24, 49, 162, 191
Du côté de la côte (1958) 32
Dürer, Albrecht 19–20, 23

Education 9, 16–17, 119, 127–8, 133, 138, 163, 190, *see also:* pedagogy
environmentalism 70–1, 74–7
essay film 1, 57, 69, 72–3, 75, 101, 134, 166, 170
ethnography 15, 106, 110, 161
existentialism 156, 158

feminism 3–5, 16, 19–22, 25–6, 41–2, 63–5, 92–3, 100, 107, 117, 122, 134, 143–5, 155–6
 and critique 17, 122, 143–4, 157
 and ethics 11, 47–8, 184
 and militancy 15, 64
 and narrative 65, 69, 71, 74–5, 77–8
 and pedagogy 3, 9–11, 127, 150–3, 161, 167
 and solidarity 61, 77, 93, 122, 134
Festival d'Avignon 84, 94, 117
filmmaker 7, 46, 92, 101, 131–4, 138–9, 144, 169
 artistic process of 29–33, 35, 38, 170–2

Left Bank group 7, 10
 women filmmakers 55–6, 58–61, 63–5, 118, 145, 162–3
film theory 25, 33, 42, 139, 144, 147, 169
Focillon, Henri 16–7, *see also:* formalism
French New Wave 50, 56, 57–9, 64, 118, 130–5, 139, 156, 158–60, *see also:* Jean-Luc Godard, François Truffaut, Alain Resnais

gender 5, 15–20, 26, 70, 88, 132–3, 160, 163 193–4n2
 and authorship 147
 essentialism 5, 17, 25
 and space 56, 105, *see also:* male gaze, masculinity, women
genius loci 99–106, 110, 190
Les Glaneurs et la glaneuse (2000) 8, 24, 29, 33–9, 41, 44, 48–9, 69–78, 94, 128, 138, 145, 161
 as comeback film 6, 41, 47, 144, 193
 and digital filmmaking 11, 48–9, 169; self-representation in 6, 34, 76, 143
 as travel film 2, 44, 69
Les Glaneurs et la glaneuse: Deux ans après (2002) 29, 41, 69, 94, 128, 138, 143, 161, 169, 193
gleaning 24, 29, 35–9, 47, 69, 71–5, 169, 175, *see also: Les Glaneurs et la glaneuse* (2000), *Les Glaneurs et la glaneuse: Deux ans après* (2002)
Godard, Jean-Luc 50, 57, 131, 133, 144, 156, 175–6, 189, 192–3

HIV/AIDS 25–6, *see also:* Demy, Jacques *Kung-Fu Master*
Hollywood 55–65, 132, 149, 151, 153

Iran 113–23
installation art 34, 47–8, 83–92, 94–5, 110, 126, 128, 138, 144–5, 162, 186

Jewish history 83, 86, 89, 91–3
JR 24, 41, 44, 128, 138, 167, 174, 193, *see also: Visages Villages*
Les Justes au Panthéon (2007) 5, 83, 87–90, 92–6
juxtaposition 32, 73–4, 101, 104, 169–70, 183, 190

Kung-Fu Master (1988) 26

Le Guin, Ursula K. 69–75, 77–8
Left Bank 10, 57–8, 131, *see also:* filmmaker, Chris Marker, Alain Resnais
Lions, Love ... and Lies (1969) 55–6, 59–67, 138
Littman, Lynne 60–1, 63–4
Los Angeles 60, 64, 106–10, 191, *see also:* California, *Mur Murs*

#MeToo 4, 41
male gaze, *see also:* Mulvey, Laura 15, 146, 157, 177
Manovich, Lev 171
marginalization 33, 59, 69, 73, 110, 130, 132, 162
Marker, Chris 57, 186, *see also:* Left Bank
marriage 48, 118, 123, 191–2
 in film 19, 88, 109, 176–7, 179
 Varda's marriage *see* Jacques Demy, *see also: Le Bonheur, Mur Murs, Quelques veuves de Noirmoutier*
masculinity 16–19, 23, 69–72, 74, 177, 192
metaphor 29–39, 45–6, 69, 74, 76–8, 85
Model Shop (1969) 55, 57
Mozart, Wolfgang Amadeus 175, 179
Mulvey, Laura 43, 145–6, 157
Mur Murs (1981) 32, 73, 99, 106–9, 190

nakedness 46–8, 105, 192, *see also: Jane B. par Agnès V., L'Opéra-Mouffe*
New American Cinema 56, 59, *see also:* Shirley Clarke, 1960s
Norberg-Schulz, Christian 99–100, 110, *see also: genius loci*

L'Opéra-Mouffe (Diary of a Pregnant Woman, 1958) 20, 42–4, 46, 73–4, 76, 99–102, 143, 145, 190
orientalism 5, 120–2
O saisons, ô châteaux (1958) 32
Oscars 7, 11, *see also:* awards

Pantheon 8, 83–95
Paris 57, 69, 71, 76, 83, 115–16, 121, 157, 159, 162, 181, 184, 186
 and architecture 2, 8, 24, 99, 101–5

 in films 1–2, 9, 32, 42–44, 77, 99, 101–6, 110, 157, *see also: Les Glaneurs et la glaneuse, Cléo de 5 à 7, L'Opéra Mouffe, Daguerréotypes*
 as Varda's home city 9, 17, 94, 99, 101–4, 106, 137–8, 170
patriarchy 15–16, 20, 25, 76, 106, 135, 140, 151, 177–8
 resistance to 21–2, 50, 179
pedagogy 2–3, 6, 11, 127–8, 142, 161–3, 167, 175, 190, *see also:* education, teaching
 and digital culture 11, 161, 163–6
 and film studies 9–10, 144–7
 and feminism 3, 9–10, 142, 163, 167, 192–3
Les Plages d'Agnès (2008) 32, 41–3, 45–6, 49–50, 83, 128, 134–5, 138, 143, 145
Plaisir d'amour en Iran (1976) 16, 113–4, 119, 120
La Pointe Courte (1955) 91, 131, 145, 161, 170, 176, 190–1
postwar, see Second World War
pregnancy 15, 20, 42–3, 46, 74, 101–2, *see also: L'Opéra-Mouffe, Réponse de femmes, L'Une chante l'autre pas*

Quelques veuves de Noirmoutier 47–8, 110, 186

Réponse de femmes: Notre corps, notre sexe (1975) 15–16, 46, 191–2
Resnais, Alain 57, 131, 184, 186, 191, *see also:* Left Bank
Rive Gauche *See* Left Bank

Sans toit ni loi (Vagabond, 1985) 49, 140, 143–7, 149, 161, 177, 181, 187
Sausalito 106–7, *see also:* California, *Uncle Yanco*
Second World War 16–18, 83–4, 106, 139, 156
self-portrait 6, 45, 50, 56, 134–5, 182, 185, 193, *see also:* Agnès Varda, autobiographical work of
sexism 6–7, 16, 19, 25, 63–4, 118–19, 185, 191–3
sustainability 5–6, 10, 29–30, 37, 39

tableau vivant 21–2, 170–1, 185
teaching 9, 127–8, 131, 137–41 143–7, 150, 155, 161–7, 175, 189–90, *see also:* education, pedagogy
Truffaut, François 50, 57, 131, 133, *see also:* French New Wave

Ulysse (*Ulysses*, 1983) 44, 157, 162
Uncle Yanco (1967) 44, 49, 99, 106–7
L'Une chante l'autre pas (1977) 113, 115, 120–2, 138, 162
urban geographies 8, 101, 106, 110, *see also:* Paris, Los Angeles

Varda par Agnès 41, 92, 128, 138, 143, 193
Varda, Agnès
 autobiographical work of *See: Agnès de ci de là Varda, L'Opéra Mouffe, Les Plages d'Agnès, Varda par Agnès*
 and digital media 2, 6, 11, 38, 47–9, 69, 127–8, 161–7, 169–74, 190, 193
 education of 9, 16–19, 107
 and the French New Wave 10, 50, 56–9, 64, 118, 130–5, 139, 155–6, 158–60, filmography of 3–4, 8, 17, 22, 78, 89, 113, 127, 138, 142, 184
 financial support for films of 7, 38, 57, 61–4, 115–18
 installation and multimedia art of 6, 8–9, 34, 47–8, 83–95, 110, 128, 138, 144–5, 162, 182, 186
 legacy of 1–5, 9–11, 29, 39, 93, 127–9, *see also:* awards, Left Bank
Varda, Rosalie 1, 42, 74, 101, 127, 189

Women 17, 92–3, 133, 136
 as artists 6, 9, 25, 60, 63, 78, 117, 184
 in feminist movement 41, 55–6, 59, 64–5, 131, 135, 156
 as film directors 6–7, 50–1, 55–65, 124n8, 131, 133–4, 144–5

www.ingramcontent.com/pod-product-compliance
Lightning Source LLC
Chambersburg PA
CBHW062225300426
44115CB00012BA/2227